Designs on the Heart

Designs on the Heart

Karal Ann Marling

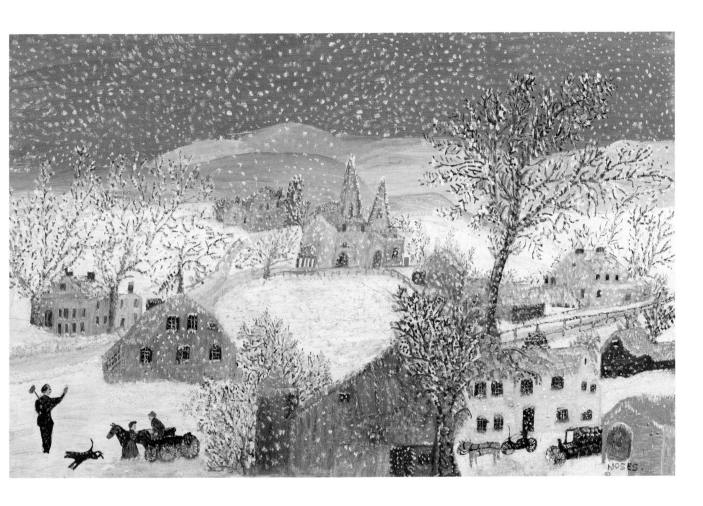

The Homemade Art of Grandma Moses

Harvard University Press
Cambridge, Massachusetts
London, England · 2006

Copyright © 2006 by the President and Fellows of Harvard College
All rights reserved
Printed in the United States of America

Grandma Moses illustrations copyright © 2006, Grandma Moses Properties Co., New York.

Quotes from *Grandma Moses: American Primitive* copyright © 1946 (renewed 1974) Grandma Moses Properties Co., New York; quotes from *Grandma Moses: My Life's History* copyright © 1952 (renewed 1980) Grandma Moses Properties Co., New York.

Title page illustration: Grandma Moses, *Get Out the Sleigh* (1960). Oil on pressed wood, 16″ × 24″, Kallir 1474.

Publication of this book has been supported through the generous provisions of the Maurice and Lula Bradley Smith Memorial Fund.

Library of Congress Cataloging-in-Publication Data

Marling, Karal Ann.
 Designs on the heart : the homemade art of Grandma Moses / Karal Ann Marling.
 p. cm.
 ISBN 0-674-02226-2 (alk. paper)
 1. Moses, Grandma, 1860–1961—Criticism and interpretation. I. Title.

ND237.M78M37 2006
759.13—dc22 2005056419

For my mother,
Marjorie Matilda Marling,
and her mother,
Harriet Arvilla Karal,
whose work was never done

CONTENTS

This book is not quite a biography of Anna Mary Robertson Moses—Grandma Moses (1860–1961). She wrote her own story in several versions and what she didn't write, she talked about in public, often and volubly. But in doing so, she rarely probed her public life as an artist. Others have written detailed analyses of her style and her formal evolution over time. What has not been written is an account of how an obscure rural woman of advanced years came to the attention of the gallery world in the first place, the hostility that greeted her rise to fame, and her enormous popularity among advertisers, consumers, and celebrities—the buyers most indifferent to critical opinion. Her popularity was certainly propped up by publicity. At the same time, the persona of the "public Grandma" brought comfort and pleasure to the many who loved her work. I want to explore why—and specifically why in the 1940s and 1950s—Grandma Moses became a fixture on the national scene as well as an icon of Americanism.

Grandma Moses was loved both for her piquant self and for her pictures, and it seems worthwhile to ask what the themes she repeated so often meant to her audience and to herself. The two questions are not the same. Mrs. Moses enshrined in her work snatches of popular poetry, bits of folk song and folklore, ways of doing things, images and myths that grew out of her long life, beginning with her childhood in the 1860s. Her reprise of nineteenth-century culture was oddly suited to American interests in the complicated period when the Depression was finally limping to a halt, World War

II reengaged the nation's energies, and peacetime brought a fresh set of social and geopolitical challenges. There is an unexpected fit, in other words, between Grandma Moses' memories of the past and Americans' efforts to cope with a very volatile present.

The third unexplored dimension in the story of Grandma Moses is branding, or what today's filmmakers might call "product placement." Although she was not the first artist to find her paintings emblazoned on consumer goods, her staggering inventory of merchandise—the greeting cards and wallpaper and yard goods and chinaware—says something important about the terms of her reception. She was of and for *the home* in a manner unique among her contemporaries. Cynics and skeptics have been quick to dismiss Grandma Moses on the basis of her wares, as if inspiring a line of draperies disqualified an artist from further consideration. But the reverse is true, I think. The artist whose work was part and parcel of the Early American–style home of the postwar years is clearly saying something important about the life being lived there.

I would not have been able to press these issues without the generous assistance of Jane Kallir and Hildegard Bachert at the Galerie St. Etienne. Ms. Kallir's grandfather was Grandma Moses' principal dealer, and that New York City gallery has maintained a series of remarkable scrapbooks that document the public aspects of her life in meticulous detail. These books are stuffed with clippings from newspapers and magazines in the United States and abroad, covering almost anything having to do with the artist: ads, letters to the editor, tearsheets of every kind, crossword puzzles in which her name appeared, bits from local newspapers in towns so small that the papers have long since disappeared. Without access to the Moses Scrapbooks, it would have been impossible to explore the terms of her popular appeal in any reasonable depth.

In the interest of expedience, I have not always provided citations for the more obscure dailies from which information has been drawn. I direct the interested reader to the scrapbooks themselves for multiple copies of similar articles, numerous ads for the same product, and similar materials. The Galerie St. Etienne also maintains files of exhibition catalogs and handouts, photos of merchandise, photographs of Grandma Moses herself, and parts of the artist's working file of "clip art" (clipped out of any printed source that came to hand). Jane Kallir has shown how and where this cache of motifs has been used in the art of Grandma Moses; there is no reason for me to reinvent her painstaking work on this key facet of the painter's style.

We are all, like Grandma Moses, products of our experience. As I soon learned when beginning this study, my personal and scholarly experience coincided in many and complicated ways with the interests of Grandma Moses' audience and, at times, with those of Grandma herself. There's a farm in my history, a pair of delightful grandmas, folk songs, a love for winter and Christmas, some Sunday painting, several "sugaring-off" excursions in New England, and the Grandma Moses sewing box I received as a present on my ninth birthday.

But the notion of looking into Grandma Moses was not mine. Paul D'Ambrosio, chief curator of the Fenimore Museum at Cooperstown, New York, enlisted me to write this book to coincide with the tour of a Moses exhibition organized by the museum. The generous financial assistance of the New York State Historical Association funded the labors of my research assistants, Cassie Wilkins and Nogin Chung. Nogin, in particular, has been a supportive partner during the several years over which this book has taken shape. My brother, Gregory Marling, provided good company on a swing

through the parts of eastern New York and western Vermont we called "Grandma-land." Mary Ellen Geer has been my dream editor: tireless, wise, smart, and very kind. Finally, the College of Liberal Arts at the University of Minnesota supplied the time and grant support necessary to complete the work.

Grandma Moses believed passionately in remembering. So do I. It may not be orthodox history, these memories of feelings hitched to things, these snatches of melodies, these vivid colors, the smell of apple blossoms. But this is a story that needs telling, all the same.

Designs on the Heart

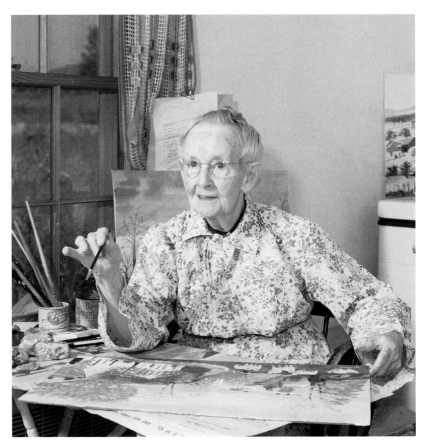

Grandma Moses at work in her new house. 1952. Photograph by Ifor Thomas.

Flying Over Quilted Landscapes

The view of the country from 27,000 feet up on a crisp winter day ought to be overwhelming—"This land is your land" spread out vast and mighty and beautiful, like a resounding chorus of the almost-folk song. It's not. A plane's-eye view minimizes spaces, miniaturizes scenery. Over New England, a light coating of snow drifts up in odd corners of the acreage, tracing out the higgledy-piggledy patterns of woodlots and little fields marked off by Robert Frost fences. The trees are a tracery of faint black lines against the whiteness, a fine, complicated stitchery on the velvet of the slumbering earth. The countryside passes below like a crazy quilt of odds and ends—satins, velvets, ribbons, silks, in whatever shapes and sizes come to hand—all featherstitched together in the 1870s by the young ladies of Bennington, Vermont, or Eagle Bridge, New York, for a bride-to-be.

In a lovely story written in 1906, "The Bedquilt," New England writer Dorothy Canfield Fisher drew upon the deep roots of needlework in a women's history of America to describe the endless domestic labors of an old maid who earned her keep in the household of relatives scarcely aware of her presence. In her sixty-eighth year, Aunt Mehetabel starts a quilt of her own devising. It takes five years to complete, but in the meantime, her handiwork has become a point of local pride. Visitors arrive to see it. The quilt takes the prize at the County Fair, six miles from home—the most distant place the old lady has ever visited. And then she comes back contented, says Fisher, and sits staring into the fire, "on her tired old face the su-

preme content of an artist who has realized his ideal."[1] There New England lies, looking from the air like Aunt Mehetabel's quilt, the work of patient hands warming the fields for the coming of spring.

Pass over unseen borders into New York State, Ohio, Indiana, and Minnesota on the Mississippi, and the quilt is now made up of calicoes and ginghams, the tails of old work shirts, and once-upon-a-time curtains from the kitchen, arranged in regular quarter-section squares. Here and there the patchwork is broken, rearranged in highly original ways. Vermont's "Mariner's Compass" design suddenly trails off in favor of the "Stair Step" or the "Broken Dishes," as if the girls who came to the quilting bee described in Harriet Beecher Stowe's classic *The Minister's Wooing* (1858) had settled their argument about the relative superiority of the "Oak Leaf" pattern versus the common "Shell" by doing bits of both. Maybe the farmer moved his barn to accommodate a new mechanical irrigation system—circles everywhere. Maybe some rebellious, yearning soul dropped a French knot here and there, like punctuation marks or a signature against the flatness of the cloth. Here I am! Here I am!

The quilt is *her* signature, *her* place, *herself,* unless somebody else claims it for other purposes. A case in point: the quilt in Robert Rauschenberg's 1955 "combine painting" called *Bed,* a work so aggressively revolutionary in its day that it was censored out of the Spoleto Festival. According to the story the artist told about *Bed,* he didn't have any canvas one spring day in New York City, so he began to eye a bed quilt acquired—from a woman, of course—during a stay at Black Mountain College. He stretched it like a painting, added the pillow, and went to work. The quilt itself—probably Southern-made, and well used—is a kind of variant on the popular "Log Cabin" pattern. Now as artists will, Rauschenberg denied any intention to shock. It was one of his "friendliest pictures," he said.[2] Why not take him at his word?

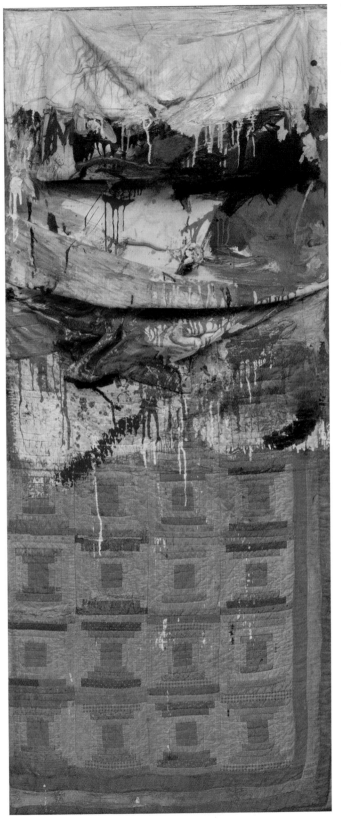

Robert Rauschenberg. *Bed.* 1955.
"Combine" painting with pillow and quilt.
The Museum of Modern Art, New York.
Art © Robert Rauschenberg / Licensed by
VAGA, New York, NY.

Prologue: Flying Over Quilted Landscapes

3

With Rauschenberg's added slashes of Abstract Expressionist brushwork, *Bed* becomes the self-portrait of the artist on a cold night—a representation because the quilt is tipped up perpendicular to the wall, like a painting or an artifact in a museum of folk art. In its proper position, parallel to the floor, covering Rauschenberg's bed, it could be a map, a part of the landscape of slumber vanishing beneath the wings of a DC-9 somewhere over Asheville and Black Mountain College. The female art of the quilt—the female place—has been appropriated in a particularly masculine way. The painted quilt when stood erect and undomesticated becomes the biography of a man, *his* picture. Art. Rauschenberg said that "all material has its own history built into it."[3] The handsome old "Log Cabin" quilt is still there, in its historical essence, but diminished and disinherited, its old, old story reduced to the faintest of whisperings.

Somewhere just east of the Hudson Valley, not far from the place where Vermont, Massachusetts, and New York come together in an uneasy alliance of hills and upland fields and tumbling little rivers, stands what is left of the hamlet of Eagle Bridge, New York. And here the crazy quilts and the patchworks and the "Log Cabin" quilts-turned-to-art all come together, too, in the embroidered farmsteads of Washington County. The farms here are edged with locust trees, stiffly tall and narrow. Route 67 meanders down from Vermont through the seven villages that make up the town of Hoosick. The last of them is Eagle Bridge, named for an ancient wooden covered bridge decorated with statues of eagles—and it is easy to miss. An abandoned train station next to the rusted tracks of the Boston & Maine line. A post office in a trailer. A swaybacked restaurant on the edge of town, full of cracked linoleum and mismatched chairs. A garage. And the Moses Farm Stand, close by a little two-lane road that

scoots uphill and disappears in a clump of locust trees: Grandma Moses Road.

Grandma's son Forrest was once the proprietor of the vegetable stand. He and his brother built a little one-story house on the road named for her, the house in which she spent her final years. But before it comes into view, right at the top of the second rise, perches Mrs. Moses' original farmhouse, facing the meadows and the distant hills of the family dairy farm, where she settled with her husband Thomas in 1905. A historical marker wobbles in the grass that spills down toward the asphalt. They called the farm "Mt. Nebo" after the mountain in the Bible where Moses disappeared into history, like a westbound jet, at the age of one hundred and twenty. Mrs. Moses lived to see her 101st birthday before she passed into the annals of county history in 1961. Her true place in the roll call of the immortals has never been clear, though. A "primitive," according to some. A "folk artist." A model senior citizen, feisty and active. A media celebrity. A marketing bonanza. And all because at the age of 78 she was "discovered" as a painter, a self-taught creator of images whose subject matter often came from the fields across the road and who took up the brush when arthritis made it harder and harder for her to make pictures in needlework.

Eventually, old Mrs. Moses was encouraged to try cozy interiors at the urging of potential buyers. "That don't seem to be in my line," she retorted, but tried anyway.[4] *The Quilting Bee* (1950) is a good example. A big piece of the picture is taken up with windows that open on the fields across the road, a landscape resolved into triangles of green angled this way and that, like the pattern on the quilt the ladies are working in the warm light from the out-of-doors. Their quilt frame is tipped up like Rauschenberg's *Bed,* until it is almost a painting within the painting, but this is no metaphor for restless sleep. In-

The Quilting Bee. 1950. Oil on pressed wood.
20" x 24". Kallir 883. Private collection.

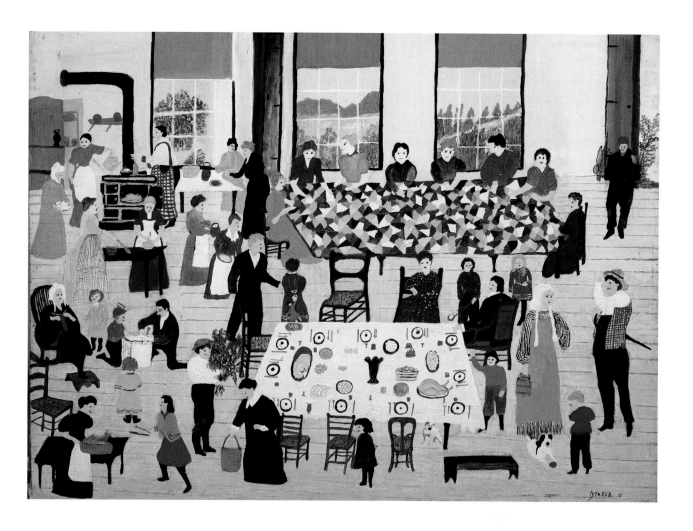

stead, the quilt is paired with a table in the foreground set with china and silver and hams and turkeys, for a "lunch" after the quilting is done.

This is a feminine space. The few males present bring in game for the larder, turn the dasher to make ice cream, or court young ladies

come to visit on this special occasion (the pretty "Miss Nellie" of the old folk song called "The Quilting Party").[5] But the focus is not on the men. The story being told is that of the industrious women and the three pictorial elements that define their labors: the land outside the window, the quilt, and the table heaped with the bounty prepared by their own busy hands. As Mrs. Moses lays it out, the picture feels like flying back in time over a memory of family, friendship, green fields, and good things to eat.

Flying over an ocean is something altogether different. The scenery below is clouds, shaped to no particular terrestrial pattern—hints of ruffles in the waves riding upon the blackness of the sea. The long trip to Australia has nothing in common with soaring over the American landmass. The quilts, the ladies, the stitches, the nostalgic symbols of feeding or bedding down are back there somewhere, far behind the contrail of the jet. Once on the ground, the pilgrim still has a long trek to Broken Hill, a broken-down mining town on the southernmost rim of the Outback, the featureless red desert of dust and heat that lies flat as a cracker in the heart of Australia.

Broken Hill is home to one of the most enigmatic figures in Australia's recent cultural history: Pro (a.k.a. Kevin) Hart, ex-miner, bodybuilder, fundamentalist Christian, and self-taught painter. Folk artist, "discovered" in 1962. Primitive. Naive. "Bush painter." Celebrity, given to combative statements on all topics. Collector of old cars, old watches, paintings by much-honored Australian artists, pipe organs. A cottage industry in his own right. And among critics and curators, a puzzle and often a pariah. An outsider. Who else, they ask, would be delighted to have his pictures reproduced on air-conditioning units and kitchenware? To make TV commercials for carpeting? Pro is a populist, which discriminating critics (and artists)

Kevin "Pro" Hart. *Country Race Meeting.* 1960.
Monash Gallery of Art, Australia.

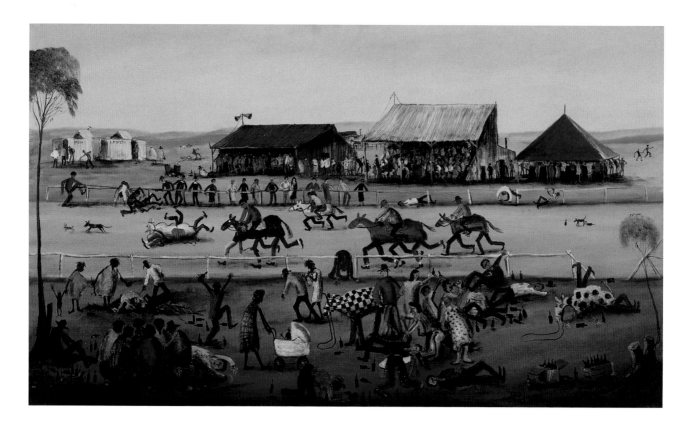

are not supposed to be. He paints miners and bugs and landscapes and the narratives that compose the national story Australians like to tell about themselves. Most of Hart's best-known paintings (avidly copied by the many "Brushmen of Broken Hill," who turn out tourist pictures in his style) are landscapes that tell stories.

Hart is one of Australia's most prolific illustrators, providing suites of paintings to accompany the poetry of Henry Lawson and Banjo Paterson, tall tales about the exploits of the semi-legendary outlaw Ned Kelly, and the lyrics of "Waltzing Matilda," the unofficial national anthem. Spare, energetic stick figures play out their dramas

before slippery panoramas, thick with fatty pigment laid on in bands of red and yellow and green. Scabrous gum trees spring tall over the scenery. The paintings are a grid of verticals and horizontals—the essential flatness of the outback versus the insistent thrusting oddity of the eucalyptus. The trees, says Pro, establish the Australian-ness of this place: "I like to show an Australian atmosphere by combining different types of trees, . . . incorporating features from the coolabah, box, and gum."[6] Fantasy trees, satin-stitch trees conjured up out of the same slick, smeary brushwork that defines the red soil—these are not real botanical specimens, but they do recreate the sense of being at the margins of the bush, dwarfed but curiously energized by the forbidding landscape.

Sometimes the themes come from the life of Broken Hill. A panorama of Christmas Day in a mining town, with a drunken Santa leading a parade of children down the High Street. Race Day. Washday at the diggings. A tipsy party in a miner's backyard, with babies, dogs, and drunks scattered across the scene like blowsy cabbage roses on old wallpaper. These are not skillful renderings in any academic sense. The drawing is cartoonish and the paint application is, at best, idiosyncratic. Still and all, a Pro Hart painting—like an Eagle Bridge subject by Grandma Moses—contrives to be exactly right, true to the artist's understanding of his or her place in the wide world and the comfort of the familiar, however mythologized, mundane, or irrelevant to the great debates of the smaller world of art. The "mistakes" pale alongside the energy, the ordering process, the participatory zeal that make these unprepossessing pictures a part of a common life lived rather than a commentary upon it.

If they are outsiders—Grandma Moses and Pro Hart—what fence line, what featherstitched seam of importance have they strayed beyond? If naives, what sophisticated perceptions *should* they have

brought to a peep at a middling sort of midday in New England or New South Wales? Are they some species of living marginalia, sending postcards back from places hidden in the folds of the map? Is ruralness or eccentricity or the failure to seek professional training of a specialized sort an immediate disqualification from respectful interest? Or do these factors invite public notice from the "wrong" segment of the public—from the people who flocked to Aunt Mehetabel's hometown to see the wondrous quilt that kept her at her needle for almost five years?

One of the greatest difficulties the tourist encounters on the flight over the terrain occupied by picture-makers like these is where to land. Worse yet, the tour guides best equipped to answer the questions have been engaged in a seriocomic years-long battle over terminology—over just what to call the Pros and the Grandmas and the Aunt Mehetabels, and just where they fall on the aesthetic spectrum. The terrain is still dangerous and open to attack. In 1977, in an influential and contentious essay published in conjunction with an exhibition of scrimshaw, embroidery, carvings, jugs, and the like, Kenneth Ames took up the issue of nomenclature. He examined several possibilities. Were those who figured in the exhibition strange, old, unskillful, backward, given to fantasies of a golden age, childlike, incompetent, marginalized, or merely insane? His conclusion was that the scholar is better served by forgetting the boundaries and the categories and looking at the objects themselves; that they had something to do with a "folk tradition."[7]

More recently the Smithsonian American Art Museum, closed for renovations, sent its collections out on tour in a series of thematic traveling shows, one of them entitled "Contemporary Folk Art."[8] Mercifully, the show's catalog assumes that the viewer will take a marvelous laughing giraffe with huge (false?) teeth and an attenu-

ated body covered in soda bottle caps as folk art, whatever that may be. No further definition necessary. But only two of the fifty-one artifacts illustrated are by "unidentified" makers. If the whirligigs and the holy pictures had been folk songs, the words might have been labeled "traditional"—lyricist unknown. Not so with the Smithsonian's objects. Even the giraffe (attributed to "unidentified") is dated—and the term itself suggests that further research will inevitably turn up a name, a biography, another muddled tale of what it means to make beautiful things somewhere beyond the confines of a place where real art is properly created. The implication is that the giraffe has got to have a story to excuse the bottle caps and the humor.

Rauschenberg's *Bed* needs its backstory, too. And one was supplied on demand by the artist: Black Mountain, warmer weather, no need for heavy bedclothes. But the story doesn't compromise some fundamental mysteriousness about that quilt on the wall. When a person least expects it, objects can reach out and whisper to her, telling lies or half-stories of their own. Some years ago, as I was marching through the train station in Washington, D.C., headed for a New York–bound express, a peculiar artifact murmured to me from a pushcart on the main concourse. "Folk Art," the sign said. The attraction was a pottery alligator about a foot long, heavy, scored with a checkerboard of scales, each one obsessively indented at the center with the same instrument (a stick, I think), and glazed in a nasty brownish green, the color of a swamp or perhaps cocktail olives long past their prime. The gator had a wrinkled snout with pursed "lips" at the end of it, as if he were about to whistle at the passersby. So far, nothing too extraordinary. But from his back arose a head-and-torso figure in a dull red costume, a penis-shaped figure with a beard,

punctured eyes, and a mouth just like Mr. Gator's. And his little red hands—his mittens—were the claws of a crawdad. Aha! It must be old St. Nick, I thought—Santa stoned and lost in the Everglades. "Sandy Claws" himself! There's a story here, a mad piano riff on a holiday album by Jerry Lee Lewis.

So I bought the big lump of a thing and later shrouded it in a paper bag for a flight west out of New York City across the snowy fields. At the airport, the X-ray screener couldn't figure out what was in the bag. So I unveiled "Sandy" in all his glory, provoking gales of laughter from everyone around me. Eventually it wound up as a doorstop noteworthy for its great weight, its piquant ugliness, and the fact that the room smells faintly Christmassy whenever you notice the alligator and his pal.

And it soon became authentic "Folk Art," thanks to a little casual research. My doorstop is a piece by Mike Hanning, a self-taught potter born in Corpus Christi, Florida, in 1954. Included in his artistic repertoire are pitchers and jugs and animal statues, all featuring the same appended figure. Sometimes the little man is glazed in black, which makes that specimen into an example of "Black Americana." Sometimes his hat is a stocking cap, sometimes a straw hillbilly topper. Sometimes he rides a rooster. Sometimes Santa (are those really claws? or Hanning-style mittens?) rides a two-headed chicken. Hanning is, according to one of the several Internet dealers who handle his fantasy vessels, a "True Southern Potter" who uses local clay and homemade glazes.

Yahoo.com delivers up screen after screenful of alligators, a scrolling map of gatorness: pictures thereof, some of them painted in mud; whirligigs with snapping jaws; alligators carved with chainsaws; alligator banners that read "Gators love Fried Green Tomatoes." And so on. Important to each of the websites—almost as im-

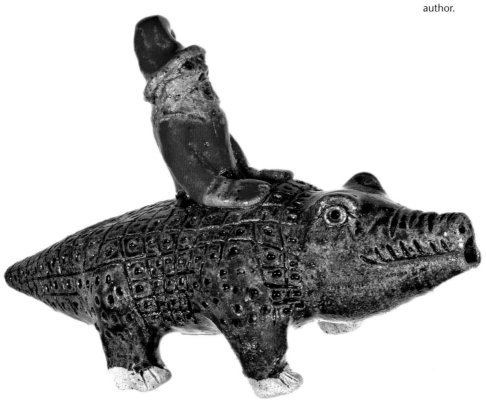

Mike Hanning. *Christmas Gator.* c. 1990. Glazed ceramic. 8″ x 12″. Collection of the author.

portant as the various animated or stationary gators—is the story, not about swampland and legend, but about the artist. Born in Coffee County, Tennessee. In Caines Ridge, Alabama. In Corpus Christi, Florida. "Made in the U.S.A." Paints barefoot in his backyard. Out of stock on the snapping gator right now, "but will create one in 10–15 working days." Uses junk, dirt, old bottles, leftover plywood scraps. "Featured in *Country Decorating Magazine.*" Rural. Southern/hillbilly. Authentic. Raised in the projects. Loves Elvis and Howard Finster. Worked on a chain gang. Sold melons for a living. A visionary from a blue highway way off the customary flight paths to and from New York City.

Being a Folk Artist these days, painting barefoot in one's own

backyard, is a lot like being the late, great Johnny Cash or Dolly Parton, apparently. You come from some backward "holler" and you learn your music from the radio, from Elvis, or from an aged relative. You get yourself discovered in Memphis, Nashville, or Branson, Missouri. And, if possible, there's a blot of lawbreaking or some other indiscretion on your official biography (a steamy affair, a father in jail, and so forth). Those are the bona fides for an authentic voice, redolent of old times: a disinclination to follow rules and a true heart. This is what makes real Folk Art.

For a more nuanced view of the subject, however, consult Bob Dylan's *Chronicles,* the story of a blameless young man from Hibbing, Minnesota, who goes to New York seeking fame and fortune as a folk singer, circa 1961. Middle class, not Southern, and endlessly inquisitive. "Folk songs," he writes, "were the way I explored the universe, they were pictures and the pictures were worth more than anything I could say." The ballads told stories stuffed with all kinds of characters, mythic and real, "vividly drawn archetypes of humanity."[9] Folk music is the song and not the singer, Dylan seems to say, except that his definition somehow emerges from his own life story in the Greenwich Village "folkie" hangouts of the early 1960s.

A lot of Dylan's word pictures and his melodic stories are old ones, even older than Alan Lomax's pilgrimages to Appalachia in the 1930s in search of uncontaminated folkishness. But modern admirers of American folk music are less interested in purity than in evolution—how specific events, often profoundly unnewsworthy, triggered poetry and melody that still conjure up vivid pictures long after Frankie shot Johnny (or Albert) down in St. Louis back in 1899; how untaught genius makes a ballad that people—the "folk" in Folk Art—preserve and cherish and change to their own purposes. It is not so much that "the folk" get together to write a song, but that the

ballad is meaningful to them in a way that makes it as much a property of the listener as of any "auteur." In that sense, the Beatles' "I Wanna Hold Your Hand" is a folk song, too.

Who are the folk in the age of cyberspace and CDs? And what is their art, their folklore? Is it advertising, as several prominent thinkers claimed in the 1950s and 60s? Is it TV? Joseph Bertiers, whose real name is Joseph Pius Mbatia, is a 40-ish sign painter living in Nairobi, Kenya. In 1985, he had his first show as a gallery artist in Los Angeles. Since then, he has been the subject of a second major exhibition and a book on his work.[10] Using the commercial style of his earlier signboards advertising local beauty parlors and butcher shops, Bertiers creates images of current events described by CNN, *Time,* and *Newsweek.* The heroes of his pictures were, in the late 1990s, media celebrities: O. J. Simpson, Tonya Harding, Bill Clinton, and Princess Diana depicted in narrative panels grouped into series, each one telling the story of the Whitewater Affair or "The Maiming of Nancy Kerrigan," for example, as so many verses of a strange yet compelling ballad.

Bertiers sees pictorial fragments and reconstructs highly dramatic, often moralizing tales—factually incorrect, as often as not—on the basis of visual bits and pieces held together by the media fame of the week's big scoop. These are pictures that arise from and are intended for the public arena. The stories are based on the deeds of public figures of more or less intrinsic significance; Prince Charles and Princess Diana could be the Frankie and Johnny of their day, topics of conversation, idle gossip, communication, affirmation, and judgment shared by the public and the painter. Bertiers/Mbatia is a folk artist selling his wares in the global marketplace of mass culture.

If Bertiers is the Andy Warhol of Kenya, then Andy Warhol, with

his affinity for the iconography of mass culture and advertising, was a disco folk artist from Studio 54. Pro Hart, Robert Rauschenberg, Mike Hanning, Andy Warhol—and Grandma Moses, who died in 1961 just as Dylan arrived in New York City. Frankie and Johnny, "Blowin' in the Wind," and Grandma's favorite, "The Old Oaken Bucket," occupy the same poetic realm. We know folk art when we hear it or see it, even if we see it in the form of things that are trying way too hard to be folk art. Homemade jam in Ball jars swathed in checkered gingham. The whittlers at the county fair. The geese with the ribbons around their necks who march around the wallpaper borders of suburban kitchens. Dealers who haunt craft shows with their wooden watermelon slices and jewelry made from old silver forks. "Crafters" selling kits to make old-fashioned scrapbooks on the home shopping channels. A big clay alligator with Santa Claus perched on his back. A Rolls Royce decorated with tableaux from Australian history; a paint-smeared quilt from the Carolinas; a pair of curtains made from fabric decorated with scenes from paintings by Grandma Moses.

Grandma Moses was born in 1860. When you wanted to go somewhere then—to Hoosick Falls or to the rural Shenandoah Valley of Virginia, where she settled as a new bride—you went by wagon or rattling railroad car. In 1961, when she died, travel was still difficult in places like Nairobi and Broken Hill. There were still "hollers" deep in the South where ballads lurked unrecorded and quilters worked away out of love or pure necessity. Folk art was a little like the traditional dress of a bride. Something old: a weathervane, a New England sampler, stories about the good old days. Something new: the Kingston Trio jazzing up an old story-song on a hit record. Something borrowed: the rhythms, the design vocabulary used for generations by seamstresses and mandolin players alike. Something

blue: the sky over the spot where New York shakes hands with Vermont. Old, new, borrowed, blue—and trimmed in homemade lace. Come! Tell the story of that brave little bride of 1887 before her words are blown away in the roar of a jet climbing to 27,000 feet, high over the last of New England.

1. The Air Castle Years

She wasn't always a pert old body given to homemade velvet dresses and odd little hats that perched atop her knot of white hair like ancient blackbirds trimmed with cobwebs. She hadn't always worn spectacles or taken a few drops of turpentine in a glass of sweet milk at bedtime to soothe the arthritis in her fingers. And she wasn't always anybody's Grandma. Once upon a time, she was a wide-eyed, bottom-heavy little girl with ideas of her own, living on a farm—the old Cottrell-Skiff place—in Greenwich, New York, not far from the Vermont border. To the east lay the Green Mountains. To the west, the Hudson River, the Taconic Hills. Her Pa was a farmer; he owned a flax mill with a little cupola on top. It burned down one afternoon in her childhood, but she always remembered that the cupola would have made a beautiful house for her homemade paper dolls.

She remembered those days through all of her 101 years. Those places: the farmstead a mile or so outside of Greenwich where she was born in 1860, deep in the valley of Battenkill Creek; the nearby town of Cambridge, site of the old turnpike inn where British troops had set up a hospital in 1777 during the Battle of Bennington. When "Sissy" Robertson was born, the old inn had just been repainted in the distinctive pattern of red and white checkerboarding that made it a landmark throughout the Cambridge Valley, clear down to Hoosick Falls. She never forgot the stories about the Checkered House (which burned to the ground in 1907). It "is old," she wrote almost a half-century after the fire. It was "a stopping place for the stage, where they changed horses every two miles. Oh we traveled

Anna Mary Robertson at age four, 1864.
Photograph.

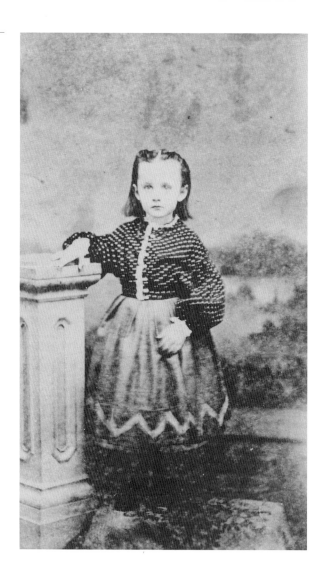

fast in those days."[1] She never forgot the towns and the stories: Cambridge, Greenwich, Hoosick Falls, Eagle Bridge, Bennington—communities northeast of Albany and Troy, small but substantial enough for trading, weekly papers, fairs, and remembering the great historic events of 1777, 1812, and Abraham Lincoln's election in 1860.

"I anna mary Robertson, was born back in the green meadows and wild woods, on a Farm in washington, co. In the year of 1860, Sept. 7. of Scotch Irish Paternal ancestry. Here I spent the first ten years of

Checkered House. 1943. Oil on canvas. 36″ x 45″. Kallir 317. The IBM Collection.

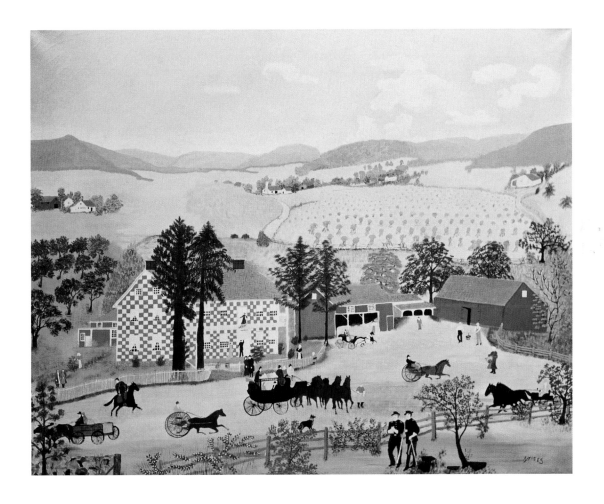

my life with mother Father and Sisters and Brothers, those were my happy days, free from care or worry, helping mother, rocking Sister's cradle, taking sewing lessons from mother sporting with my Brothers, making rafts to float over the mill pond, Roam the wild woods gathering Flowers, and building air castles."[2] The third of ten children, the oldest of five girls, she was expected to tend to baby

Celestia and look after Arthur, who was two years younger than she—but just about the same size. That was the way of things in a large family. "We came in bunches, like radishes," Anna Mary later quipped. She and little Arthur (called Bubby) sometimes waxed philosophical when springtime turned the meadows into a riot of wildflowers. Bubby thought the sight was "almost as pretty as heaven."[3] For Sissy, there couldn't ever be a heaven without flowers in all the colors of the rainbow.

They must have told stories in the Robertson house. The children knew that one of their father's grandfathers came to the Cambridge Valley from the Catskills just before the Revolutionary War. That back in the eighteenth century another of their ancestors, a Cambridge pioneer, had married a genuine Indian girl. That Archibald Robertson, Pa's Scots-born grandfather, was a wagonmaker who built the first wagon to run on the Cambridge turnpike. Pa's elder brother, an eccentric sort who had visions of automobiles long before they were invented, made a good living for himself in the painting trade, striping buggy wheels and putting monograms and scenes on the sides of fancy conveyances. Pa himself, Russell King Robertson, was, according to his daughter, "a dreamer, a believer in beauty and refinement . . . [and] a great instructor to us children."[4] One winter, while recovering from a bout of pneumonia, he painted the walls of the farmhouse with landscape scenes remembered from a trip to Lake George—better than wallpaper—while Sissy and Bubby tried to make off with some of the paint to make pictures of their own.

Many of Anna Mary's earliest memories had to do with colors and pictures. She had a little pink apron with two pockets. On Thanksgiving Day, 1864, just a year after the Pilgrim's feast became a national holiday, Father said that Sissy was to have a real, red, store-bought dress from Union Village. Well, when he went off on his er-

rand, Mr. Robertson found that the stores were all closed for the day. No red dress. A little while afterwards he went to Center Cambridge and brought home that dress for his little girl, as promised. But it wasn't red. Not really. Maybe brick or brown. "So I never got what I call a red dress."[5] The incident was a lesson in stoicism: don't complain about disappointments, the child learned. It's no use. They happen all the time.

Grandma Robertson understood about little girls who loved bright colors. Once when she came visiting she brought Sissy some sheets of tissue paper, in green and pink, to decorate the petticoats for her paper dollies. Usually she had to make do with berry juice for red lips and Mother's bluing bag of indigo for the eyes. During Anna Mary's growing-up years, color went hand in hand with the new factory-made goods that began to filter into the valley. One such product was the pre-knitted ribbing called "stockinette" that came by the yard. Snip off a length, run up a seam for the toe, and there, quick as a wink, you had hosiery in wonderful shades of lavender, pink, and brown. And there was knitting wool in every imaginable shade. Carpenter's red chalk. The red dye used to mark the sheep. Scraps from a colored envelope. After Pa painted the inside of the house, Sissy began to paint sunset scenes in the brightest pinks she could find. The other children teased her because she called them her "very pretty lamb scapes," the pinker the better.[6] "Not so bad," said Father. There were more important things for a little girl to learn, said Mother, who nonetheless gave her daughter "giblets" of cloth left over from the sewing to make pretty quilts for her dolls.

Anna Mary never gave up her fondness for the aesthetic of those "lamb scapes." "I love pink," she wrote during her own Grandma years, "and the pink skies are beautiful. Even as a child, the redder I got my skies with my father's old paint, the prettier they were."[7] In

1945, a writer for *Collier's* magazine asked her about a painting centered on a candy-pink house that seemed strangely out of place in an old-fashioned rural scene. "Oh, that," the old lady who was once little Sissy replied. "Onct when I was a little tyke I asked Pa why he couldn't paint our house pink, and he said houses just didn't come pink. Well *that's* a pink house, isn't it?"[8]

Anna Mary would eventually wed Thomas Moses in November of 1887 in the front parlor of the minister's house in Hoosick Falls. Weddings were less formal in those days. Her family didn't make the trip from the farm. The bride wore a special going-away outfit, mainly homemade: high-button shoes, long black stockings, and a green suit with a matching hat, trimmed with a pink feather. The pink feather was a spunky emblem of personal taste, identity, and a determination to make all things pretty. Until she was six, however, Sissy didn't know her own proper name. A passing stranger asked her what it was, and only then did her mother tell her she had been named after two maternal aunts, Anne and Mary. Her father didn't like the choice, so he called her Sissy for his own sister, Sarah.

A year later, Anna Mary found out for the first time how old she was. She and Bubby were outdoors, eating cherries right off the tree. Mother called her in. It was Anna Mary's seventh birthday, she said. Seven was the traditional age of reason; now the former Sissy was of an age to ponder her own place in the world of the Cambridge Valley. The stories about her grandfathers and great-grandfathers, and an adventurous aunt who was forced to flee Missouri one step ahead of the Confederates; the tales of Indian raids and British generals; the picture of little Sissy in her copper-toed shoes, taken at the photographer's studio in Cambridge when she was four; that startling seventh birthday; the real story of her contentious name—all these stories and pictures taught Anna Mary Robertson who she was and where she came from.

Home of Hezekiah King in 1800. 1943. Oil on pressed wood. 23″ x 28″. Kallir 265.

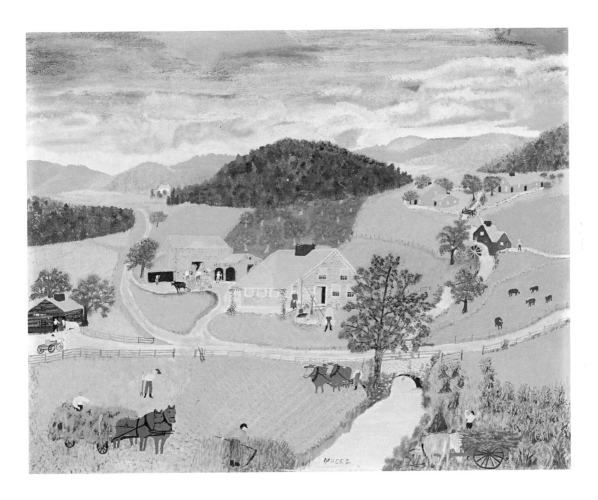

In 1946, as Anna Mary Robertson Moses—age 86—had begun to be mentioned regularly among the nation's artistic notables, her New York dealer prepared a book containing some of her autobiographical writings and lots of her recent paintings. Many of her pictures harkened back to the genealogical stories of her girlhood. *The Home of Hezekiah King*, which she painted at least five times in the early 1940s, elicited a handwritten text describing the building of the farmhouse in 1778, its destruction by fire in 1800, and even the

Home of Hezekiah King, 1776. 1943. Oil on pressed wood. 19" x 23". Kallir 217. Phoenix Art Museum, Arizona.

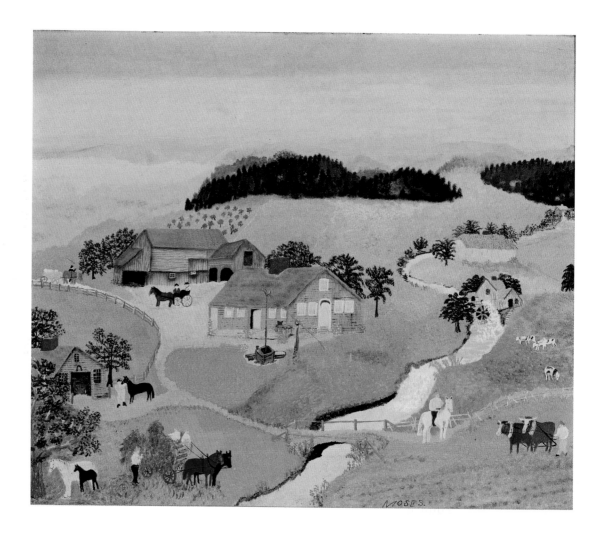

dimensions of the foundation sills.[9] King was Mrs. Moses' great-grandfather, and in other fragments she describes his travels, his service fighting the British at Ticonderoga, his several professions, and the history of the property itself. It is clear that she had walked the ruins of the house at one time, studied local maps, and examined the

powder horn on which Hezekiah, on February 24, 1777, inscribed a verse to commemorate his part in the Revolutionary War. Although she may have had pictorial renderings of some sort to inspire her historical views, her pictures of the old King place in 1776 or 1800 are not in any sense "memory pictures" of scenes Mrs. Moses actually saw. Instead, they are memories of familial memories, of stories fleshed out by an unshakable conviction that the past and the present are part of a vast and for the most part lovely continuum.

Despite the coming of automobiles and hot-air balloons, factory-bought clothes and radios, noisy farm machinery, old houses and new ones, nothing seems to change much in Mrs. Moses' Cambridge Valley. The Checkered House, gone since 1907 (although postcard views survive), crops up in her paintings of the inn in 1850 and again, in 1862, when baby Sissy was only two. Yet she remembered the place and depicted it with a presence and a weight that insist upon its continued existence. Despite all evidence to the contrary, there *is* a red-and-white checkered house on the highway south of Cambridge, not very far from Eagle Bridge; you can sometimes catch a glimpse of it out of the corner of your eye, they say, on mornings when the light is just right. Old Mrs. Moses knew it was gone, of course, but when she wrote about what she painted so many times, she said "the Checkered House *is* old."[10]

Stories about the family and the old days hugged Sissy like her favorite nursery-rhyme quilt during her growing-up years. "I had been told that my Great Great Grandfather E. Robertson, was sent out as a lookout, back in the year of 1777," she stated by way of explanation of a painting called *Black Horses* (1942). According to the story, he spied the British army coming through the woods as he was working in his fields. So he unhitched his two black plow horses and rode off on one of them, like a New York State Paul Revere, to warn the Bennington Boys that the enemy was headed toward Troy to

Black Horses. 1942. Oil on pressed wood.
20" x 24". Kallir 181. Private collection.

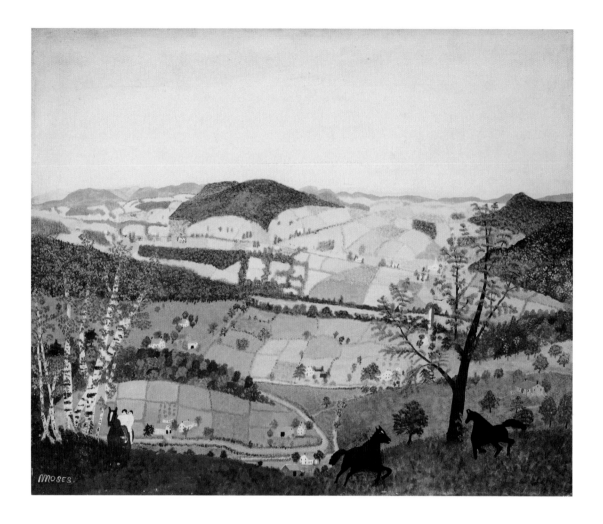

capture the Americans' supply of salt pork. In the midst of the battle that ensued, one of those beautiful black horses was killed. In Mrs. Moses' memory of the story, the fluid forms of the horses are all that remain of a saga of gore and bloodshed, undercut by the tidy, quilt-square landscape of cultivated fields and the two little children

astride a third horse, blissfully unaware that they have wandered into a perilous moment in local history.[11]

In 1952, with the newsreel cameras rolling, old Mrs. Moses was inducted into the Daughters of the American Revolution in honor of her fame, her forebears, and her pictures of the era in which various Robertsons and Kings had saved the day for the colonial rebels. In 1953, at the request of the D.A.R., she painted a panoramic view of the Battle of Bennington for their Washington museum. The inspiration for the picture came from a certain old book—highly prized, according to those who knew her: a reader, a geography book? This she consulted whenever a subject demanded a Redcoat or a great lady from "way back in history."[12] If she needed a soldier of a certain era, a buggy, a bonnet, she could find one in its well-thumbed pages. When little Sissy finally went off to the Eagle Bridge schoolhouse, she took her own mother's *Historical Reader,* old, heavy, and "hard work for you to read," she warned the readers of her autobiography.[13] This is probably the research volume she treasured, one of her props in old age when she perched on a pile of pillows and Bibles and dog-eared books to reach her paints and brushes with greater ease.

Once Sissy went off to school, she also inherited her brothers' blue-back *American Speller,* the *American Analytical and Rhetorical Reader,* and *Morse's Geography Made Easy.* A broad streak of moralism and patriotism ran through all of America's nineteenth-century schoolbooks. The best known of the readers were those by McGuffey—never very popular in the Northeast, where many alternatives existed. But McGuffey merely distilled the contents of older New England texts, with their tales of brave soldiers, heroic times, and a boy named George Washington who couldn't tell a lie.[14]

The readers and the family stories and Mrs. Moses' own trips to

Battle of Bennington. 1953. Oil on pressed
wood. 18″ x 30″. Kallir 1100. Private collection.

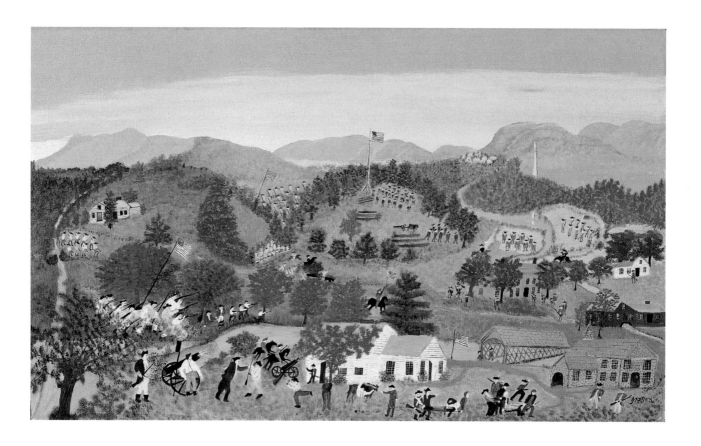

nearby Bennington all went into the picture for the D.A.R. It was
not an easy assignment: by her own admission, she painted the bat-
tle scene three times before it looked right. Too many trees in one
version. She had to "take . . . some down to let the soldiers in."[15] In
another, as her much-amused family and friends were quick to point
out, she had included, off to the right of center peeking out from be-
hind a hill, the gigantic 306-foot Battle of Bennington Monument,
dedicated in 1891 with a huge parade (witnessed by future President
Calvin Coolidge) and a speech by Benjamin Harrison. Mrs. Moses

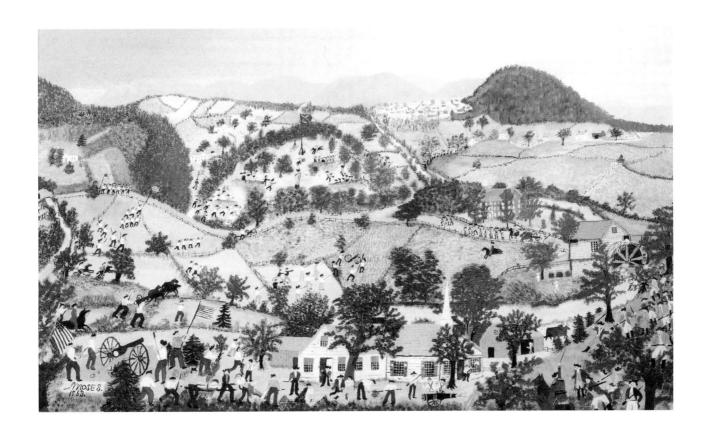

Battle of Bennington. 1953. Oil on pressed wood. 17″ x 29″. Kallir 1113. National Society of the Daughters of the American Revolution.

knew Bennington *with* its landmark Monument: to paint the battle without it was, at first, unthinkable! And family stories had made the skirmish part of her own history as a longtime resident of Eagle Bridge who could pick out Ethan Allen's Bennington among the leafy hills to the east by the sight of the Monument, spearing Vermont like a giant's embroidery needle made of stone.

Despite the name of the battle and the prominence of the towering obelisk, the actual conflict had taken place west of Bennington in New York State, where the battlefield is now a historic site in its

own right. Both Vermonters and 'Yorkstaters agree, however, that whatever happened between Bennington and the Cambridge Valley that day in 1777, the skirmish led directly to Burgoyne's defeat at Saratoga. This was a pivotal moment in the Revolutionary War. And Mrs. Moses was quick to point out that, despite her gaffe with the Monument, this was her history, too. The site was only miles from her farm. One of her own great-grandfathers, Archibald Alexander Robertson of the Continental Army's Albany Company Militia, fought in that action. Her history painting is set in Anna Mary's time and Grandpa Alexander's time at one and the same time.

The D.A.R. eventually got a third try at the battle scene, but without the Monument, the life seems to have drained out of the composition. In Mrs. Moses' early versions, the tiny soldiers march in formation through tidy fields scored like calico patterns on quilt squares. When they pause, it is to hoist their red-white-and-blue flags into the wind just like the American Marines raising the Stars and Stripes over Iwo Jima on February 23, 1945, in the nation's most famous photograph of war. In Mrs. Moses' historical memory, one war dissolves into another. It is all bedtime stories. Nobody dies. In her "incorrect" versions of the *Battle of Bennington,* there is no bloodshed, no mayhem. In the center foreground, one single little figure is being carried off the field on a litter. Yet nobody seems concerned, least of all the officer in question, who raises up his head and salutes the audience with a jaunty wave of his hat. In a memory war, a story war, a monument war there are no casualties—only fifes and drums and speeches, old engravings, modern newspaper photographs, and dreams.

Another of Mrs. Moses' historical pictures, entitled *Lincoln* (1957), came from the eyewitness testimony of one who lived to a remarkable old age, spanning the period from before the Civil War to the

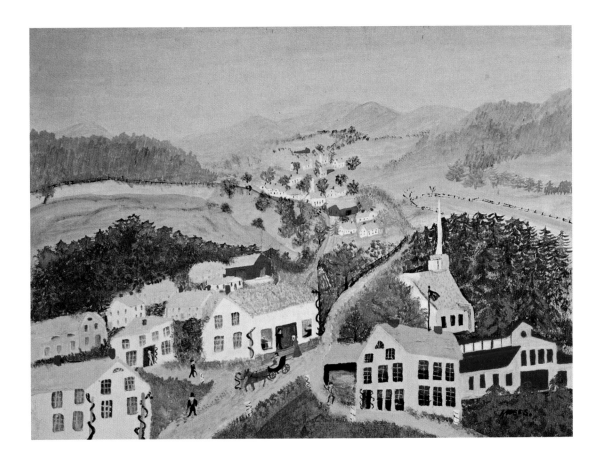

Lincoln. 1957. Oil on pressed wood. 12″ x 16⅛″. Kallir 1305.

launch of Sputnik. That witness was Anna Mary herself, who tells about taking a buggy ride through the valley with her mother and her Aunt Lib when she was not quite five, from the family farm in Greenwich down to her Grandma's house just above Eagle Bridge. Outside Cambridge they noticed black crepe on the houses, and when they reached town, "the pillars on the store were all wrapped in black bunting." What was going on? President Lincoln, said the storekeeper, "was shot the night before." "Oh, what will become of

us now?" Mother asked Aunt Lib, and the fervor of her words stuck in Sissy's mind.[16]

On April 26, 1865, Pa and some of his friends drove all night in wagons to pay tribute to Lincoln when the funeral train stopped in Albany. It was the most people that he'd ever live to see in one place, Russell Robertson told his wife.[17] In her old age, Mrs. Moses allowed as how she might not have remembered the events of '65 had it not been for the grown-ups' palpable grief and distress. But when she turned to the subject in 1957, only a few years before the assassination of John F. Kennedy, the emotions were still raw. In her picture, the road runs gaily downhill into Cambridge. As it nears the village, smears of black appear on the fences. In town the flagpoles, the pillars, the doorposts, and the hitching posts are wound around with thin strips of black material, like so many vile snakes in an idyllic Eden. The flag outside the store is not so much lowered to a half-mast position as it is simply limp, dead, its field of bright stripes bowed down in mourning. The buggy sits immobile in the middle of the road: Aunt Lib holds little Sissy, done up in the bright red dress she never got. Mother talks to the merchant. She wears a lavender dress; as Anna Mary would shortly learn, lavender was always for the ladies. In Walt Whitman's lament for a dead Lincoln, "lilacs . . . in the dooryard" of an "old farm-house" stand for the pain of the poet's loss, emotions as tender as those of any woman.

In one sense, Mrs. Moses' *Lincoln* is highly unusual even in her own repertory because the painting represents a national event through the actions of a little girl and two women—figures usually excluded from historical tableaux and confined to domestic ones. But here, the awful black snakes hiss and the bright colors of the landscape pale in response to what the women feel, three blooming flowers in the midst of fields shrouded with hopelessness, as the

dreadful news works its way up the valleys and into the distant woods. Sissy and Walt Whitman and old Mrs. Moses at age 97 have met in a sorrowing Cambridge, New York, back in lilac season of 1865.

Just about the time that Sissy learned she was Anna Mary and had a birthday on September 7th, her life began to change. Folks still told the old stories at home, but it was time now for Russell Moses' eldest daughter to go to school. When her mother was a girl, it was good enough if a woman could sign her name; Ma had been a good student but she left school when she was eleven, went out to earn her keep by doing housework, and by the time she was twenty-one had three babies of her own. That was the way in the country in the 1860s. There were two terms in country schools in those days— three months in the winter and three in the summer. Generally, girls didn't attend in the winter; their linsey-woolsey dresses and shawls weren't warm enough for the long walk and the drafty classroom. But whatever the term was, there were preparations to be made. Used books had to be rounded up from the neighbors. Slates came from a catalog store in Albany. And Carpenter's Dry Goods store in Cambridge stocked new yard goods for spring go-to-school dresses.

One evening in November, bundled up in the old red sleigh, Anna Mary's mother took her to Cambridge for a dress. The child had never been inside a store before. Something big was about to happen. As it turned out, Carpenter's store didn't sell ready-made dresses—just yard goods. And there were only two suitable lengths of calico in stock: black and white checks or cinnamon brown. Anna Mary favored the cinnamon, but she got the checks because Ma said it would last longer. The calico wasn't the only surprise, though. Back home, Mother cut out the dress but it was Anna Mary's task to sew it together by hand, in a tedious backstitch. This was to be her

new school outfit, and her sudden introduction to the hard work of managing the many chores of a household.

So Anna Mary went off to school in her homemade dress for six summer terms, all told. "Then began the hard years," she wrote, when paper dolls were all but forgotten and the serious business of living began.[18] In school, Anna Mary was a poor speller (like Abraham Lincoln). Her punctuation was uncertain. There was much discussion of the old times, Bible times. Even the geography book started with Adam and Eve and Noah. But there was fun, too. She and Bubby and their brothers learned poems and nursery rhymes and jingles that taught the pupils the mountains of North America or the state capitals or the lakes of Canada. And little Miss Moses got to draw maps, beautiful maps in color with mountains and lakes represented by lovely patterns, like the smocking on a pinafore or the checkered calico of a school dress. Her handwriting was lovely, too—evenly formed letters, each one drawn as if it were a little picture.

The last evidence of Anna Mary Moses' formal schooling came in 1874, a couple of days after her fourteenth birthday. She gave a kind of graduation speech entitled "Let Home Be Made Happy," in which she accepted the woman's part as a wife and mother but emphasized instead the sheer physical beauty of a happy home.[19] Flowers and well-ordered fields were as important, she posited, as industriousness and good cheer. By the time she said her piece, Anna Mary had been a working woman for two years. When she was only twelve, Pa had driven her over to the Whitesides' place in Cambridge to earn her keep as the hired girl. Although one of her later employers allowed her to attend another warm-weather session at the Eagle Bridge Schoolhouse, for which she wrote that speech in her beautiful hand, these were indeed her "hard years." Away from home.

Burdened with housework from dawn to dusk. Cooking. Cleaning. Sewing. Washing. Ironing. Churning. The Whitesides treated her like a daughter and so did the Vandenbergs, who let her finish school. And the Burches and the rest. But it wasn't home.

When he delivered Anna Mary up to the neighbors as a hired girl at the age of twelve, Pa was being neither punitive nor cruel. Such was the reality of life in rural New England. A census taken in London in the 1850s showed that one of every three women was "in service." The practice was even more common among the daughters of farmers, who were expected to work for their keep as domestic apprentices, learning how to manage a household while lessening the financial burdens of a large family on their own parents. In America, the process was known as "putting them out." Girls became little servants and boys were hired men or novice tradesmen, as circumstances allowed. The well-regulated house in which the twelve-year-old helper might find herself was a kind of mirror of the moral order, in which every individual found her proper place within the community. Sometimes specialized help came in the form of a weaver or a woman with a portable sewing machine who hired out by the day; Ma made use of their talents on occasion. But Anna Mary was a part of the family for which she worked on a long-term basis.

In her novel *Work,* serialized in 1872, Louisa May Alcott tells the story of a young girl, reared by an unsympathetic aunt and uncle on a New England farm, who sets off to make her way in the world. The structure of the book comes from John Bunyan's allegorical *Pilgrim's Progress,* a favorite of Miss Alcott's influential father. In fact, the heroine is named Christie after Bunyan's "Christian," whose many trials and temptations lead, in the end, to salvation. Christie's first trial is a position as a domestic servant in the home of a Mrs. Stuart, who interviews the girl while making a watercolor copy of Turner's fa-

mous *Rain, Wind, and Hail* (a painting which, as Alcott slyly remarks, "was sold upside down and no one found it out").[20] Although she has to endure a suffocating atmosphere of luxuries and useless talk about art, Christie does educate herself with books from the attic and moves on to her next job (as an actress!), having profited from the experience.

Christie is no Anna Mary, to be sure. While waiting table for Mrs. Stuart, she reminds herself constantly that her father was a gentleman, that she is nobody's servant. Until redemption finally comes at the age of forty—and with it, the realization that work is the true salvation of humankind—she finds it hard to accept her lot. Her slow progress toward enlightenment contrasts with the ready acceptance of work and community shown by the characters in Harriet Beecher Stowe's *Poganuc People* of 1878, a series of local color sketches set in rural New England in the half-century before the publication of the book. "The sons and daughters of farmers and mechanics," Stowe writes with no little nostalgia, "would willingly exchange labor with each other; the daughters would go to a neighboring household where daughters were few . . . but they entered the family as full equals, sharing the same table, the same amusements, the same social freedoms, with the family they served."[21]

While Mrs. Child, author of one of the nineteenth century's most popular handbooks on housekeeping, insisted that both children and domestics should be set to braiding cloth scraps into rugs lest any odd leisure moments be passed in idleness, Anna Mary's employers kept to the old ways idealized by Mrs. Stowe.[22] The Whitesides took her to church on Sundays—Anna Mary drove the horse—at a building erected by their forebears back in 1800. Going to church, she said, "was a pleasure in olden times." There was gossip, a lunch, hymns, "a day of pleasure and rest from drudgery."[23] And all the way

home, folks would sing their favorite songs. "Sweet Bye and Bye." "The Mountains of Life." "Work, for the Night Is Coming."

Work: meals to cook, a garden to weed, linens to wash and iron, paths to shovel in the wintertime, silver to polish. "Life was a sort of routine," old Mrs. Moses would recollect in the 1950s in a commentary on her picture of the Eagle Bridge farm where she had lived for almost fifty years. "Monday washday, Tuesday ironing and mending, Wednesday baking and cleaning, Thursday sewing, Friday sewing and odd jobs, such as working in the garden. . . . And thus it was from year to year," starting in Cambridge, at the Whitesides' house, when she was only twelve.[24] That's how the world worked, the world she would one day paint. Catharine Beecher's famous *Treatise on Domestic Economy* (1841) described the same time-honored method of allotting specific tasks to the days of the week (except, of course, for Sundays).[25] So did Sarah Orne Jewett's *The Country of the Pointed Firs* (1896), a Maine novel in which one of the local characters, speaking in a down-East dialect, decries too much regularity in the matter of chores. "I must say I like variety myself," the good woman observes. "Some folks washes Monday an' irons Tuesday the whole year round, even if the circus is goin' by!"[26]

The cycle of the tasks followed the cycle of the seasons, round and round. After the Whitesides came the Vandenbergs. After the Vandenbergs, Mrs. Burch, a widow. And after Mrs. Burch—well, lots of others. Anna Mary finished out her schooling. She saw a talking parrot at the State Fair in Albany. She lost two brothers and a sister to illness. Her parents moved. But Anna Mary learned how to keep house. How to sew without complaint, with the silver thimble Mrs. Whiteside brought her from Troy as a reward for reading the Bible all the way through one summer. How to store up and treasure the memories of home, when all of life was a springtime full of water-

melon and peanuts, sunshine and flowers—the happy days at home that would be painted in leisure hours, in different times. During World War II, when Bing Crosby sang of home in the dreamy strains of "White Christmas" (Mrs. Moses' grandson, Corporal Ed Moses, was then serving in New Guinea), and in the 1950s, when Crosby's "I'll Be Home for Christmas" played incessantly on all the local radio stations,[27] those particular themes came to dominate Grandma Moses' pictures. She remembered happy times at her own birthplace, her father's farm in the Cambridge Valley, the place where Sissy once picked cherries with Bubby, and the home where she had painted her pink "lamb scapes" and hoped for a bright red store-bought dress.

Her life, the stories of her ancestors, the place where she was born in 1860, the Whiteside Church: these were at least as important as any "real" history, like the Battle of Bennington. All the places and the tales and the memories added up to "Home Sweet Home"—an old song and the title of a picture she painted in 1941. This was who she was, where she came from, what she believed in: the eternal cycle of which she was a living part, her moral order, her community, her self, her *Home Sweet Home.* Her castles in the air still hovered gently, expectantly, over Washington County, New York, in a high puffy pile of rose-colored clouds.

2. The Old Oaken Bucket

In later years, the artist known as Grandma Moses was asked why she painted one particular subject—a farmstead with a well in the foreground—over and over again, especially since she generally disliked repeating herself to oblige a dealer, a neighbor, or a potential buyer. "I have painted a good many of them," she allowed. "And I wish now that I had sent the History with them. It would have been a monument to that poor forgotten Boy Paul Dennis."[1] Dennis's story (always "Dinnis" in Grandma's uncertain spelling) was a local legend in the days of Anna Mary's youth; she first heard it from old Mrs. David Burch, in whose house in South Cambridge she was working in 1877. One evening after the dishes were done, the hired girl and her mistress went out looking for wild strawberries. When they stopped for a drink at the well, Mrs. Burch told her that this was no ordinary well but "*the* well of the old oaken bucket."

In rural New York State in the 1870s, a poem called "The Old Oaken Bucket" was widely known. And in a pre-electronic world (Mrs. Moses saw her first movie in Syracuse in 1914), people in rural communities knew lots of poems and poetry set to music. During their last years at the country school, Anna Mary and Arthur learned the facts of history and geography by singing rhyming verses. And on Friday afternoons, in order to improve rote memory and confidence, pupils were expected to give recitations: set pieces, poems, even bits of humorous doggerel. On one such occasion, his sister recalled, Arthur made a bow and recited a ditty called "Dried Apple Pies," an anonymous jingle on the awfulness of eating apples home-

The Childhood Home of Anna Mary Robertson Moses. 1942. Oil on pressed wood. 14″ x 28″. Kallir 160. Private collection.

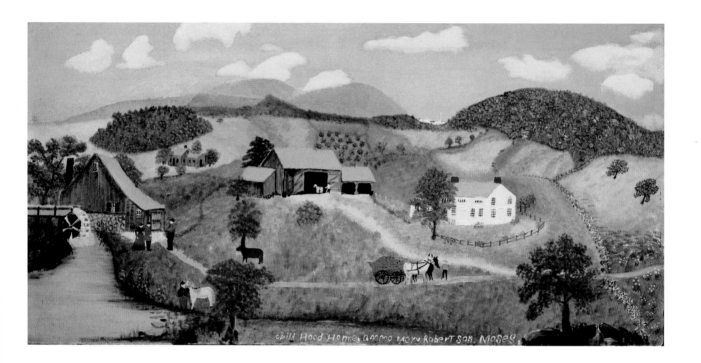

preserved for the winter. Old Mrs. Moses still remembered the words several generations after she first heard them from her brother's lips: "Apples on a cord were strung / And from the chamber window hung / And there they served a roost for flies / Until ready to be made into pies. / Tread on my corns or tell me lies / But don't pass me dried apple pies!"[2] Anna Mary shared the low opinion of those leathery apples. By the time they reached the pie plate, she opined, "most of the flavor was gone."

"The Old Oaken Bucket," on the other hand, was a long, serious, sentimental poem—a tearful memory of one's childhood home that enjoyed widespread popularity throughout the nineteenth century. Attributed to Samuel Woodworth, a lyric poet-printer from Scituate,

The Old Oaken Bucket. 1943. Oil on pressed wood. 24″ x 30″. Kallir 228. New York State Historical Association, Cooperstown, New York.

Massachusetts, who also wrote operas and historical drama about heroes of the American Revolution, the poem first appeared under his name in 1818. Soon afterward the text became a song, adopting the tune of a traditional Scottish ballad. In 1870, a new melody from an English composer lent the song even greater prominence. The Woodworth lyrics were printed in many illustrated editions, with

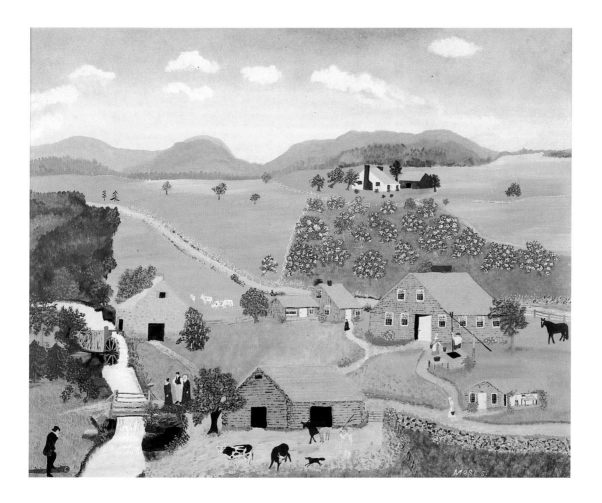

sweet Victorian pictures of a lad and his dog at a flower-wreathed well in front of a cozy farmhouse that might have been Grandma Moses' own.

Many versions of the song were recorded and played. As early as 1915, the Knickerbocker Quartet was heard on an Edison Diamond Disk warbling about the beauties of "the deep-tangled wild wood" and the speaker's aching nostalgia for the rustic loveliness of his father's home, symbolized by the cool, pure water from "the old oaken bucket, the ironbound bucket / The moss-cover'd bucket, which hung in the well."[3] The first line—"How dear to my heart are the scenes of my childhood"—describes the emotional tenor of the art of Grandma Moses with uncanny accuracy. But "The Old Oaken Bucket" acquired a special place in the affections of the girl from the Cambridge Valley when she heard the *real* story behind the poem and stood on her own two feet in the place where it all began.

Mrs. Burch told Anna Mary that once upon a time, back in the 1700s, her great-grandfather had lived on this farm. So did his older brother, Paul Dennis. And Paul took a liking to the daughter of one of the neighbors. Her parents objected to the courtship because Paul and his parents were poor. In defiance of their wishes, young Dennis and his sweetheart continued to meet whenever they could and when they couldn't, they left love letters for each other in the crotch of an apple tree. That made trouble. Finally, in despair, Paul went off to sea, lovesick and homesick—and there he wrote "The Old Oaken Bucket." When he returned to the port of Boston three long, sad years later, he brought the poem to Woodworth, the printer. The perfidious Woodworth, according to Mrs. Burch, printed the poem as his own.[4]

In the late 1930s, while Grandma Moses was beginning a new life

as an artist, Woodworth and his poem (often called a "heart picture") made the news one last time because his ivy-covered tomb in San Francisco's Laurel Hill Cemetery was about to be demolished. The family, it seems, had removed and cremated the body years earlier, fearing damage at the hands of sentimental pilgrims, who had worn a path to the stone crypt. After Woodworth was gone, the faithful came no more: "Marble facings cracked and neglect laid its careless hand on all as if the sweet song of the poet had echoed for the last time in heart memory."[5] But the attachment to home and its beauties expressed in the poem had not gone entirely out of fashion. Or rather, home had come to the forefront again with the trials of the Great Depression and the intimations of a great war to come. In the heart of Anna Mary Robertson Moses, the story and the setting were part of home, and the essence of what her life was all about: Paul Dennis, poems from school, being a hired girl, and drinking cool water from the well on the way to pick wild strawberries one summer evening, long, long ago.

In her remarkably varied inventory of painted subjects, *The Old Oaken Bucket* makes more than its fair share of appearances, beginning in the early 1940s. Mrs. Moses herself dated the first *Bucket* to the winter of 1940–41. A bout with illness kept her in bed against her will for most of the cold weather season—and she plotted mischief. "When I was lying there," she said, "I thought I was going to paint the story of the 'Old Oaken Bucket' because I knew how it originated. I painted it when I got up, that was the first one I tried, but later I painted it again and could remember more of the details."[6] At the instigation of her son Hugh and his wife Dorothy, who were looking after Mrs. Moses, she entered that picture in the inaugural New York State exhibition at the Syracuse Museum, for which cash

prizes had been pledged by prominent citizens. Much to the delight and amazement of the family, her picture was a winner, showing "great beauty of color and design."[7]

Although she had been "discovered" several years earlier by a New York art lover, the Syracuse exhibition marked her first sustained exposure to the media. The artist herself was photographed for the newspapers standing in front of her painting, accepting the prize from Thomas J. Watson, president of IBM, a prominent collector soon to become a major supporter of Mrs. Moses of Eagle Bridge. She was a "natural," wrote one brand-new fan of the 81-year-old phenomenon.[8] Within months, the works of this "elderly primitive" were being sought after by New York's fashionable elite: rich ladies, fashion leaders, exiled countesses, theater people.[9] Katherine Cornell and Margaret Sullavan were proud to display her work; Mrs. Moses, in turn, boasted to reporters that she was "apaintin'" something special for Cole Porter. "Know him? He's a song writer—a real good one, too."[10] Meanwhile, her photo and *The Old Oaken Bucket* (1941) were reproduced constantly in newspapers and magazines, adding to her fame and prompting a flood of "orders" for replicas.

Sophisticates appreciated the novelty of Mrs. Moses' simple, rural subject matter. Cole Porter himself hailed from Peru, Indiana, and his most successful show tunes, despite their syncopated wit and irony, were variations on a "primitive" Tin Pan Alley formula that included love, apple blossoms, and wishing wells. Indeed, the earliest versions of Mrs. Moses' *Old Oaken Bucket* seem almost like stage sets for a Broadway production not yet scored or scripted—the background buildings and the hilly landscape were in place from the beginning, but the story line was curiously blank. The Dennis/Woodworth lyrics call for several key iconographic points of reference: an orchard, a meadow, the woods, a mill, a waterfall with a

bridge and a rock, the house of the singer's father, the dairy house, and the well, with its bucket. The prize-winning Syracuse painting contains a mill (largely hidden behind a tree), a farmhouse, a cow barn (to account for the dairy), the well, and in the distance, the neighbor's house—necessary for the Anna Mary version of the story because "Dinnis's" lost love lived there. The landscape slopes up vertically from the cows frisking in the foreground, as if to give each element of the setting its own proper weight and place. Yet there is no Paul Dennis to lament the day he left the family farm behind him—only a nondescript little fellow tending the herd, far away from the well with its old-fashioned sweep for raising the heavy bucket to the surface.

Throughout the 1940s, the painter came back again and again to the Dennis farm and the story told by Paul's great-grand-niece, as if to consolidate all possible details in precisely the right order. Eventually, the trees erupt into blossom, a lone boy appears at the well, and then a multitude of additions: a little girl on her way to the dairy, and a churn, and a lady (often in lavender) standing wistfully in the door of the house; all manner of little boys in short blue pants looking after the cows, a bigger mill, a stable for the horses, and even a tiny female figure from time to time, cloaked or not, watching her lover from a distance. There are variations, too. *The Old Oaken Bucket of 1760 in Winter* (1944). *The Last Old Oaken Bucket* (1945; it was not, of course). One for Helen Hayes, another for the Garson Kanins. A letter sent to Eagle Bridge in September of 1943 by an imperious buyer asks for a version exactly 26¾ inches wide and 21½ inches tall, "rather like the one" the writer had seen in the home of a friend. "It shapes up to a high hill in the center."[11]

The last of the *Buckets,* completed in 1960, 83 years after old Mrs. Burch told her Paul's heartbreaking story, when Anna Mary herself

The Old Oaken Bucket. 1947. Oil on pressed wood. 23″ x 27″. Kallir 669. Private collection.

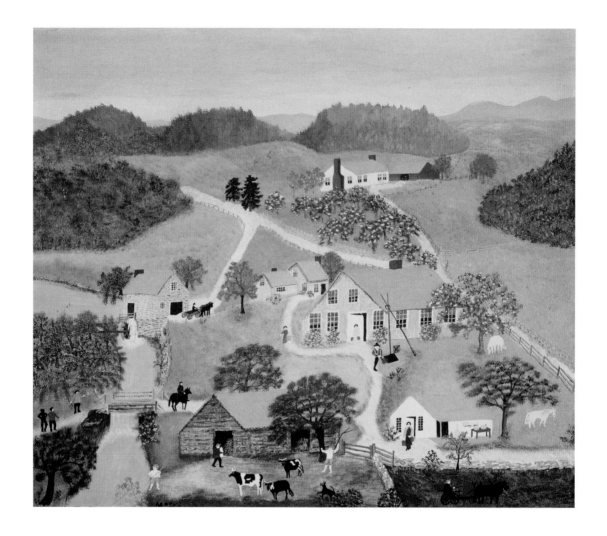

was 100 years old, dissolves into a joyous incoherence of summer color. A family of sprightly blonds in blue surrounds the well: a father, a mother, and a little girl watched over by a wraith of an old lavender-lady in the doorway, who may be Mrs. Moses herself. The well-sweep mechanism is little more than an abstract shape now, the

faintest memory of an old story. And the trees are all dappled with pink.

The story (or Woodworth's version thereof) was a pictorial favorite during the post–Civil War era, when soldiers from both sides failed to come home. Sheet music, bookmarks, and popular prints from many sources turned the words into vivid pictures. But the most famous of all these images came from the firm of Currier & Ives. Mrs. Moses' habit of "borrowing" from their commercial lithographs of the later nineteenth century was apparent from the beginning of her career. She admitted as much with naive charm in the pages of the *New York Times* in 1945: "The artists I have always liked are Currier & Ives. I certainly have admired their work, but how they managed to turn out the number of pictures they did has always puzzled me."[12] The chief image-makers of her youth, Currier & Ives were quick to capitalize on the current interests of potential buyers. Thus in 1864, in the midst of the Civil War, they issued a print entitled *The Old Oaken Bucket* after a design by Fanny Palmer, the most gifted member of their stable of featured artists.

Reissued in 1872 by popular demand, the print includes two lines of Woodworth's verse and an array of details calculated to tug at the heartstrings.[13] The boy is a plump little fellow drinking from a classic fairy-tale wishing well. His father's house at the right (with appended dairy) has an elegant hipped roof; two fashionably dressed little girls play on the front steps. On the opposite side of the composition, the rocky cataract, the bridge, the mill, and a herd of cattle wading in the millpond flesh out the list of items mentioned in the poem. Two men chat amiably on the footbridge. A farmer plows a distant field. And a family of ducks lends the crowning touch of domestic serenity. This is home.

Jane Kallir, whose grandfather was Mrs. Moses' dealer, makes the

The Old Oaken Bucket

After Fanny Palmer. *The Old Oaken Bucket.*
1872. Lithograph published by Currier & Ives.
The Henry Ford Museum, Dearborn, Michigan.

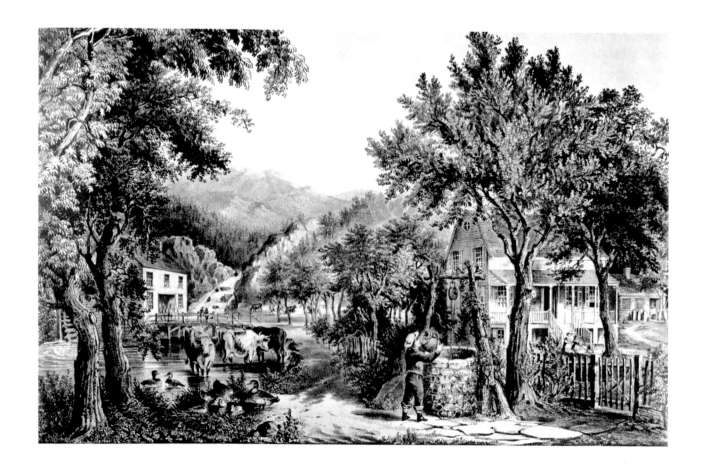

case that prints like this one provided the impetus for a torrent of nineteenth-century folk art—that they became models for many ambitious, untrained painters.[14] Mrs. Moses left behind correspondence in which she responded to advice not to copy pictures by other artists.[15] But her *Buckets* are not direct copies of anything, although they do raise the question of where she may have seen the Currier & Ives prints which influenced the choice of many of her favorite subjects. Some have speculated that the Whitesides, during

her term of service in their home, had a cache of Currier & Ives lithographs and allowed her to copy them in crayon or chalk.[16]

On the other hand, the Currier & Ives revival of the 1920s and 30s provided more immediate access to the pictures of Mrs. Moses' youth. Beginning in 1929, Harry T. Peters' several volumes on Currier & Ives reproduced a range of genre prints with an emphasis on old-time iconography that went to the heart of an American tradition all but forgotten in the "modern" machine age.[17] His studies were widely available in accessible, book club editions: Doubleday reissued his original volume in a mass-market format in 1942, as Mrs. Moses emerged from the obscurity of Eagle Bridge to become a major figure on the art scene.

In addition to reproductions of Currier & Ives prints, Grandma Moses had a stash of other reference data, including photographs scissored out of newspapers, church handouts, ads, pictorial magazines, calendar pictures, greeting cards, halftones, and other clip art from local weeklies which she used in a variety of ways. Orthodox, art-school perspective eluded her, for instance, so she often "borrowed" a crucial motif from among her clippings, traced it outright or redrew it, and inserted it into a work-in-progress. The mill and the complicated machinery of the wheel and the race needed for the Paul Dennis story came directly from a small photo-offset view of a gristmill preserved among her papers.[18]

Her problem was to match the print's angle of vision from the left with that of her own flatter buildings scattered through the rest of the landscape. Because she often chose not to make her viewpoint consistent—or found perspective irrelevant to the problem of inserting what was necessary to represent the contents of the story— Moses paintings seem almost Cubist in their ability to walk the viewer around a series of shapes placed in no particular relationship

Home for Thanksgiving. c. 1940. Oil on pressed wood. 10″ x 12″. Kallir 34. Private collection; formerly in the collection of Louis J. Caldor. After an 1867 George H. Durrie lithograph published by Currier & Ives.

to a single vanishing point. They are art—diagrams of a reality already absorbed, remembered, and stored away in the mind's eye, as far removed as possible from a casual glance at the scenery of the Cambridge Valley from the window of a passing Ford. They are not the same as the pictures she found in her magazines or in the prints of Currier & Ives.

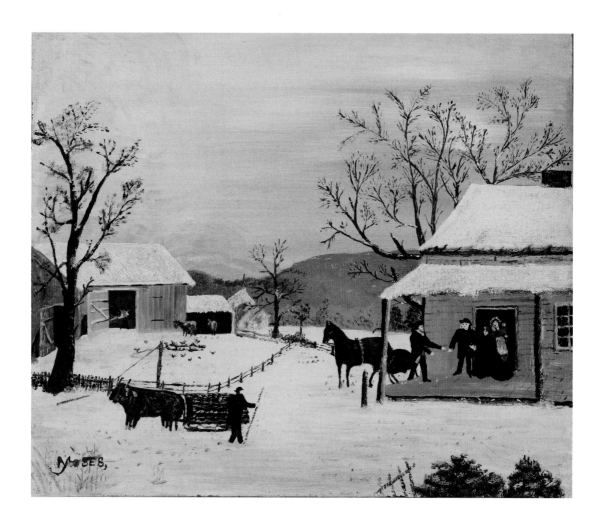

One figure that turns up constantly in her work is the young man with the flail or staff who tends the cows in many of the *Bucket* paintings. This stock figure, sometimes dressed in red or brown or blue, comes from the foreground of one of the most beloved of Currier & Ives' seven thousand prints: *Home to Thanksgiving* (1867). A color reproduction of a painting by George Durrie showing the younger generation of a Connecticut family coming home for the traditional New England holiday, this print is the source for the hired man tending the oxcart at the dead center of a Moses version (c. 1940) of Durrie's picture. Turned away from the viewer slightly, he helps to introduce the scene—one of Grandma Moses' other favorites. But he also enlivens a composition which might otherwise be lacking in visual interest except for the crush of activity on the porch of the old homestead. Mrs. Moses habitually deploys anonymous figures in this way, scattering them across the landscape like so many colored sprinkles on a cupcake to add sparkle to the visual field and depth to the narrative.

Several of the cow-tenders in the *Bucket* paintings (the ones in short blue pants) seem to have strayed from an altogether different narrative: the nursery-rhyme saga of "Little Boy Blue," the child who neglects to blow his horn even though the cows have strayed into the cornfield and a sheep into a nearby field. And where is their little guardian, asks the famous Mother Goose verse? Why, he's "under the haystack fast asleep!" In 1947 Mrs. Moses undertook a thematic series of paintings, not unlike the Currier & Ives sets depicting the seasons of life, the times of day, or the *7 Stages of Marriage.* In this case the stories all came from the Mother Goose rhymes, first published in America in 1787 (the year the Constitution was signed), and printed so frequently thereafter as suitable moral fare for children that their European origin was eventually forgotten.

In 1860, New Englanders raised the claim that Mother Goose was

Little Boy Blue. 1947. Oil on pressed wood. 20″ x 23″. Kallir 660. Private collection.

actually Elizabeth Goose of Boston, great-grandmother of the wife of publisher Isaiah Thomas. Scholars have searched in vain for a Thomas edition of the verses. But the same nineteenth-century tourists who hunted up the tomb of Samuel Woodworth also frequented the gravesite of Elizabeth "Mother" Goose, née Foster (d. 1757), in

the Old Granary Burial Ground in Boston, with only the flimsiest of evidence for the connection. Their pilgrimage reinforced New England's long-standing claim to cultural hegemony. It also encouraged tourism, a new, lucrative industry in the Northeast as agriculture and manufacturing both moved elsewhere in the aftermath of the Civil War. And it made *Mother Goose's Melody* (Boston, 1843), advertised as the "only true" text of the old woman's poems, a kind of patriotic touchstone of Americanism.

In the 1870s, when the Philadelphia seamstress who invented the flag was also "rediscovered" by enterprising descendants, Mother Goose became Betsy Ross with a pen instead of a needle, a patriotic icon for women and girls. In April of 1884, in Richmond, Virginia, the well-to-do parents of future author James Branch Cabell held a spectacular dress-up fifth birthday party for seventy-five guests, in honor of their little boy. The society editor breathlessly reported every detail in the local newspaper. All the familiar characters were represented in fancy dress: Tom, the Piper's Son; Jack and Jill; and Little Boy Blue, masterfully impersonated by no fewer than four little boys.[19]

Although Mother Goose never went out of print and her jingles provided ideal fodder for schoolhouse recitations, the late nineteenth and early twentieth centuries revived the comfortable old verses in new forms befitting a cornerstone of America's literary inheritance. Picture books, dime-store ceramics, printed embroidery patterns, and valentines all featured Jack and Jill, Tom, and the other dramatis personae of the Goose anthology. Maxfield Parrish was only one of the famous illustrators who created fresh interpretations of "Little Boy Blue." His imagery for the 1897 edition of L. Frank Baum's *Mother Goose in Prose* was greatly admired in its day.

More appealing still, however, was Maud Humphrey's chubby, rosy-lipped, curly-headed boy in blue slumbering on a bed of hay, an

The Old Oaken Bucket

55

image awash in the Victorian child-worship and mother-love of her day. At the height of her popularity in the 1890s, Humphrey—a contemporary of Charles Dana Gibson, Howard Chandler Christy, and the other titans of the trade—was earning an estimated $50,000 a year for her work, an almost unheard-of sum for a woman of that era. It is sometimes said, without much justification, that the model for her adorable slumbering shepherd was her son, the future movie star Humphrey Bogart (born in 1899). But the emotional content of her rendering comes from two lines of verse that are often omitted from the orthodox text. Where is Little Boy Blue? asks Mother Goose. Asleep on the job! answers her interlocutor. "Will you wake him? No, not I. / For if I do, he's sure to cry." It would have been an act of unspeakable cruelty to wake Maud Humphrey's dimpled darling, and so he dreamt on as a million doting Mamas of the Gilded Age watched and sighed in pleasure.

A similar case of motherly nostalgia flavored Eugene Field's poetic recasting of the story of Little Boy Blue in his beloved *Poems of Childhood* (illustrated by Maxfield Parrish in 1904). This time, the little boy has vanished from his nursery. The speaker fondly, sadly, takes stock of a dusty toy dog, a tin soldier, a trundle bed, and remembers the night when the child lay dreaming and "an angel song / Awakened our Little Boy Blue" to a new life in heaven above.[20] Parrish's pictures for the Field volume first appeared in the *Ladies' Home Journal* in 1901. Mother Goose, it seems, was everywhere.

And she also hovers over Grandma Moses' *Little Boy Blue* (1947), an intriguing composition in which no fewer than eight brown cows wreak havoc in the corn. The sleeping boy in blue, splayed out like a Hellenistic faun on a mound of new-mown green hay, with a round brown object (Maud Humphrey's straw hat?) abandoned by his side, seems almost incidental to the action, however. Haymakers toil. A

carefree boy and girl romp through the hayfield. A hired hand gets after the errant cows. A farmer plows behind a team. Another man in a straw hat chases a dog. And off to the right, at the very edge of the picture, stands an old well house of Disneyesque design, from which a wispy old lady in a lavender dress has drawn a bucket—an *Old Oaken Bucket*—of water. Mother Goose herself? Or Grandma Moses, watching out for the little fellow dreaming away, safe and sound, as the life of the farm bustles around him?

Mary and Little Lamb, part of the same, short-lived series of Moses paintings from 1947, is not strictly speaking a Mother Goose tale at all, although American anthologists have labored mightily to add it to her canon. Often attributed to "Anon." if not to Mother Goose, the poem was the work of one of America's most influential figures of the nineteenth century: Sarah Josepha Hale. For forty years—from 1837 until 1877—she was the editor of the illustrated *Godey's Lady's Book,* the first widely read magazine directed exclusively at the interests of women. A champion of family life as the basis for the well-being of the greater American family of citizens, Hale almost single-handedly "invented" the use of the Christmas tree as a focus of the child-centered home at mid-century. And she pestered Abraham Lincoln until he made the old New England legend of the Pilgrims' feast with the Indians into the Thanksgiving holiday—one of Grandma Moses' favorite subjects.

Hale's poem about a little girl, her pet lamb, and the schoolhouse saw the light of day for the first time in 1830 in the fall issue of a periodical called *Juvenile Miscellany.* Just months later it was set to music and was included in 1831 in a collection of "religious, moral, and cheerful" songs intended for use in schools.[21] Also a featured selection in many school readers, the story of Mary and her lamb sometimes appeared in truncated form: the first four lines, in which the

Mary and Little Lamb. 1947. Oil on pressed wood. 24" x 34". Kallir 650. Private collection.

lamb follows Mary; or the first eight, in which the other children are delighted at the breach of decorum; or the first twelve, in which the teacher turns the animal out, to wait for its mistress until the class is over.[22] But Hale's famous verse rattles on for another three stanzas after that.

In these less familiar lines, the lamb's devotion to Mary is credited to her tender care for helpless animals, and the teacher seizes the opportunity to preach the virtues of love, gentleness, and kindness.

And the choice of the lamb cannot have been entirely fortuitous, given the New Testament parable of the Good Shepherd, the guise in which Christ was often represented by Victorian image-makers. Bucolic, sentimental, and vaguely religious, Sarah Hale's little poem plucked at the heartstrings of the same mothers who treasured their little boys in blue (the color of the Union Army). The charming story felt so true that it had to be! And so began the search for the real Mistress Mary.

The town of Sterling, Massachusetts, was the first to lay claim to Mary. She was, civic boosters proclaimed, one Mary Sawyer, born in 1806. As a toddler, she had nursed an orphan lamb back to health and dressed her pet like a doll in pantalettes and a special blanket. But when she was old enough to go to school the poor lamb was turned out to pasture, until Mary's prankster-brother Nathaniel (or was that the lamb's name?) persuaded her to bring it along to class all dressed up and sit it up in a seat like another pupil. Miss Polly Kimball, the kindly teacher, enjoyed the fun. Now there happened to be a classroom visitor that day, John Roulstone, nephew of a local minister. *He* wrote the poem, as this version goes, the first three stanzas only. As for the lamb, it met its fate one Thanksgiving morning, gored to death by a bull. Mary's mother knit two pairs of stockings from the wool. As an old lady, Mary Sawyer unraveled them, attached bits of the yarn to autographed cards, and sold them at a Boston fair held to raise money for the preservation of Old South Church.

Nobody said so, but the implication was that Sarah Hale, poetess of Newport, New Hampshire, had somehow hijacked the Roulstone poem. And Sterling was determined not to let her get away with it! The town fathers bolstered their claim by erecting a statue of the lamb on the Sterling Town Common. The barn where the lamb was

born was designated a historical landmark, too, until it burned down in the 1980s. Meanwhile, some Sterlingites said that Roulstone was the teacher and that he died of consumption in the 1820s. Others said it was Mary who passed away in 1824. Despite folkloric inconsistencies, postcards sold in Sterling during the card craze of the first decade of the twentieth century showed the "original house" in which Mary and the Little Lamb lived, with an oval insert framing a photograph of a very old woman in black bombazine identified as the "Original Mary Sawyer."

The battle of the lamb might have remained just another odd incident in the history of American antiquarianism had it not been for the intervention of automaker Henry Ford, the most famous American of his era. In the 1920s, equipped with a vast fortune and a boundless enthusiasm for the rural America of his youth, Ford began to collect Americana on a gigantic scale. He was not interested in the haunts of the rich and sophisticated. The humble, practical artifacts that he assembled showed how life was lived in a presumably simpler time, before the Model T, the assembly line, and the modern age they introduced had changed the nation beyond all recognition. If madcap American moderns were dancing the Charleston and the Bunny Hug, then Ford and his wife Clara would hold square dances at their Michigan estate with old Appalachian fiddle players, folk music, and Stephen Foster tunes played on an enormous Steinway piano.[23]

The couple launched a program to publish traditional American tunes of the past century and to republish the school readers from which he had read the story of Mary and her lamb as a farm boy. A quixotic character who aimed to celebrate and preserve the very way of life his own enterprises had displaced, Ford spent much of the 1920s attempting to turn South Sudbury, Massachusetts, into

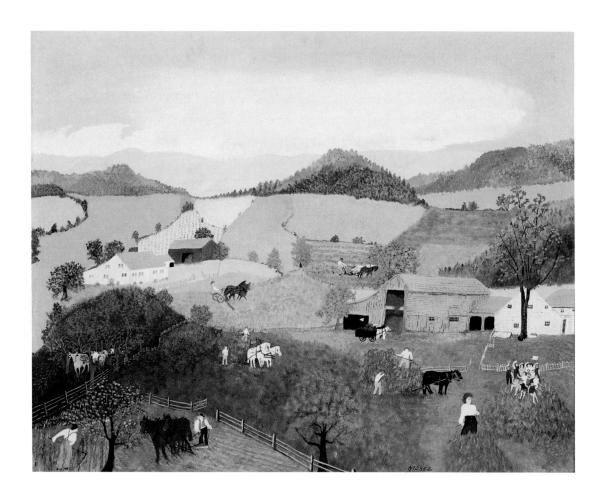

The McDonnell ["Old MacDonald"?] Farm. 1943. Oil on pressed wood. 24" x 30". Kallir 313. The Phillips Collection, Washington, D.C.

a kind of historical theme park, an outdoor museum loosely based on the model provided by Rockefeller philanthropy at Colonial Williamsburg. By the end of the decade his focus had shifted to Greenfield Village, a Ford-built historic village in Dearborn, Michigan. The Greenfield idea began with his purchase in 1923 of a New

England country inn in South Sudbury, said to be the place where poet Henry Wadsworth Longfellow first heard the landlord tell the tale of "The Midnight Ride of Paul Revere" from Lexington to Concord. Restored to its former glory—but equipped with modern bathrooms, electricity, and ample closets—the Wayside Inn became a stellar tourist attraction for motorists, complete with a picture-perfect Old Mill re-erected on the site.

The inn was to have been the nucleus for a collection of similar structures which, taken together, would exemplify the hardy, wholesome simplicity of the rural New England town in times past. Easily accessible by a new macadam highway, South Sudbury was conceived as a sort of didactic thoroughfare, leading Americans in automobiles back in space and time to the simpler virtues of yesteryear.[24] In 1923, while touring the Sudbury area, Henry Ford discovered Sterling and its connection to the Mary-had-a-Little-Lamb story. Perhaps the verse had added appeal because his good friend, Thomas Edison, in the first recording of a human voice ever made, recited that very poem on a tinfoil cylinder phonograph on December 6, 1877. Perhaps that had been Ford's very first lesson in his old school primer. For whatever reason, Ford seized upon the wooden schoolhouse on Redstone Hill where Mary may or may not have brought her lamb, trucked it to Sudbury, and in 1927 opened it as *the* American Little Red Schoolhouse, conflating one durable American icon with another.[25] From 1927 until 1951, sixteen local children in grades 1 through 6 were educated there annually at Henry Ford's expense to demonstrate the superiority of an old-time education.

There is no reason to believe that Mrs. Moses was intimately acquainted with the ins and outs of the saga of the Little Lamb. But there is also no reason to think that she was unaware of Ford's adulation of rural schools like the several she had attended. Nor is there

any doubt that she knew Sarah Hale's poem. Her painting of Mary and the lamb is another fine example of the kind of domesticated order Mrs. Moses imposes on the literary scenes she chooses to represent and the pictorial prototypes she may or may not have collected. There is a special, intimate logic that she, like Currier & Ives' Fanny Palmer, brings to the iconography of her work. If the story line of a given painting calls for a millpond, then there ought to be ducks. A milk house, cows. A haystack, a crew of busy haymakers. And if Mary is going off to school in that indefinite time period between the old days, when little girls were kept home in cold weather, and 1947, when school started anew for everybody in September, then the leaves must be turning and the fields growing brown and fallow.

So her Mary, in a pink dress, makes her way down the path to the schoolhouse where the children are frolicking in the sunshine and the gray-haired teacher stands by the door, ringing the morning bell. The pupils are barefoot: it is not yet cold enough for store-bought shoes in the early autumn, in Sterling or Eagle Bridge or Newport, New Hampshire. The schoolhouse is brick. Now there were brick schools in the Cambridge Valley (although not in Eagle Bridge in the 1870s). But more important, the brick makes the school really red: a little *red* schoolhouse of tradition, in harmony with the autumnal colors of the fall foliage spreading across the distant Berkshire Hills. A single, massive hill rises up behind the schoolhouse as if to protect it from harm, to insulate the scene from the dangers of childhood. The landscape is dying, as it does every year. The children and the little lamb are signs of rebirth—a new generation, a perpetual springtime in the seasons of humankind.

Anna Mary had no little lamb, only "lamb scapes." But in 1887 she did become a sort of Mary herself—later accounts of these years call her Mary Moses, Mother Moses, Aunt Mary—when, at the age

of twenty-seven, she married the tall, quiet hired man from the Sylvester James farm, where she was the hired girl. With a pink feather of hope and newfound joy attached to her wedding hat, Anna Mary and Tom Moses left for the South where the weather was warm and good farms, it was said, were there for the taking. In later life, Grandma Moses painted autumn scenes, but infrequently. Her best-loved landscapes were green with the sap of life or white with the purity of snow, tossed like a marriage quilt over the slumbering hills.

In Virginia, in the valley between the Blue Ridge and the Alleghenies where Tom and his bride settled, she gave birth to ten babies. Five lived. Five died. That was death enough for her. "Five little graves I left in that beautiful Shenandoah Valley," she wrote, on a farm called Mount Nebo, because that was the place where Moses died, too—or disappeared into the arms of the Lord, like her dear little ones.[26] Tom and Anna Mary, Winona and Hugh, Forrest and Loyd and little Anna came back to Eagle Bridge in 1905 and called their new farm Mt. Nebo. Moses would paint it over and over in the years to come. Her own little tract of paradise was almost always colored with the brave green of new beginnings or the white soft snow of rest.

3. Making Soap, Washing Sheep

From the time Anna Mary Moses first made contact with her future friend and dealer in 1940, Otto Kallir had been urging the old lady to put her life story and the stories behind her paintings into writing. This proved no easy task. By 1945, gentle prodding had yielded up three short autobiographical sketches covering her activities to 1927, the year of her husband's death.[1] Eventually, by 1952, Kallir had collected 169 handwritten pages, only 37 of which dealt with her remarkable, late-in-life career as an artist.[2] Another fragment, written for the *New York Times* in 1948, appeared as a commentary on Thanksgivings she had known, beginning with the story of her Pa, the red dress, and the first official observance of the holiday in the Cambridge Valley of the nineteenth century.[3]

With the exception of a nuts-and-bolts essay for the *Times* on the paints she used and her preference for masonite over canvas, however, Mrs. Moses seemed reluctant—or unable—to articulate the kind of musings on the meaning of art that came easily to more orthodox luminaries of the New York scene.[4] Yet what she did have to offer by way of explanation for her belated passion for art also explains the structure of her various autobiographical fragments, which dwell on the significant events of her life as a daughter, a wife, and a mother—an active working woman in a rural setting—rather than the pursuits of her leisure time, after that vital work was done.

"What a strange thing is memory, and Hope," she wrote in her own version of stream-of-consciousness prose. "[O]ne looks backward, the other forward. The one is of to day, the other is the tomor-

row, memory is History recorded in the brain, memory is a painter it paints pictures of the past and of the day."[5] Her memories concerned the things that loomed largest in her experience. What the family had done when she was a little girl. What she had learned there on the farm. The tasks she performed as a hired girl. And most of all, raising a family and earning a living in the years from 1887 to 1927—the forty years of her marriage which were, to Anna Mary Moses, the most important years of her long life. Although most artists of her day (and ours) would not spell out their life stories in the children's first steps, the butter churned, the potato chips sent to town for sale at 30 cents a pound, the farms rented, and the dinners prepared, Mrs. Moses did because these were the things she had cared about, the skills she had mastered, the sources of her pride, her private sorrows, and her ultimate personal satisfaction.

After their wedding, Thomas and his wife boarded a train headed south into the old Confederacy and did not return to New York State until 1905. In those almost twenty years, they worked a succession of rented farms in the Shenandoah Valley of Virginia. The Bell Farm: there Anna Mary acquired her reputation as a champion butter-maker. A dairy farm near Fort Defiance. Thomas sent to Vermont for a butter "print" or mold, carved with the name of Moses (the one-name trademark signature that Anna Mary later used on her pictures). Babies. The Dudley place, closer to Staunton. The young mother made sunbonnets and pieced cotton stars—the "Star of Bethlehem"—for the children's nightshirts, so she could tell which was whose. She won first prize at the local fair for her canned tomatoes and saw her first automobile. The Moses family bought the Dangerfield farm, known locally as Mt. Airy, and called it Mt. Nebo from a familiar Sunday school text. Everybody was baptized at the

Episcopal chapel, even though Anna Mary confessed to a young relative in 1934 that "Thomas and I never held much to church goin'."[6]

This was a busy and, for the most part, a happy sojourn. It was also productive. Like many Americans of her day, Mrs. Moses was fascinated by how to do things, by the technology and techniques of production. The Henry Ford or Thomas Edison of the domestic front, she remembered in detail what it had been like to churn three or four times a day, and to print her own butter, "20 prints to a tray, . . . four trays to a crate, . . . two crates a week," bound for the fashionable resort of White Sulphur Springs.[7] One of the most vivid passages in her discussion of farming in the South described how to make apple butter, a crucial condiment in a rural economy in which refined sugar, like store-bought commodities of all kinds, was often hard to come by.[8]

During the Civil War, as a form of protest against the South, many northerners refused to buy cane sugar and molasses; New Englanders used maple syrup instead and developed the industry into a icon of Yankee virtue during the 1860s. For country people everywhere, however, apple butter was the primary winter sweet. Making one's own treats from the fruit of the land was a mark of a frugal and skilled housewife. Preserves, conserves, and canned goods occupied a place of honor at country fairs, where they—like quilts and embroidery—proved the mettle of an industrious woman. And, as Anna Mary Moses stated, in her day apple butter was "a necessity," not a luxury.[9]

Lydia Maria Child, in *The American Frugal Housewife* (1833), a manual of "Hints to Persons of Moderate Means," urged mothers to equip their daughters with practical skills: "Young ladies should be taught that usefulness is happiness, and that all other things are but

incidental." Berating mothers who introduced their impressionable female children to the manners and frivolities of Saratoga Springs and other watering holes of the idle, Child praised instead those who schooled their daughters in the practical arts of sewing and canning.[10] Work was virtue. Thrift and practicality were its handmaidens. So making apple butter every year in the late summer was more than a frolic—although frolic there was as well. It was a form of communion with the land, the family, and the community of helpers it took to carry out each of the precise steps needed to make up forty gallons that were just exactly right. Not too sweet or too sour. Not too thick or too thin. Blue-ribbon perfection.

Apple Butter Making (1947) is among the relatively few of Mrs. Moses' pictures to deal with her years in Virginia. The Southern pictures appeared mainly in the 1940s in the flush of creative productivity that came at the beginning of her turn in the limelight. Commenting on a view of her father's new farm at Oak Hill completed then, she wrote that "some call this a pretty valley. But give me the Shenandoah valley every time."[11] The Virginia paintings therefore seem filled with special meaning for her—and the apple butter picture most of all. The farmhouse around which the day's activities swirl has been taken directly from a photograph of the young Moses family (and their own hired man) gathered in front of the former Dudley Place, sometime in the 1890s. The bricks, the shutters, the pediment over the porch, the lyre-shaped railings, and the vine across the doorway are all shown in great detail. And similar care has been taken in depicting each step of the recipe she gives for making apple butter correctly.

At the far left are the barrels of sweet cider made from ground apples (and the apples themselves). Then comes the huge brass kettle full of boiling cider. Then the three measures of quartered apples (or

Apple Butter Making. 1947. Oil on pressed wood. 16½" x 23⅝". Kallir 653. Private collection.

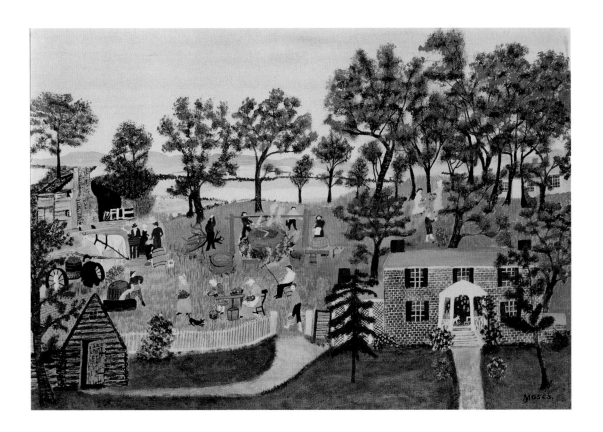

"snits"), nicely cored (and, in the painting, peeled with a little machine clamped to a table), and poured into the kettle. The fire, fed with tree limbs, is stirred up constantly. More apples are dropped into the bubbling mixture by the women; and in the right-hand background, behind the house, the familiar lavender lady and two children are picking the last of the apples. (Another version of the scene adds windfall apples on the grass and a full-blown cider press in operation.)

Making Soap, Washing Sheep

Hers is a daylight scene but in the evening, she says, the youngsters took over, stirring the kettle two by two, in pairs: a boy and a girl, another boy and girl. By midnight, the mixture had thickened and romance had blossomed. Now it was time for the expert—the woman in an apron standing on a raised platform at the side of the fire—to adjust the seasoning. She might pour in a precious sack of sugar, some cinnamon, some oil of cloves. The only step in the process that Mrs. Moses fails to illustrate takes place after the fire has burned itself down and the big stoneware jars are finally filled. But that was a story for another day, another picture. The doing, the process, the sights and the smells are as real to the artist as the one, single stoneware jar of Virginia apple butter she still had left in 1947, when she sat down in Eagle Bridge to remember Virginia long ago. The long dresses and the knee britches set the scene in that once-upon-a-time when Anna Mary Moses was in her prime. Or in the old days when folks always made apple butter at the end of the summer, when the trees hung heavy with fruit and their fragrance filled the warm Southern breeze.

The temptation in contemporary society is to judge a person's contribution to the world's business in terms of wages—or Andy Warhol's 15 minutes of fame. By that measure the women of the American past, without paying jobs or fiction-writing to their credit, often sink into invisibility. In the rural economy of the late nineteenth and early twentieth century, however, it was taken for granted that husband and wife were partners in their enterprise, that a farm could not succeed unless she processed and preserved what he grew—in addition to her work of clothing the family, keeping a clean and attractive house, cooking, washing, and performing all the other weekly tasks specified in the words of the old housewives' jingles. Country fairs acknowledged the essential labor of

women by offering prizes and recognition to those whose sewing and canning and baking were deemed superior. Neighbors knew who could offer the best advice on seasoning the apple butter. Local merchants knew whose butter was the sweetest, whose eggs were the freshest.

Middle-class intellectuals of the nineteenth century, prominent women like Sarah Josepha Hale, accepted the notion that there were two separate spheres of influence in life, neatly divided between the sexes. "I place women's office above man's," she wrote in *Manners: Happy Homes and Good Society All the Year Round* (1868), "because moral influence is superior to mechanical invention."[12] But there is not the slightest hint in Anna Mary Robertson Moses' musings about her own life that she would have agreed with Hale and the other urban advice-givers of her day. Mrs. Moses knew from girlhood, when she went out in service to polish the skills of a farm wife, that her involvement with the "mechanical" would be at least as great as her husband's. He knew how to plow a furrow. She knew how to put up apple butter.

Some of the most engaging of Grandma Moses' paintings concern themselves with the "how-to's" of farm living: how to make candles, soap, maple syrup, or a quilt, how to cut a Christmas tree, pack for a move, celebrate a holiday. Her narratives stop dead whenever she has the opportunity to tell the reader the best way to get a job done. Even as she wrote her reminiscences, in the 1940s, Anna Mary Moses knew perfectly well that nobody made their own candles anymore: she listened to the radio, sewed by the light of electric lamps, and enjoyed all the benefits that modern commerce brought to Eagle Bridge. But like the curator of a historic site, she believed that the old-fashioned ways ought to be remembered. Like the "pastkeepers" of the 1890s who aimed to preserve the venerable town of Deerfield,

Massachusetts, as a vital link to the history of New England—and a ongoing source of their own collective identity—so Grandma Moses asserted her place in the continuum of family and regional history by telling stories that amounted to precious heirlooms from a vanishing moment in time.[13]

Much to the amusement of his critics, Henry Ford was also concerned with the how-to's of the old days. His collections included not only coaching inns and country schools but also the farmhouse in which he was raised, antique farm machinery, gristmills, and the kinds of cast-iron apple-peelers that Mrs. Moses replicated in her pictures. Ford was a contradictory character, and what he hoped to prove with his artifacts is still a subject for dispute. But the stupendous quantity of material now housed in the museum across the street from the Ford Motor plant in Dearborn, Michigan, strongly suggests that there is a continuity between that factory and the American past. The affordable car changed America, as Grandma Moses showed in works that contrasted her trips to town by automobile with the stagecoach and wagon expeditions of the eighteenth century. Despite all that change, however—despite an apparent rupture with the past—a fundamental continuity remained. That was a tenacious Yankee drive to improve daily life through "mechanical invention," ingenuity, and the kind of know-how that characterized the work of the American farm wife from pioneer times to the 1940s—from Henry Ford's boyhood farm in Springwells Township, Michigan, in 1863 and Sissy Robertson's girlhood in the Cambridge Valley in the 1860s to a modern America of Fordson tractors and old ladies who made pictures of "old tyme" stuff for the sheer fun of it.

In one of George Sheldon's imaginative recreations of colonial life as it had been lived in his ancestral home in Deerfield, he described

an old lady, sitting by the fireside, knitting a stocking while rocking a cradle. The mother of the house worked at her spinning wheel. The father made tools for the farm with his sons. The men tended the fire from time to time. And in its flickering light were seen "the twisted rings of pumpkin, strings of crimson peppers, and festoons of apples" dangling from the ceiling beams to dry. Everybody worked at something. Everybody made something. "Idleness was a crime."[14] On Grandma Moses' painted farms, the same is true. With a few exemptions for frolicking children and courting youngsters, everybody works. If not a crime, then idleness is a failing. It is a central fact of her art that old Grandma Moses, busy as never before in her years of supposed retirement, reasserted that proposition by demonstrating her expertise in the work of her world and reminding others of the unceasing labor that was once a woman's proud lot.

May: Making Soap, Washing Sheep (1945) is another "recipe" picture, an illustration of the written instructions included in Mrs. Moses' autobiography. Just as apple butter is made in the late summer, so the proper season for soap comes in the spring. Making soap was one of those chores that simply had to be done on an annual basis, short on fun but necessary just the same. One nice day early in May it was time to collect the winter's grease, already strained and heated to cook out the impurities: nasty stuff nonetheless. Meanwhile, out in the yard, the "leach" was started. Through a perforated barrel of wood ashes saved from the winter's fires was poured enough water to extract the lye. Fat and lye together went into a big kettle over a fire, tended by the housewife who might add a little grease, a little more lye, until the batch was ready to test or "try." If a cupful of the new soap could hold its own in a bowl of water and make "a nice strong jelly, amber-colored," said Mrs. Moses, why then it was done.

May: Making Soap, Washing Sheep. 1945. Oil on pressed wood. 17″ x 24″. Kallir 509. Miss Porter's School, Farmington, Connecticut.

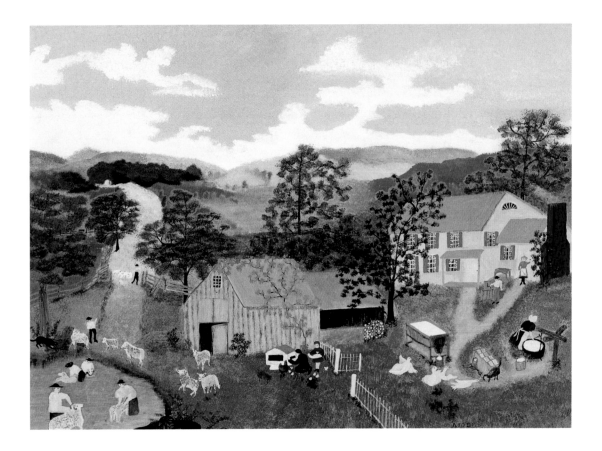

Drain the stuff into another barrel. Do the laundry for the rest of the year. "That was women's work," she said. "We were thrifty, nothing wasted, nothing lost."[15]

Mrs. Child offered pretty much the same tried-and-true formula, cautioning that if more than three pounds of fat were added per pailful of lye, the soap would not "come" nicely. This was a common enough error owing to a "want of judgment about the strength of the lye."[16] But the superior soap-maker, of course, was always a fine

judge of lye, like the diligent woman in black tending the kettle in the Moses picture. All the necessaries have been provided for: a pile of wood for the fire, the molds for laundry bars, a leaching tank, a storage barrel. There is even space for a little fun, after all. In Mrs. Moses' apple butter scenes, a little black dog nips at the bright red peelings as the ladies prepare the snits. In the soap-making picture, the comic relief comes from a fierce black cat doing battle with a flock of ducklings who threaten to disrupt the operation. But the humor is balanced against the serious work. Mrs. Child advised her readers to make their own soap because it was frugal to do so. By such acts of vigilance, she argued, the woman of the house made the difference between family poverty and prosperity. Her work was the great equalizer between men and women.

Grandma Moses' *May: Making Soap, Washing Sheep* is a good illustration of the division of production between men and women. The painting falls into two halves, separated by the white barn on the center axis. To the right is the farmhouse and its proper work, including tending the soap kettle. On the left, the men of the household use the soap to wash the woolly sheep in the pond with the help of a vigilant herd dog (the counterpart to the cat on the distaff side of the composition). In her text on soap-making, Mrs. Moses concedes that the actual transformation of the clean wool into clothes for the family was a relic of her mother's day, when the girls of the house "didn't get any education" because they had to weave and spin and knit stockings. In the old days, too, the flock had to include one black sheep (not shown in her picture) for the yarn with which to make the "pepper and salt" cloth used for the homemade suit of a young man leaving home to make his way in the world. A "freedom suit," they called it then, so well woven that it might wear for a generation.[17]

In the larger cities and towns of *fin de siècle* America, freedom suits were already looked upon as relics of a faraway colonial past. In 1893, for example, the executives in charge of the New York State exhibits at the World's Columbian Exposition in Chicago set up a separate board of women managers entrusted with artistic and cultural affairs. One of the ladies' most innovative ideas was to mount a "Colonial Loan Exhibit" of historical artifacts collected by the women of New York. Their planned exhibit for the Chicago Fair reflects an intense interest in the colonial past at the turn of the century, fostered in part by the sense that the very industries the Exposition celebrated had compromised the traditions of the past—the folkways which had guided and sustained Americans for centuries.

The benefits of modern life came at the cost of losing a vital part of the national heritage of independence, self-sufficiency, and respect for the work of women. So while one part of the New York State effort went toward showing the superiority of canned fruits and vegetables from local processors and manufacturers of tins, another celebrated the days of kitchen-canned tomatoes, homemade apple butter, and the lye soap tended, in Mrs. Moses' picture, by a colonial-looking dame in a long black dress, a long white apron, and a sunbonnet. The Colonial Loan Exhibit in Chicago included a spinning wheel and a flax wheel, lent by a Mrs. Sanders of Schenectady, to whom the artifacts used by Sissy Robertson's mother had already become precious relics of the Revolutionary era. So was an "old sampler" of the 1800s, from Brooklyn. And so, on better evidence, was a swatch of fabric from Martha Washington's wedding dress. But Mrs. G. H. Van Wagner of New York City sent a historical "freedom suit," of the kind described by Mrs. Moses as a part of a living rural tradition, circa 1870, a century after the colonial era had passed.[18]

Admittedly, during Sissy Robertson's childhood homespun began

to disappear from the rural scene. "They commenced to buy everything," she said. But store-bought calico did not fundamentally alter the rituals of farm work. In her popular "Samantha" novels, Marietta Holley assumed the persona of a woman of Sissy's day. *My Opinion and Betsy Bobbet's* of 1873, the first in the long series, describes the tasks of the typical year in Samantha's own country vernacular. "Sugerin' time come pretty late this year," she complains, and "no sooner had I got that out of the way, than it would be time to clean house, and make soap," followed by the usual washing, cleaning, baking, churning. "And well doth the poet say—'That a woman never gets her work done up,' for she don't."[19] And then there was candle-making. In 2006, candles are the essence of romance—a low-tech, mesmerizing alternative to electric bulbs, and a very big business. Both soap-making and candle-making are also popular hobby crafts without much connection to colonial history: supplies come from Internet distributors, and printed instructions recommend the use of tools like crockpots and aerosol spray cans of silicone. In the 1870s, though, candles were labor-intensive necessities of life, especially for poor country people.

When she was a very little girl, Mrs. Moses stated, her mother had used sperm oil lamps. But fuel grew so expensive that a cheaper substitute came into play—the so-called "slut," a scrap of cloth held down by an old copper penny in a saucerful of cooking grease and then set alight for a sputtering, foul-smelling flame. Plainly, candles were preferable and were made in quantity on the Moses farm. Late fall and early winter were prime candle-making seasons. When the farmer slaughtered his beef—one animal per year—the waste fat or tallow was dried and saved. Unlike costly beeswax candles, which were dipped over and over again in a laborious process, ordinary home candles were made by pouring melted tallow into molds

threaded with wicks. In cold weather, the molds were set outside where the candles hardened up quickly.

The same molds could be reused several times a day until the supply of lights was adequate for the year ahead. Mothers, hired girls, children: everybody who contributed to the inside work helped with the candles. "It was tiresome for me," Mrs. Moses recalled, "but it was a necessary job, just like soap making."[20] Yet in her painting *Candle Dip Day in 1800* (1950), she shows the tedious dipping method, in which wicks were dangled over rods and then lowered into the hot wax many times until they reached the desired thickness. This painting is not a "memory picture," another illustration of her own life's work. Instead, it is a colonial-era fantasy that harks back to a time when it was even harder to get the job done.

Candle Dip Day reuses some of the conventions of *Making Soap*. The composition is divided into halves by a tree that neatly bisects the farmyard. On the right, the kitty chases ducks, the windowpanes define the wall of the house, and two women in colonial fancy dress—stiff bodices, lace collars, aprons, and mobcaps—dip wicks into a simmering cauldron of pure white wax and hang the rods to cool on a special candle rack. Although the apparatus spills over onto the left side of the picture, masculine symbols predominate there: a farmer in crossed bandoliers heading for the barn, a yellow rooster, a puppy with a ball, and oddly enough, a little boy of 1950s vintage, wearing a striped T-shirt. The modern child signals that this is Grandma Moses' contemporary recreation of what an important home industry looked like, long before her own time.[21]

In a way, *Candle Dip Day* is a tourist picture. On any given morning in the crisp air of early spring, whole families can nowadays be found pressing cider, stitching quilt blocks, making brooms, churning butter, weaving baskets, or dipping candles as an exercise in

Candle Dip Day in 1800. 1950. Oil on pressed wood. 9¼" x 9". Kallir 941. Private collection.

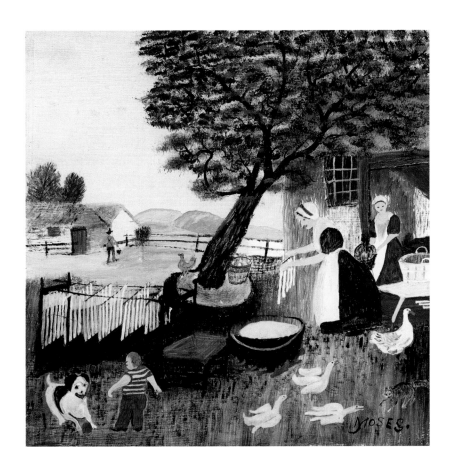

learning about the old days, when the arts and crafts of daily life were the means of survival. Folk festivals, museums, and shopping centers from Maine to Ohio, from California to the Deep South stage such do-it-yourself opportunities, offering a recreational taste of life before supermarkets and cable TV. In the 1940s, outdoor history villages—Plimoth Plantation, Mystic Seaport, Old Sturbridge Village, Old Deerfield Village—began to present demonstrations of antiquated home industries conducted by artisans dressed in period costume.

Making Soap, Washing Sheep

This was a painless, sensory immersion in Old New England, a pleasant excursion into a history where nothing had ever been "tiresome" or messy or downright dangerous (like the fires and the bubbling kettles in a Grandma Moses painting).

In *Nobody* (1882), novelist Susan Warner describes the trials of a New England farm family that took in summer boarders eager for a taste of the simple life of their ancestors' era. But simplicity as 1882 interpreted it meant creature comforts on a scale the countryside never knew.[22] Clean towels in vast quantities. A batch of fresh-fried doughnuts every morning. Thanksgiving dinners on a daily basis. All the luxuries of city living, with home-dipped candles and homemade apple butter besides. If Sissy Moses had ever read classic New England fiction—and she did not—she would have guffawed at the surfeit of quaint stuff that made her own paintings so appealing in the 1940s and 50s. By the end of the nineteenth century, however, a growing nostalgia for the imagined simplicities of the past had already been institutionalized in advertisements for boarding establishments and vacationtime festivities in rural New England. In 1899, Deerfield mounted the first of its famous summer fairs; tourists were tempted by the work of regional candle-makers, basket-makers, weavers, and quilters, working in traditional, time-honored ways. Eventually potters, metalworkers, and embroiderers joined in what amounted to the rebirth of a sleepy New England backwater under the aegis of a Society of Arts and Crafts.

The trademark or logo for the revived handicrafts of Deerfield consisted of a homemade candle burning before a window glazed with the tiny panes of a bygone era. The guttering light in the window came to symbolize the gulf between past and present. On one side of the divide stood Edison's Electric Light Company, founded in 1878, and on the other the humble candles that the mothers of

Old Times. 1957. Oil on pressed wood.
16″ x 24″. Kallir 1296. Private collection.

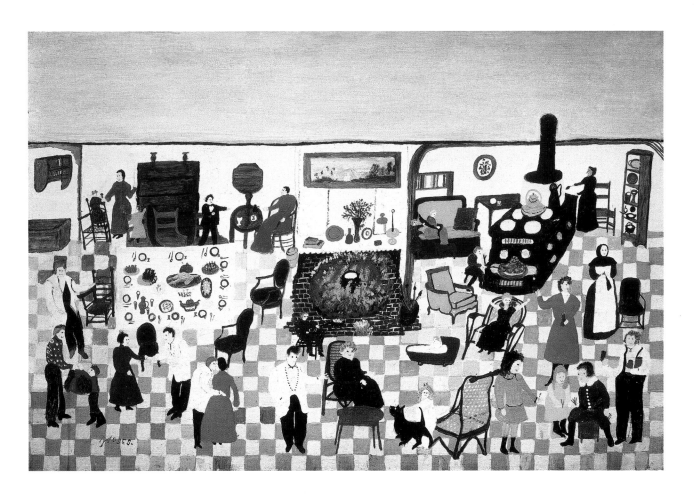

Deerfield (and Washington County, New York) stored up for the long winter nights ahead. The antidote to the manifest ills of a modern America suddenly dependent on factories, inventions, and all manner of wonders beyond the control of their users was the "Good Old Days" of self-reliance and self-sufficiency. A time of candles and freedom suits and apple butter. A utopia of the imagination which, in reality, had been hard and often "tiresome." But even an old lady

who had struggled with hot candle molds and smoking tallow as a little girl could not help casting her own thoughts back to those "Good Old Days" and showing perfectly turned out colonial ladies dipping their candles without undo effort on a perfect cool morning somewhere in a New England of the spirit.

The whole enterprise of historical tourism was helped along by a genre of pictures-for-sale featuring modern women in colonial garb reenacting the labors of their female forebears. These were staged photographs, sometimes hand-colored, suggesting that the camera operator had been magically transported back to the 1700s for the purpose of telling the future what Ye Olden Tymes really looked like. Wallace Nutting, a minister-turned-entrepreneur who retailed New England in the 1920s (he created a chain of historic house museums; he manufactured reproductions of period furniture; and he turned out framed images of colonial doorways and sun-dappled lanes in mass quantities), is often associated with these peculiar photos.

There were many historical photographers active in the trade, going back to the 1890s; many of them were women, to whom the camera offered a means of creating art without the social obstacles that barred female students from conventional art schools. Photographers were not required to study naked models in the company of rowdy young men. Indeed, the world that Marion Harland, Mary Northend, and the Allen sisters chose to represent with their cameras was a rural America of some indefinite time in the past populated by women, for the most part—women solemnly engaged in domestic tasks. They bake pies, they sew, they churn butter. The men, when males put in a rare appearance in these photographs, stay outdoors, plowing behind their horses. Or, bearded and ancient, they nod by the fireside.

These "colonials," as they were known in the trade, made excellent illustrations for the best-selling books of antiquarian lore centered on household industries—books written by a growing class of professional women authors following in the footsteps of Louisa May Alcott, Susan Warner, and Marietta Holley. The first edition of Alice Morse Earle's influential *Home Life in Colonial Days* (1898) set the pattern for a torrent of volumes which followed, describing what the history books had not: what it was like to live and work in the rooms so lovingly arranged in the historic homes on the East Coast tourist circuit. The ladies who wrote the books were avid antiquers themselves; their preoccupation with the relics that defined their make-believe world often led them into charming anachronisms. Thus a Mary Northend snapshot of the "colonial fireplace" in the Dorothy Quincy House in Massachusetts shows a set of pewter molds for tallow candles being used as evocative mantle decorations.

Women of Mary Northend's generation put candle molds on the chimneypiece to lend a touch of ancient charm to an otherwise modern room. But would Anna Mary Moses have done so? Would she have loved their books? Spoken sagely about the Colonial Revival? Probably not. To Mrs. Moses of Eagle Bridge, now in her years of retirement, work was a precious memory, far more important than charm. Without work and family and community, the apple butter would never be so sweet nor the wool so soft.

4. Sugaring Off

Of all the half-forgotten labors of old New England, none is more picturesque than the early springtime ritual known as "sugaring off." Like images of jolly Santa Clauses and stern Pilgrims clutching Bibles, seasonal vignettes of the methods and the primitive machinery used to coax sugar from maple trees have been staples of the popular magazine since the late 1800s. Sugaring off meant New England, antiquity, a sweet, snowy American Eden at the changing of the seasons. Old Mrs. Moses' treasure-box of pictorial source material was full of maple sugar–related clippings, ready to be deployed whenever the occasion demanded sap buckets and spigots.[1]

She copied some of her cuttings outright in sketches for use in specific paintings. Others were traced in pencil directly onto the masonite surface of a work in progress. Prints like the famous 1872 *Maple Sugaring: Early Spring in the Northern Woods* from Currier & Ives were mined for useful details. The peculiar shape of the sugar barrels in the lithograph, the costuming, the posture of the man pouring sap into a collection vessel, and the apparatus that holds the cauldron of sap over the fire turn up repeatedly in Grandma Moses' syruping pictures, rearranged, turned this way and that, like pieces of a quilt.[2]

In an effort to appeal to a broad audience, Currier & Ives had chosen subjects of proven interest. Sugaring off in the New England woods was such a theme. In 1856, the firm issued one of the most famous of all its prints—*American Forest Scene: Maple Sugaring,* after a painting by A. F. Tait. Rich in both hue and local color, this particular

Maple Sugaring: Early Spring in the Northern Woods. 1872. Lithograph published by Currier & Ives. The Henry Ford Museum, Dearborn, Michigan.

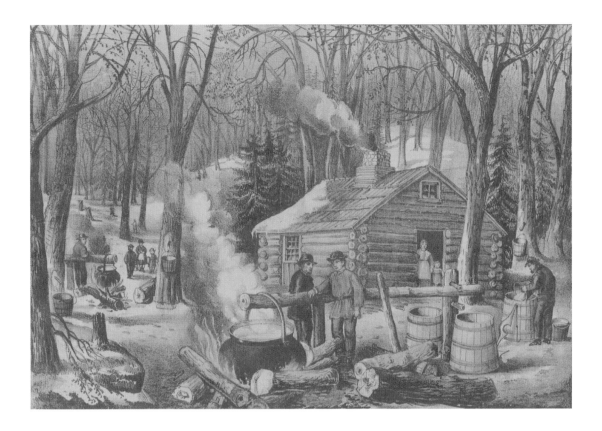

print concentrated less on the labor of making sugar and more on the social ritual that surrounded the first stirrings of spring in rural New England, with the neighbors, women, children, and a clutch of tourists coming together to enjoy the "jack wax," or hot syrup cooled in the last of the winter's snow. In their 1860 catalog, Currier & Ives described the image in fulsome terms as "an agreeable picture of a peculiarly American character," stressing the camaraderie between the "city folks, come out to taste the sweets of the country" and the natives, who gossip "either on the sugar trade or the next election," leaving the boys and girls to do the real work of the day.[3]

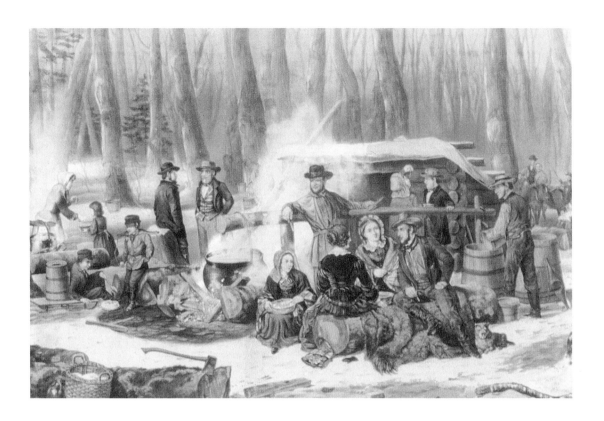

A. F. Tait. *American Forest Scene: Maple Sugaring.* 1856. Lithograph published by Currier & Ives. The Henry Ford Museum, Dearborn, Michigan.

This print, too, was pillaged by Mrs. Moses for usable motifs. The team of oxen plodding through the trees. The lad carrying two pails of sap dangling from a yoke. The dog for a touch of comedy.[4] One of her earliest renditions of the theme, entitled *Bringing in the Maple Sugar* (1939, or before) was included in her first one-woman show in New York City in 1940. Her winter scenes in general and the sugaring-off scenes in particular appealed to her earliest commentators on the basis of their cheerful sparkle (to the horror of purists, the painter sometimes sprinkled packaged "glitter" made of mica on the wet paint of her snowscapes!). The *New York Herald-Tribune*

Sugaring Off. 1955. Oil on pressed wood.
18″ x 24″. Kallir 1166. Private collection.

said that Mrs. Moses "delightfully pictures the occupation of maple-sugar gathering, which invariably brings out a festive note in her work."[5] *Time* magazine gave two columns to the exhibition and the iconography of farm living, including "boiling maple sap on the winter snow."[6]

The compositional liveliness of the images, with a myriad of incidents and details spotlighted against the dazzling whiteness of the

snow, had enormous visual appeal in its own right. The orderliness, the high color, and the good spirits were all the more startling in the context of the art of the 1940s, especially the glum remnants of the social protest art of the Great Depression. It is also noteworthy that the collector who first "discovered" Mrs. Moses, when asked by reporters to comment on the significance of her work, said that her renditions of farm life "are executed with [a] pictorial accuracy which . . . should make them valuable as historic documents of a past era"[7]—or of the time when Anna Mary Robertson Moses delighted in "the maple-sugar parties" of her childhood.

Perhaps because of her status as a hired girl, Sissy Moses "never got into sugaring-off parties," she admitted somewhat ruefully. "They came later than my day, further up in Vermont it was an old custom. Younger ones would have a gay time, they'd pour the syrup when it was just ready to turn to sugar on dishes of snow for each to eat; they would eat their fill and go home to dream sweet dreams."[8] In the Tait print of 1856, the pretty little girl sitting by her mother in the foreground—the one wearing the bright red cloak—is doing exactly what Grandma Moses' story specifies: the blue bowl in her lap is filled with snow and dollops of sweet syrup hardening into candy. It seems entirely possible, then, that the material Anna Mary Moses records in her autobiography sometimes includes more than memory alone. Sometimes she writes of things that come from her *pictorial memory* of what the celebrated sugaring-off ritual ought to have looked like.

From personal experience, however, she states that the Robertson clan tapped their own trees in February, when the snow began to taper off in upstate New York. The sap the children collected was partially boiled down outdoors, as the Currier & Ives pictures have it. But at night, the day's work was brought indoors for finishing off

on the cookstove. It was fun, she says, to collect the buckets and keep the fires burning all day. The best part of all, though, was eating buckwheat cakes and hot biscuits with maple syrup or drinking a special seasonal tea, a concoction of sap cooked with ferns. A homemade health tonic, fern tea was "very nice" if laced with cream.[9]

Given Mrs. Moses' interest in the ins and outs of other farm tasks, it is a little disappointing, at first, that she fails to tell the reader all about sap buckets, wooden taps, gathering pails, sugar shacks, and the perky little "roofs" fixed over the spouts to keep impurities out. Nor does she seem interested in the folk wisdom that holds it's time to stop the boiling when the sap starts to smell like old socks! But this was all part and parcel of the men's work, of course. And while Grandma Moses has often been lumped with the so-called "memory painters," in this instance personal memory may be less pertinent than massive governmental publicity. According to scholars of folk art, memory painting is a distinct category pertaining to vernacular images that preserve recollections otherwise doomed to slip into oblivion.[10] In the case of maple sugaring, however, Mrs. Moses was not the only person bent on keeping the memory of the sugar industry alive. The whole state of Vermont was in cahoots with her.

The novelist Dorothy Canfield Fisher, who made a second career out of boosting the quirks and wonders of western Vermont, was also a realist. In the aftermath of the Civil War, she wrote, Vermont had all but succumbed to debt with the failure of its local industries. The woolen mills, the potteries, the forges, and the hat factories moved elsewhere, leaving behind the least urbanized population in the country and terrible poverty on the rural mountain farms that remained. And yet, in the days of Fisher's own childhood in the 1890s, Vermont had seemed to be a paradise of abundance. "I was

often sent down" into a treasure-packed cellar, she recalled, "with an old chisel and hammer, to chip off a week's supply of sweetnin' from the big barrel of dark crystallized maple sugar (white sugar was for company)."[11] Maple sugar was a sweet symbol of that other Vermont—simple, agrarian, proud, and productive. But its past, she also insisted, "is a part of today."[12] In the worst days of the 1930s, the six governors of New England banded together to sell their region on the basis of old-fashioned, sweet-as-sugar charm. Covered bridges, red barns, and sugar shacks took their place alongside ski trains and history villages to create a kind of double vision of the old Northeast. Past and present intermingled in a nostalgic haze arising from the Vermont sugarbush.

As early as the 1890s, Vermont's Board of Agriculture was busily promoting two paths to economic stability. One was tourism—perambulating summer boarders from the cities who stayed on local farms. The second was a series of high-profit agricultural ventures including lumbering, sugaring, and the production of merino sheep to stock Western ranches. These two prongs of attack converged on a nascent sugar industry and an official body known as the Vermont Maple Sugar Makers' Market.[13] Tourists would come to join in the time-honored rites of sugar-making. The Board's role in all of this was to guarantee the purity of a product which itself bespoke the purity of an Old New England, miraculously still alive in the sugarbush of the Green Mountains and the Berkshires. This was the same territory idealized in the popular New England fiction of the local-color school. Encouraged by the success of Mrs. Stowe's "Down East" novels, other writers including Sarah Orne Jewett, Rose Terry Cooke, and Elizabeth Stuart Phelps had conjured up a rural utopia, a golden age of sweetness and sugar.

In Harriet Beecher Stowe's *Poganuc People* (1878), the rituals at-

tached to the seasons of the year are marked by wholesome local festivities to which visitors from the city are always welcome. For them, as Mrs. Stowe presents her stories, the homemade carpets, the braided rugs, and the candles on the mantle serve as "immortal monuments of the never-tiring industry of the housewife," or moral lessons in the essential goodness of the old New England ways. In the afterglow of firelight, the "apple-bee" is a wintertime fantasy of sleigh rides and courtship; the young people take their places around tubs of apples and quinces, competing to see who can make the longest peel or whose initials will appear on the carpet when a pretty miss tosses a discarded apple peel over her shoulder. The only hint of modernity comes in the form of a brand-new "patented apple-peeler and corer," which in no way alters the time-honored games of romance enjoyed by the company and the spectators alike.[14] The onlookers include the matrons of the community, exchanging recipes for apple pie; the minister, deep in theological debate; and the reader, who is invited to sigh with nostalgia for the lost perfection of that firelit room, so long ago.

Such a mood of retrospection—of longing for an era half-remembered—is the theme of John Greenleaf Whittier's "Snow-Bound" (1866), written by the Massachusetts poet at the very time when a picture-perfect New England legend began to take the place of a region in severe economic decline. Whittier wrote the century's most beloved poem in response to a request for an article describing his memories of boyhood for a children's magazine. The article rapidly evolved into a little book about wintertime, including "Snow-Bound," an account of a rural family forced indoors by bad weather, reminiscing and philosophizing around the fireplace.[15] While a snowstorm rages outside, the narrator's old aunt "Called up her girlhood

memories / The huskings and the apple-bees," symbolic to the poet of the purity of heart she had retained throughout a long lifetime. Insulated from the storms of war and social change that lash the world outside the New England farmhouse, the world inside is always the same. From the troubled New England of 1866, Whittier invites his reader to retreat with him to another New England of the heart, to "Sit with me by the homestead hearth, / And stretch the hands of memory forth / To warm them at the wood-fire's blaze!"[16]

When former President Calvin Coolidge, a Vermonter himself, came to write his autobiography in 1929, he set his own boyhood in Whittier's world of "Snow-Bound," where the year was marked off by haying, apple-picking, sheep-shearing, "husking bees [and] apple-paring bees." Best of all, however, was sap season in the sugarbush, around the first of April, when the work of the farmer's year resumed in earnest. "With the coming of the first warm days," Coolidge wrote, "we broke a road through the deep snow into the sugar lot, tapped the trees, set the buckets, and brought the sap to the sugar house, where in a heater and pans it was boiled down into syrup and taken to the house for sugaring off. We made eight hundred to two thousand pounds, according to the season."[17]

In August 1923, Warren Harding died unexpectedly. Vice President Coolidge was back in Vermont at the time, visiting his aged father at the latter's farmhouse in Plymouth. Old Colonel John Coolidge, also the local notary, swore his own son into office as President of the United States in a hasty, midnight ceremony right there in his parlor by the light of a kerosene lamp. Immortalized by photographs and a painting by an enterprising artist who rushed north to Vermont for the purpose, the event became a national symbol of old-fashioned values, frugality, and New Englandism. And as revela-

tions emerged about the venality of his late predecessor, Coolidge himself became a figure of rustic dignity—a piquant contrast to the excesses of the Roaring Twenties.

Columnist Walter Lippmann explained why the dichotomy between the farmhouse scene and the contemporary scene found such widespread resonance. Americans, he speculated, "are delighted with the oil lamps in the farmhouse at Plymouth, and with fine, old Colonel Coolidge and his chores and his antique grandeur. . . . They are delighted that the president comes of such stock, and they even feel, I think, that they are stern, ascetic, and devoted to plain living because they vote for a man who is. . . . Thus we have attained a Puritanism de luxe in which it is possible to praise the classic virtues, while continuing to enjoy all the modern conveniences."[18] Calvin Coolidge did nothing to contradict the assumption that he was, if not a live Puritan, then a throwback to the infancy of the nation. In 1919 and again in 1923, when news photographers were expected to arrive in Plymouth, Vermont, he donned the high boots and homespun smock of an earlier day and posed amid the wooden buckets and farm implements of his youth, as if to show that he embodied the work ethic of Puritan New England.

Coolidge's tribute to his roots in rural Vermont caught the fancy of Henry Ford, then in the midst of his campaign to breathe new life into what he supposed the American past to have been by preserving its artifacts. Inspired by the rustic inauguration, Ford made a kind of pilgrimage to Plymouth in the company of industrialists Thomas Edison and Harvey Firestone. The trio first explored the little cheese factory behind the Coolidge farmhouse (and ate curds from homemade wooden spoons) and later sat for wire-service photographs on the front porch, where the former President autographed a family treasure for the collection of Ford's museum. The

Coolidge Family sap bucket made in Vermont and autographed for Henry Ford by former President Calvin Coolidge. Photograph. Longfellow's Wayside Inn, Sudbury, Massachusetts.

gift was a sap bucket which, said Coolidge, had once been used by his great-great grandfather.[19] Much to the surprise of Calvin Coolidge and his wife Grace, they discovered that same sap bucket hanging from an iron bracket on the wall of Ford's Wayside Inn in Massachusetts when the couple stopped for the night on the occasion of their 25th wedding anniversary in 1930. Almost overnight, a real relic of the rural Vermont past had become a sacerdotal vessel in a rite of make-believe Massachusetts history.

As a symbol of Yankee industry, of the wholesome life of rural New England, sugaring had no rivals. There was something magical, too, about the prospect of cold, snowy treelots better known for frozen mud than for delights of any kind yielding up the concen-

trated sweetness of maple syrup. And there was something elemental about the process itself. Henry David Thoreau's journal entry for March 21, 1856, finds him drilling his trees, driving in cast-iron spiles, and hearing the forest come alive with the sound of plops of liquid hitting the bottoms of buckets. "It dropped from each tube about as fast as my pulse beat," he recorded. Naturalist John Burroughs, who also made maple syrup every year, described the repeated cycle of freeze and thaw necessary to create a vigorous sap run as the "equipoise of the season," the knife's edge between winter and spring that marked the eternal calendar of nature with uncanny precision.[20]

In *Vermont Beautiful* (1922), one of Wallace Nutting's ubiquitous photo-and-essay tributes to the glories of the American Scene, sugarmaking comes in for intense scrutiny. "We presume," Nutting writes, "that the maples of Maine and Michigan have sap as sweet as those of Vermont, but it has not been utilized to such great extent nor been so widely advertised."[21] Nutting's books on the various states, with their lushly colored, soft-focus "views" of creeks and byways, were sentimental best-sellers—ideal wedding presents. But Nutting himself was a thoroughly modern entrepreneur, always ready to pay tribute to superior advertising. Syrup went with Vermont the way that corn flakes went with Kellogg's, he posited, because Vermont sold its sugar better! Later in the same text, Nutting spells out precisely what he means. "The making of maple sugar has come to be a symbol of Vermont life," he explains. "In reality sugaring occupies a larger place in sentiment than in fact. Nevertheless, the Vermonter naturally cherishes the tendency of the newspapers to illustrate and write of the sugaring season."[22] Maple syrup was both picturesque and infinitely marketable.

Old Mrs. Moses, whose sugaring-off paintings began in the earli-

Sugaring Off. 1945. Oil on pressed wood. 26″ x 31″. Kallir 505. New York State Historical Association, Cooperstown, New York.

est stages of her career, was well acquainted with Vermont and with the state's campaign to sell itself as a late-winter tourist attraction on the basis of the sap industry. The highway markers in downtown Bennington, Vermont, within sight of the Battle of Bennington obelisk, point straight to Hoosick Falls and Cambridge, New York, the latter only 22 miles away (and much closer as the crow flies).[23]

Around 1929, the Widow Moses moved across the border to Vermont to keep house for two of her granddaughters during the illness of Anna, their mother and her daughter. After Anna's death in 1933, Mrs. Moses stayed on (making pictures in her leisure time with colored yarns) for another two years until her son-in-law remarried. It was there that the promotional illustrations of the picturesque Vermont industry admired by Wallace Nutting in the 1920s found their way into her box of clippings, from which they emerged in the form of *Bringing in the Maple Sugar* (1939).

In the early years of her fame, petitioners often presented themselves at the door of her farmhouse in Eagle Bridge looking for pictures. They were not hesitant to specify dimensions, or to demand a subject just like one they had seen or read about. Although Mrs. Moses disliked doing the very same picture over and over again, she often bowed to the demands of her public. So *Sugaring Off in Maple Orchard* (1940) is a reprise of the earlier picture, with the ox team, the wood wagon, the snow candy scene, and the other vignettes rearranged in a more spacious snowscape. And so it went, through the last of her sugar subjects completed in 1960 and in 1961, the year of her death.

Some of the occupations of the past have become so deeply symbolic—even pictorially necessary—that there is little left of their original essence under the trappings of historicism. At Old Sturbridge Village, the famous history attraction in Massachusetts styled after a nineteenth-century community, the aim was "to preserve the ever-good things of New England's past." Opened in 1946, Sturbridge featured costumed villagers who reenacted the crafts practiced in the period from 1790 to 1840, including the tasks of everyday life. So faithfully had Mrs. Stowe's novels described the apple-bees, the celebrations, and the holidays of New England that

Sugaring Off in Maple Orchard. 1940.
Oil on canvas; inscribed to Sidney Janis.
18⅛″ x 24⅛″. Kallir 56. Private collection.

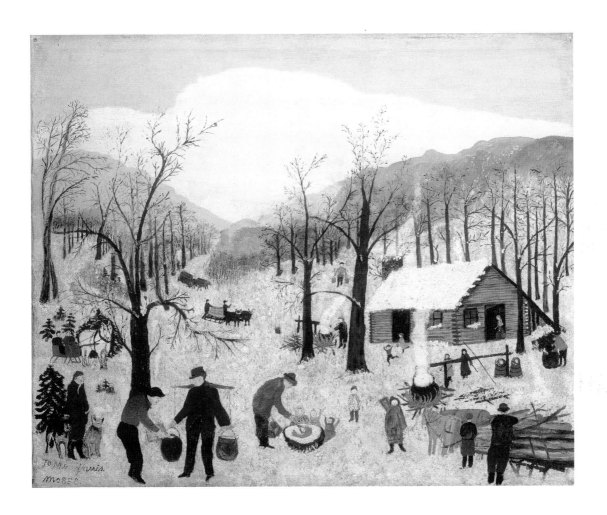

her works became guidebooks for the interpreters. Fiction became fact—or fun. And authenticity rapidly gave way in the face of mounting public interest in syruping as the most distinctive trademark of New England. "Old Sturbridge Maple Days," observed in March of the year, is only one of many New England how-to-do-it events which, by the late 1930s and the 1940s, had come to typify

what the region meant: a work ethic that could eke a living out of the thin, rocky soil, one ancient taphole at a time. Maple Days conjured up a picture of Robert Frost, the cranky white-haired poet laureate of New England, chopping wood on an April day as "Two Tramps in Mud Time" (1936) slog past from a lumber camp and leave him to his heaven-ordained work.[24]

During the 1930s and 40s, poor economic conditions throughout New England stimulated ad campaigns to bring tourists back to examine historic monuments but most of all, to enjoy the seasonal attractions of a place with four real seasons, each one of them famous for some distinct activity. Summer meant camping. Deep winter meant ski trains chugging northward out of Boston or Grand Central Station. Fall was marked by the glorious colors of leaves turning russet and scarlet and gold. And spring meant sugaring off, a traditional ritual always staged in the same, time-honored way. Squeezing through a covered bridge (another Grandma Moses subject), the tourist arrived in an earlier time to taste syrup hardening in the snow—and a sour pickle eaten afterward, just for luck.

"Regionalism" is a term used to describe the representational art of the Depression and its aftermath, in which the qualities unique to one place or another—the iron balconies of New Orleans, the cotton-pickers of the South, the wheatfields and harvesters of the heartland—were celebrated as important signs of the strength and survival of a nation premised on diversity. So regionalist New England was a pictorial amalgam of leaves and snow and maple-sugaring. Roy Stryker, head of the Farm Security Administration, was responsible for creating a photographic record of America from 1935 to 1943; under federal auspices he dispatched cameramen and -women with instructions to seek out singular aspects of the vast American Scene. In one such set of instructions, issued to a photogra-

Sugaring Off. 1943. Oil on pressed wood. 23" x 27". Kallir 276. Private collection. This was the first Grandma Moses painting reproduced in color (in 1948).

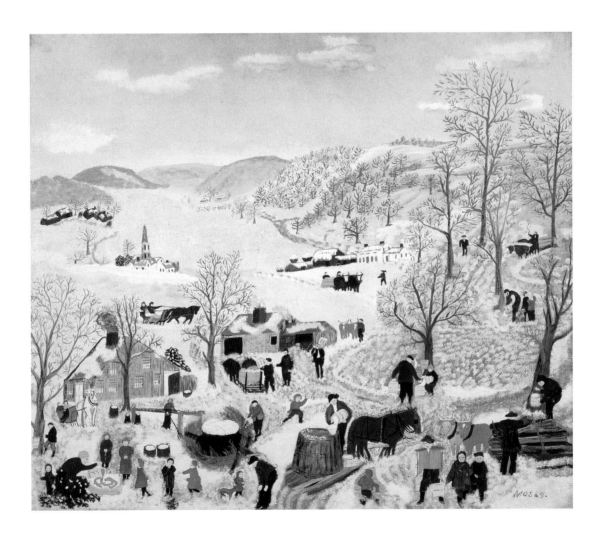

pher bound for New England, Stryker told him to look for "autumn, pumpkins, raking leaves, roadside stands," and to "pour maple syrup on it . . . mix well with clouds and put on a sky-blue platter." Make it corny, but homey, serene, full of good things to eat. "I know your . . . photographer's soul writhes," he continued, "but . . . do you

think I give a damn . . . with Hitler at our doorstep?"[25] Making maple syrup had become a patriotic duty!

The popularity of Mrs. Moses' maple sugar pictures cannot be overestimated. The first color reproduction of a Grandma Moses work officially authorized on her behalf was the 1943 *Sugaring Off* (published in 1948), in which the familiar motifs now find themselves spread over a vast expanse of snowy scenery. If her earlier versions were pinched by the forest and by her own concentration on getting the technology right, the 1943 picture puts syruping in the context of a wider world that includes a pretty little church in the middle distance and a snug village on the left horizon. The effect of the additions is to put it all "on a sky-blue platter," in Roy Stryker's terms. The workers—joyous, industrious, solemn—have a context now in a place that is bright, serene, and reverential: the kindly village life of beautiful New England.

Her sap paintings were among the first of Grandma Moses' works to attract substantive commentary. In a signed article in *Art Digest* in 1944, for example, Margaret Breuning singled out multiple versions of the sugaring-off theme for special attention. In these paintings, she states, the artist's "exuberance leads her to include too many details for a unified impression. [But] Grandma Moses never fails to impart vitality of any subject, however crowded the canvas may be."[26] Looking at the same clumps of incident silhouetted against the snow, art critic Alice Graeme was tempted to invoke Bruegel, "but Grandma Moses has never seen a Bruegel."[27] A "primitive" in tune with the so-called "Flemish Primitives"? Of course not!

In these reviews, as in others of the period, commentators are torn between their delight in the decorative patterns and high color of her scenes and a kind of guilty wish that Mrs. Moses would pay more attention to spatial recession and subtlety of tone. At the same

time, however, her supposed defects, especially evident in the "white" or winter pictures, made the maple syrup works easy to reproduce in the black-and-white pages of newspapers and ideal for the clumsy color processes used on the covers of their Sunday rotogravure sections.[28] The fact that they translated so readily into the crudest of media made Grandma Moses' sugaring pictures her signature works—trademarks, like the guarantees of purity and authenticity that adorned cans of Vermont-made maple syrup.[29]

Toward the end of the 1940s, with World War II winding down, the nation secure once more, and the sugaring pictures by Grandma Moses now known to a national audience, decorators riffed on the concept of historical authenticity in their plans for the all-American home. Whether couples were fixing up the family manse in the city or moving to a new ranch house in the suburbs, the experts from *American Home, Better Homes and Gardens,* and the *Ladies' Home Journal* were quick to recommend "Americana." Brass and bellows hanging on the chimneypiece. Dough troughs as coffee tables. Warming pans. Pewter. Dry sinks (to hold the telephone). Gate-legged tables. Home-hooked rugs patterned after "primitive" paintings.[30] And sap buckets: sap bucket lamp bases, sap bucket magazine baskets. As the mass-circulation magazines presented Early American bric-a-brac, the items needed to transform *your* house did not need to be pricey antiques. Indeed, works of modern provenance—reproductions of colonial furniture—were preferable because they were sturdy enough to withstand hard use by contemporary teenagers and scaled correctly for disguising a TV set or a telephone. The sap bucket, however, filled its decorative function nicely whether it was real or not.

The bucket—decorated fire bucket, old oaken bucket, sap bucket, what have you—had become a piece of folk art in its own right, ripe

for replication. The Index of American Design, a government project of the 1930s and early 40s, trained artists to make meticulous watercolor renderings of historic American-made objects to document the nation's craft tradition. Plates from the Index were circulated in books and illustrations beginning in 1950, and among those renderings was the distinctive wooden sap bucket, with a taper toward the top.[31] But more important than the Index's inclusion of specific objects like the sap bucket was the intense focus on the shape and design of the object of use—an artifact originally fabricated to play a role in the technological processes of making candles or collecting maple sap. Although collectors had put considerable value on such items in the past because of their associations and age, the postwar interest in the bucket was premised on different grounds. Suddenly, the bucket was beautiful—worthy of a place of honor in the living rooms of enterprising Americans, right underneath their authorized reproductions of Grandma Moses' *Sugaring Off.*

Sugaring Off was the first color reproduction approved by Mrs. Moses' representatives. But in 1947, Hallmark Cards of Kansas City entered into an agreement to publish Christmas cards bearing the usual holiday greetings and a full-color rendition of a painting by Grandma Moses. The cards came in two assortments, summer or winter scenes. The winter grouping consisted of three designs, twelve cards to a box, including a maple sugar picture of exceptional liveliness, frosted with snow caught in the upper branches of the maple trees. Hallmark planned a massive sales campaign: radio spots on the CBS network, window displays, full-page ads in the major magazines.[32] Although sales figures were a closely guarded company secret at first, Hallmark's Grandma Moses cards sold in the millions—especially the tiny *Sugaring Off.* On the inside fold, opposite good wishes for the year ahead, the copy said that the picture

was a reproduction of "an original oil painting by Grandma Moses who began painting in 1936 at the age of 76, and today is recognized as an outstanding primitive artist."[33] Thanks in no small measure to the animated throng of happy folk making sugar in the crisp springtime air of her most recognizable image to date, old Mrs. Moses became a name-brand celebrity, as famous as Vermont maple syrup. She was America's patented "white-haired girl," the "American girl who made good at 80."[34]

5. Mother Moses "Discovered"

All good Cinderella stories need a prince, and Anna Mary Moses' arrived in Hoosick Falls in 1939. His name was Louis Caldor. The circumstances of his coming are veiled in fairy-tale mystery. It was the day before Thanksgiving, says one authority—a gorgeous New England autumn day, with the smell of burning leaves in the air and "the postcard tinsel of hoar frost" on the fields.[1] Wrong! says another article on the fortuitous "discovery" of a major American talent. Caldor stopped in Eagle Bridge, not Hoosick Falls.[2] Or maybe it all happened during the week of Easter in 1938, when the hills were green and the wildflowers bursting into bloom.[3] As for Louis J. Caldor, who was he anyway? A civil engineer for the New York City Water Department who traveled upstate regularly on business? A sharp-eyed collector from East Orange, New Jersey?[4] A Manhattanite (70 East 56th Street) able to indulge his hobbies because he had recently made a bundle by inventing a new, streamlined percolator?[5]

Most everybody agreed that Caldor had stopped at the W. D. Thomas Drug Store in Hoosick Falls one fateful day. He was all alone and hungry, and ate an egg salad sandwich at the counter. He was with his wife and daughter. He had a headache, a stomachache. He needed a Bromo-Seltzer, an aspirin. However it happened, he stopped—and saw something wonderful in the window, alongside the jars of wild strawberry preserves, the fancy work, and the bits of embroidery from the local Women's Exchange. In among the ladies' displays of homemade treasures were four paintings. Pictures, preserves: leisure-time work for when the chores were done. Pret-

107

Hoosick Falls. 1944. Oil on pressed wood. 19″ x 25″. Kallir 413. Southern Vermont Arts Center, Manchester, Vermont. Formerly in the collection of actress Lilli Palmer.

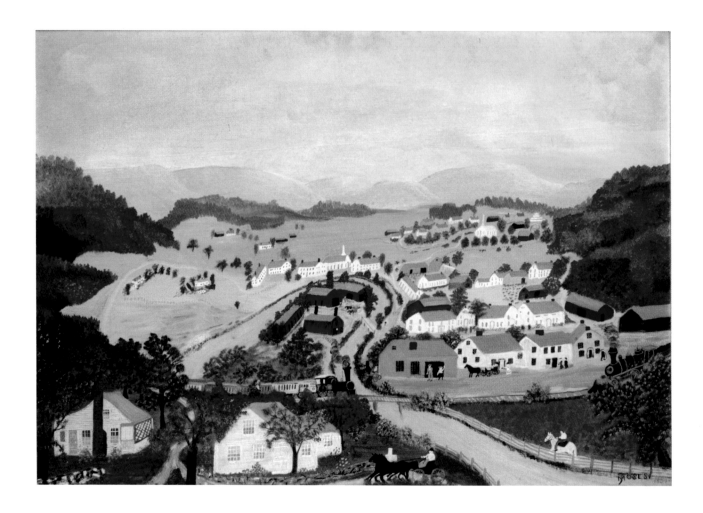

ties. Were there any more? The clerk said he still had the rest of the original consignment in the back room, where they'd been gathering dust for a year. "All in all, a dozen or so, and not a single sale in all that time." As Caldor later confessed in a letter to Mrs. Moses' dealer, "I liked them at once."[6] When the druggist offered him a bargain—10 percent off if he'd take the lot—Caldor agreed and drove off with old Mrs. Moses' address in his pocket.

The Thomas Drugstore, Hoosick Falls, New York, where Grandma Moses was "discovered." Photograph. Louis Miller Museum, Hoosick Falls, New York.

Caldor made his way to Eagle Bridge and the Moses farm; some say he followed the grubby finger of a little boy on the sidewalk who pointed the way: everybody, it seemed, knew the old lady who painted the pictures. But when he had raced along the Bennington Turnpike, made all the proper zigzags and climbed the hill, the artist wasn't at home. Her daughter-in-law, Mrs. Hugh Moses—Dorothy—answered the door. A stranger! Come to see Mother Moses! He wants more pictures! Come back in the morning! The relatives couldn't believe anyone would want Mrs. Moses' paintings, Caldor recalled. They were "'pop-eyed' with amazement."[7] "If you had been here, you could have sold all your paintings!" Dorothy sputtered when Anna Mary returned. "There was a man here looking for them, and he will be back in the morning to see them. I told him how many you had."[8] Do we have ten of 'em?

By her own admission, the elder Mrs. Moses spent a sleepless night, wondering how many pictures she did have and whether the stranger would want them. "I knew I didn't have many, they were mostly worsted, but I thought, towards morning, of a painting I had started on after house cleaning days, when I found an old canvas and frame, and I thought I had painted a picture on it of Virginia." It was a big one. Come morning, she hunted up another frame and cut the big picture in half, to make up a decent batch. Dorothy had told the visitor that there were probably ten pictures stashed around the house—and ten pictures there would be! "But he didn't discover the one I had cut in two for about a year," her mother-in-law chortled.[9]

Anna Mary Moses, Caldor learned, was called "Mother" Moses in the Cambridge Valley, where she was known as a peppy, peppery old soul, devoted to her numerous family. Her preserves were excellent, and she made pictures of one sort or another in her spare time, mainly as gifts for relatives and friends—even for the faithful post-

man. The main outlet for the creative impulses of country women with a little extra time on their hands and a love for pretty things has traditionally been the agricultural fair. By the 1870s and 80s, most fairs worthy of the name—even small ones—had a Women's Building on the grounds, in addition to an oval racetrack and a big Main Building where newfangled products were on display. The Women's Building was the realm of the domestic arts: quilting, embroidery, fine home tailoring, canning, and preserves, the latter displayed in bottles that made the colored jellies look like the stained glass windows of European cathedrals. No mere fripperies, the handiwork of skillful women was what made a bare farmhouse into a cozy home. Their work defined the aesthetic of rural America and was duly honored for bringing comfort and grace to toilsome lives of hardship.

Mrs. Moses knew all about fairs. One of the outstanding events of her young life had been a trip to the 36th annual fair held outside Albany in 1876 by the New York State Agricultural Society. Mounted in the year of the national centennial, this was an unusually elaborate show. Anna Mary, then a hired girl, got a ticket from a guest in her employer's home who happened to be the Ag Society's President. The hand-signed ticket was a singular honor in her eyes, and the trip from South Cambridge an epic undertaking: her first train ride (she got carsick), a change of lines, a ferry voyage, the bustling little city of West Troy. The fair proper had something for everyone. A Horticultural Building full of flowers. A Poultry Building full of exotic chickens. A Manufactures Building with rows of modern, cast-iron stoves from which demonstrators served up hot rolls and pies and gingerbread. The Racing Oval where ladies in long dresses jumped the hurdles while riding sidesaddle. Anna Mary stayed for three days, soaking it all in.[10] It was a glorious adventure.

Local fairs—country fairs, town fairs—were less glamorous but

Country Fair. 1950. Oil on canvas.
35″ x 45″. Kallir 921. Private collection.

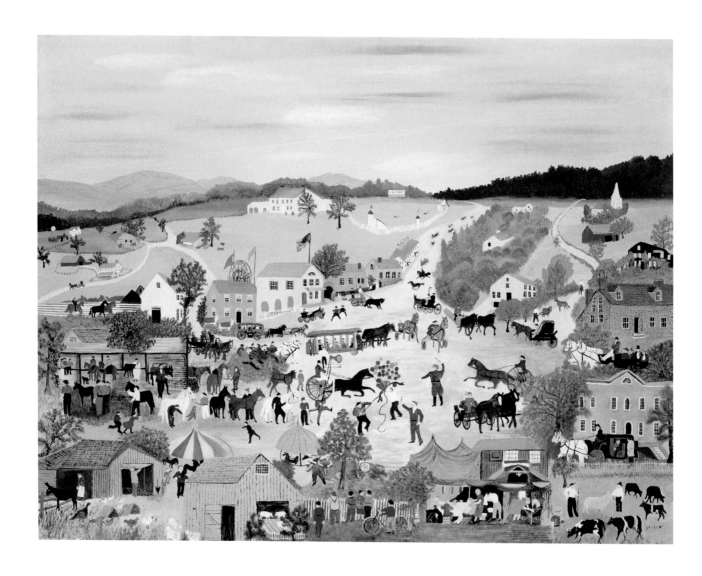

no less welcome as occasions for sociability and fun. Twenty years after her first excursion to the Albany Fair, in the late summer of 1896, Mrs. Moses, her husband, and four children went to a fair at Gipsyhill Park, near Staunton, Virginia, where she saw her first au-

tomobile. There, as a first-time competitor, she also won blue ribbons for her canned fruit, cherries, and tomatoes.[11] Back in New York State, on the farm in Eagle Bridge, the regional fair became part of the predictable round of annual events. Washing, mending, baking, sewing. Spring cleaning; fresh paper for the walls. The circus. Summer picnics. And "later there would be fairs for older people. And farmers and their wives were supposed to furnish produce for the fair. And thus it was from year to year."[12]

When Mr. Caldor came calling at the Thomas Drug Store in 1938 (it *was* Easter of 1938), many of the $2.00 and $3.00 items on display in the window had come straight from the fair. Mother Moses, for example, had shown canned fruits and raspberry jam at the annual Cambridge Fair, and won prizes for both. She also exhibited a few "pictures," but these, she was the first to admit, had not taken any ribbons. So off they went to the Women's Exchange, along with the extra jars of jam. But what, exactly, was a "picture," according to local reckoning? In the Fine Arts displays of many fairs—including the huge annual gatherings in the Midwest—the term covered a multitude of sins. Photographs, tinted or otherwise. China painting. "Theorem" pictures made from stencils. Samplers. And "worsteds," like Mother Moses' little needlework scenes of landscapes and cozy cottages. They were all of a piece, something done, she wrote, "for pleasure, to keep busy and to pass the time away . . . I thought no more of it than of doing fancy work."[13]

Indeed, her whole family dabbled in picture-making from time to time. Pa painted scenes on the walls. Anna Mary's sister Sarah had a natural gift for drawing likenesses in pencil. Her sister Celestia painted—actually took lessons when she was a teenager—but never did much. (She did tell Anna Mary, when the arthritis got so bad that it was hard to sew the yarn pictures she had been making, that using paint might be better and faster.) But yarn pictures or "worsteds," as

she called them after the smooth woolen yarn used in the background stitching, were pictures, too—paintings, the kind of thing that Mother Moses put in the window of the Thomas Drug Store and sent to the Cambridge Fair. Pictures. Paintings. They were just so many colored images made by hand.

The history of Anna Mary Moses' woolen scenes—of twentieth-century embroidery in general—has been poorly studied. But the greater number of her firmly dated "worsteds" seem to come from the early 1930s. During this period embroidery projects reached new heights of popularity across the nation, as the Depression both enforced women's absence from the workplace and encouraged home industry for reasons of personal satisfaction and thrifty gift-giving. Patterns, printed linens, and instructions proliferated. Magazines like *The Woman's Home Companion* featured complicated projects, but so did daily newspapers, which sold craft packages by mail for little more than the cost of postage.

Women who embroidered came from all points on the economic spectrum, from the frugal housewife who bought pre-stamped dish towels to finish from her local five-and-dime to the wealthy folk art collector Mrs. John D. Rockefeller, Jr., who worked a pictorial rug for her home in Williamsburg, Virginia. A highly publicized "Needlework of Today" exhibition in New York City in 1934 awarded its grand prize to Mrs. Theodore Roosevelt, Jr., another socialite, for a table screen in needlepoint and wool embroidery modeled after "old prints," supplemented by a firsthand study of birds the lady observed on a vacation in Vermont. "It has become fashionable to ornament one's home with a touch of handiwork," wrote one enthusiast during the high tide of the embroidery craze. "Is the expression up-to-date and self-reliant, or is the worker thinking back to the darker ages of design?"[14]

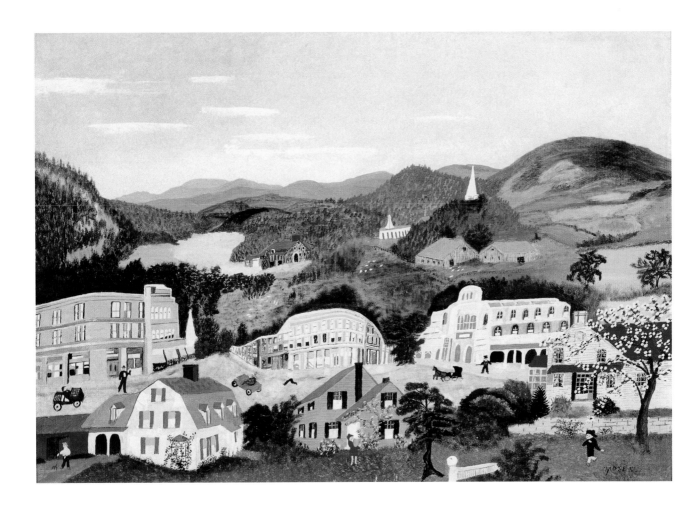

Bennington. 1945. Oil on pressed wood. 17" x 25". Kallir 567. The Bennington Museum, Bennington, Vermont.

Like every other young girl of her age and station, Sissy Moses had learned to embroider as a child in those "dark ages." As a young mother, Anna Mary had stitched stars and other designs onto her children's nightdresses, to tell one from the other. But the torrent of worsted pictures seems to have begun with a challenge. Her daughter Anna married her cousin Frank Moses in 1924 and moved into

a house on Elm Street in nearby Bennington, Vermont. It was she, according to family legend, who challenged her mother to duplicate an embroidered picture. Soon Mother Moses' worsted pictures were everywhere. The subjects—a succession of English country cottages wreathed in flowers, Scottish crofters' gardens, wagons fording streams in scenes loosely based on the landscapes of John Constable—seem to have come from magazine patterns.

The stitching is tight, neat, but never too complicated. Whereas the rankest amateur can use the satin stitch, the seed stitch, and the Romanian stitch in tandem to add depth and texture to flat areas of color, Mrs. Moses almost always relied on a simple outline or long-and-short stitch to fill in large sections of her design; the stitch was varied only by being executed vertically or horizontally. For surface enrichment, she depended on French knots deployed in great profusion for flowers or leaves. The end result is dramatic, forceful, but naive and almost impatient. If Mother Moses followed patterns, guides, or instructions, she seized upon the imagery and ignored the diagrams of recommended techniques—much as she would later do in "borrowing" compositions and details for her paintings. She may have been ahead of a trend: some of the published experts of the 1930s were pleased to note that a virtuoso demonstration of stitches no longer counted for as much among connoisseurs as the pictorial force of the finished piece.[15]

The subject matter of some of Mrs. Moses' worsteds is entirely too local to have come from published patterns. *Hoosick Bridge, 1818* (1940 or earlier) is a case in point. And here too the technique betrays a disinclination to fuss over stitches when the maker's real objective was the image of a New England icon. A more meticulous seamstress might have tacked down the long crisscross mesh of stitches that make up the latticework on the sides of the bridge.

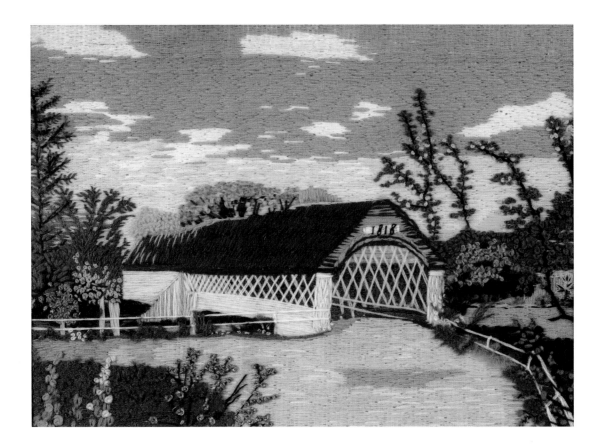

Hoosick Bridge, 1818. 1940 or earlier.
Worsted picture. 10″ x 14″. Kallir 22W.
Private collection.

But not Mother Moses, for whom the pictorial nature of the performance counted for more than its craftsmanship. Caldor's collection of Mrs. Moses' little worsteds, which were later catalogued by
Otto Kallir, was extensive. While the earliest of the lot include the
standard castles and oceans of the pattern books, local iconography
came to predominate over time.

It is fair to assume that a significant number of the "paintings"
Caldor found at the Thomas Drug Store were worsteds or yarn pic-

The Old Covered Bridge. c. 1941. Oil on pressed wood. $8\frac{5}{8}'' \times 10\frac{5}{8}''$. Kallir 77. The Wadsworth Atheneum Museum of Art, Hartford, Connecticut.

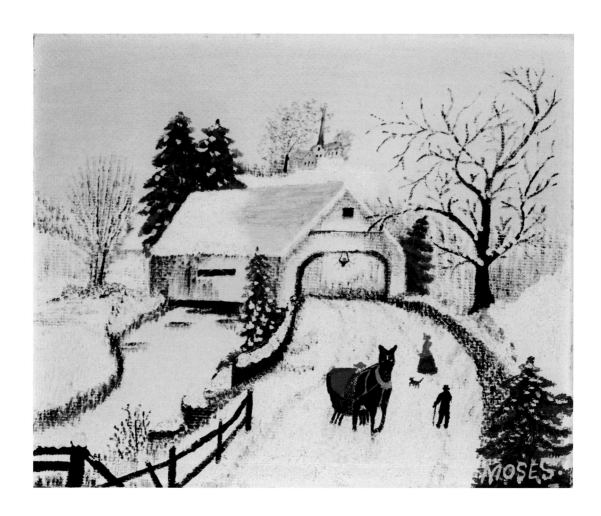

tures and that, like Mrs. Moses herself, the visitor drew no great distinction between one kind of picture and another. Collectors and curators of American folk art have taken a similarly catholic approach to objects with a strong pictorial component. No lesser authorities than Jean Lipman and Alice Winchester, in the catalog of their definitive exhibition for the Whitney Museum of American Art (1974),

devote almost half of their text to "Pictures: Painted, Drawn, and Stitched," without differentiating between media.[16] And when her sister Celestia suggested that painting might be easier on her aching fingers than plying the needle, Anna Mary Moses seems to have assumed much the same attitude: a picture is a picture. So's a painting. It's all pretty much the same thing.

The worsted pictures may also have offered a practical solution to physical problems of another kind. As early as 1927, Mrs. Moses found herself spending long periods of time away from Eagle Bridge (and thus away from ready access to wallpaper and house paint) while tending to her ailing daughter in Bennington. By 1929, the younger Anna's tubercular condition had worsened to the point that her mother moved into the Elm Street residence on a full-time basis to keep house for her son-in-law and her two little granddaughters. Only after Anna's death in 1933 and the subsequent remarriage of Frank Moses in the spring of 1935 was Mrs. Moses free to go back home—and start the artistic career that would set her on the road to celebrity at the age of 78. But between 1927 and 1935, embroidery gave vent to her growing desire to tell stories in pictures. Sewing was genteel, the sort of thing expected of old ladies. It was tidy, easy to pick up and put down as the day's tasks intervened. And worsteds made good gifts.

The story of her life in Bennington, Vermont, has been recounted by the stepmother of those two little orphaned granddaughters. Once Mother Moses had thoroughly inspected the bride-to-be, she settled on a worsted for a wedding present. "Grandma is embroidering a little oval picture in wool yarns," young Beth wrote to her own family. "It's really cute, a Scotch scene. There's a house, trees, tiny flowers, done with silk floss against the wool. . . . When I said how much I liked the picture, she said, 'Good. I'll give it to you for a weddin'

present.'"[17] Mary Hard Bort, who lived across the street while Beth's courtship was in progress, also remembered the wedding gift Mrs. Moses stitched. Later on "the yarn painting hung on a narrow wall near the dining room doorway. I was impressed that she had 'made up a picture,' for no one in my family did that," Mary said.[18] Pictures were a hobby for a restless spirit, a woman who never could sit still, arthritis or not. "If I didn't start painting," wrote Grandma Moses at the age of 84, "I would have raised chickens. I could still do it now. I would never sit back in a rocking chair."[19]

So Mother Moses' art was "discovered" in 1938 in a drugstore window at 9 John Street, Hoosick Falls, in a litter of jam jars, tatted collars, and embroideries (including her own worsteds). What happened then? In truth, not much. Louis Caldor raced back to the city, fired with enthusiasm. Because the big New York galleries rarely exhibited "worsteds," he sent Mrs. Moses a supply of canvas boards, a "regulation artist's sketching box," and some store-bought artist's paint. He continued to buy her pictures. And he pledged that "sooner or later I will be able to publicly justify my opinion of you . . . and bring you some measure of respect and recognition for your efforts."[20] But that was no easy task. Everywhere he went, Caldor found dealers disinterested in an artist already too old for a long (and profitable) turn in the spotlight. To the eyes of city sophisticates schooled in European modernism or the Old Masters, the homespun efforts of an unknown housewife represented by a booster with a suitcase full of yarn pictures were readily dismissed. Then suddenly, after a year of futile effort, Louis J. Caldor met Sidney Janis.

A man of wide-ranging tastes and enthusiasms, Janis had made his mark in the city with a menswear company—"M'Lord"—best known for a fashionable short-sleeved, two-pocket shirt of his own design. On the proceeds from the business, Janis traveled widely

and began to amass an impressive and diverse collection of modern art, including works by Dali, Picasso, and the self-taught French "primitive," Henri Rousseau. In 1934, on the strength of his reputation for being an adventurous collector, he was invited to join the Advisory Committee of the fledgling Museum of Modern Art, alongside such distinguished young Turks as Nelson Rockefeller and Lincoln Kirstein. And in 1939, under that body's auspices, Janis organized an exhibition (the first Advisory Committee show) called "Contemporary Unknown American Painters." Hung in the relative obscurity of the Members' Room, the show aimed, said Janis, "to stimulate interest in unknowns, among whom might be artists of distinction whose merits were still to be properly evaluated."[21] When Caldor heard that there was a chance to add *his* "unknown" to the list, he lost no time in introducing himself to Sidney Janis.

The Janis show affirmed MoMA's institutional fascination with the parallels between "folk art" and the High Modernism of the twentieth century. In 1932 Holger Cahill, then acting director of the museum, had organized "American Folk Art, the Art of the Common Man."[22] A large and influential show accompanied by a massive catalog, it would eventually travel to six other cities, spreading Cahill's own faith in an art which—by whatever name it might be called—represented the interests of persons working outside the established enclaves of the fine arts in America. As Cahill stated in his prefatory essay, "The work of these men [*sic*] is *folk art* because it is the expression of the common people, made by them and intended for their use and enjoyment. It is not the expression of professional artists made for a small cultured class, and it has little to do with the fashionable art of the period. It does not come out of an academic tradition passed on by schools, but out of a craft tradition plus the personal quality of the rare craftsman who is an artist."[23]

In some ways, the collection of samplers, limner paintings, and weathervanes amassed by Cahill (with the help of Abby Aldrich Rockefeller—the Williamsburg embroiderer—and her dealer, Edith Halpert) reflected a growing nativist trend in American thought; as the Depression widened, as social disaster seemed more imminent, all things American became precious. Cahill later went on to direct the WPA's Federal Art Project, a massive effort on the part of Franklin Roosevelt's administration to salvage the skills of artists in need while providing art for public places where the "common people" might enjoy it. Nor was American revivalism limited to the antique-rich East. The Regionalist painters of the heartland also took up the cry for local subject matter, for the depiction of significant moments in their past and present. In several of his best-known works, for example, Grant Wood included an emblematic cameo that was also a cherished Iowa family possession—a Midwestern pseudo-antique. Tom Benton, meanwhile, probed the history of his native soil in order to show Missourians the exploits of earnest pioneers and murderous bank robbers alike.

For the critical public, the Cahill show also symbolized a kind of cultural purity embodied in the artifacts of an America without factories, sleekly impersonal cities, and art-for-profit. A columnist for the *New York Sun* said that it was impossible to see the humble objects on display "without a nostalgic yearning for the beautiful simple life that is no more," a kind of golden age of community, sap buckets, homemade comforts, and peace. Shouldn't America's museums "take our own primitives as seriously as they already take those of Europe?"[24] And that, of course, was what Sidney Janis proposed to do at MoMA in the fall of 1939. "Unknown American Painters" opened on October 18th for a month-long run. Although Janis's introduction to the little catalog does not mention "primi-

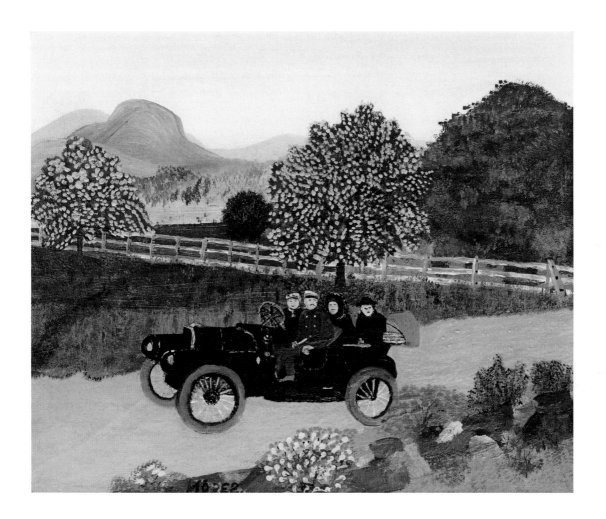

First Auto. 1939 or earlier. Oil on pressed wood. 9″ x 11″. Kallir 6. Private collection. Exhibited at the Museum of Modern Art, 1939.

tives," the eighteen artists chosen to display their work were distinguished by a uniform lack of impressive professional credentials. They were tradesmen, mechanics, housepainters, laborers, housewives, and a cloak-and-suit maker. The latter was Morris Hirshfield, a manufacturer of slippers with a propensity for sexually provoca-

tive nudes which would have given Mrs. Moses of Eagle Bridge pause, had she attended the show.

She did not, even though three of her pictures were on display. Nor did Janis spend much time discussing provocative subject matter in his catalog. Instead, he seemed intent on demonstrating the aesthetic worthiness of the chosen few. One painter from Connecticut (a "housewife") is praised for a picture "as counterpoised as a knowing Cubist painting." Hirshfield "employs a startling and inventive technique." And as for Anna Maria [*sic*] Robertson MOSES, also a "housewife" and a contributor of three oils, she "has, especially, color luminosity."[25] If Mrs. Moses had come to the Museum of Modern Art that October, she would surely have been puzzled by the reference to her luminous colors, which came straight from the little Sears, Roebuck tubes that Caldor supplied. She might have been even more surprised that nobody had taken notice of the scenes depicted in the oils themselves: *Home, First Auto,* and *Maple Sugar Days,* the latter one of her very favorite themes.[26]

Because of its size and location, the show was easily overlooked. Elizabeth McCausland was one of the few established critics to discuss the exhibition, in a review published a month after the paintings came down. McCausland questioned Janis's effort to imply that the untrained artist was "of a higher order of creative significance than the professional" just because of his or her naiveté. "The deeper danger in such formal encouragement of the primitive is that a cult is being built up comparable to Jean-Jacques Rousseau's doctrine of the splendid savage," she complained. "Let a man or woman be a simple village wight, and that *per se* makes him a good painter."[27] Innocence and simplicity alone do not make for excellence in art.

From time to time in later years, Sidney Janis would be given the credit for making a star out of Anna Mary Moses primarily because she was innocent and untaught. "She was 'discovered' by Sidney

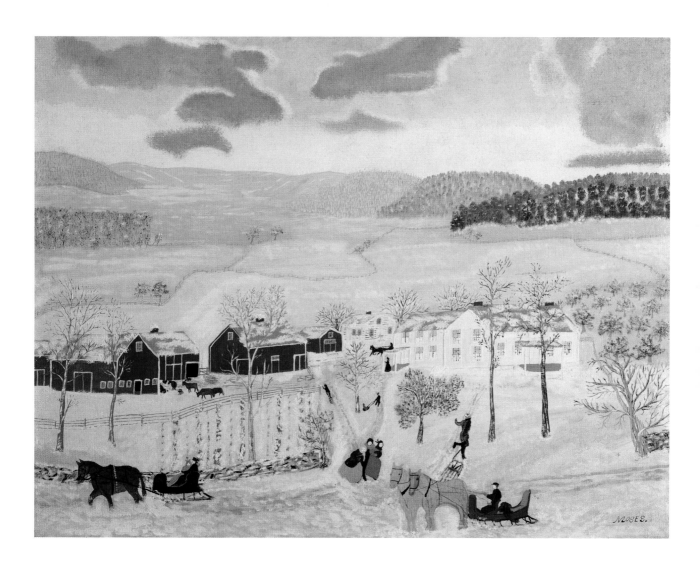

Mt. Nebo in Winter. 1943. Oil on pressed wood. 20″ x 36″. Kallir 275. Private collection.

Janis, who collects primitive painters as others collect paintings," declared an admirer in the mid-1940s.[28] But if Janis (who preferred the term "self-taught" to describe the artists he loved) did not "discover" Mrs. Moses, neither did he regard her as some kind of noble savage

from upstate New York. In fact, it was Janis who insisted on the honorific "Mother Moses" when he wrote about her, out of a deep respect for the lady he visited at her home in Eagle Bridge where she was ensconced amid several generations of Moses babies. On one such trip, a "tea-time" feast was laid out: "fresh muffins, wild strawberry preserves, and for good measure coconut layer cake, all made by her own hands. Still there is time for her to work in oils, and when the light is bad, she turns to her needlework—'worsted pictures.'"[29] Janis quotes with genuine affection her 1939 letter, thanking him for taking "the trouble" to exhibit her pictures. "Too bad you had none better," she wrote by way of apology. "I call these poor. I have some I think good, that is my way of thinking. But you have done fine, and I wish you the best of success. A friend as ever, Mother Moses."[30]

In gratitude for his efforts, Mother Moses inscribed a new sugaring scene (in oils) to Sidney Janis. Louis Caldor, meanwhile, picked up the three paintings at MoMA and started all over again, trying to find a way to keep her work in the spotlight. At that time, he began to hear word of a fellow immigrant from the old Austro-Hungarian Empire, Otto Kallir. Newly arrived in New York, Kallir had espoused the cause of artists persecuted as "degenerates" by the Nazis at his Galerie St. Etienne in Manhattan. He had also shown a prior interest in folk art and the "primitives." If the critics were to be believed, old Mrs. Moses was a primitive. So Caldor set up a meeting with Otto Kallir and showed him a few small works, some of them embroidered.

Years later, Kallir remembered one picture in particular. "It was a sugaring-off scene," Kallir said, as he described the oxen, the workers, the buckets, the load of wood on the sleigh, the children clamoring for fresh-made candy. "But what struck me . . . was the way the

artist handled the landscape. . . . Though she had never heard of any rules of perspective, Mrs. Moses had achieved an impression of depth [with color] . . . creating a compelling truth and closeness to nature."[31] Some of the other images in Caldor's possession—especially the worsteds—seemed to be copies of illustrations. But the sugaring picture was different. Were there more like this one, Kallir asked?

The second meeting with Caldor was even more memorable. Kallir's son John described it as a cloak-and-dagger rendezvous between the two men, which he attended as a reluctant witness. Rather than bringing the paintings to Kallir's gallery on West 57th Street, Caldor insisted that the principals assemble in the Bronx at the 138th Street subway exit, walk up a flight of stairs, and use a flashlight to peer into the trunk of his parked car, where the collected works of Mrs. Moses resided. For Caldor, the bizarre method of display was simply a convenience; this was where he parked during his day job! But for Otto Kallir and his son, the whole arrangement was a cause for deep suspicion. Was Caldor a Nazi agent, hot on the trail of exiles spreading anti-German propaganda? "It was weird, in the late afternoon, to take the subway to look at some paintings," said John Kallir, who at the time was a nervous high school student.[32] His father recalled that it was dark by the time they arrived in the Bronx. He also remembered looking at picture after picture propped up in the back seat of the car—oils and worsteds all mixed together—for neither the artist nor Caldor, it seemed, was prepared to judge one kind of image superior to another.

If Otto Kallir had other criteria for evaluating art—he was less than enthusiastic about obvious copies of popular source material, for example—he was nonetheless prepared to exhibit Mrs. Moses, on one condition: "That the choice of works was left to me." The

show at his gallery opened with an evening reception on October 9, 1940, almost a year to the day after Anna Mary Moses' debut at the Museum of Modern Art. The name of the exhibition? "What a Farm Wife Painted." There were thirty-four small-scale paintings—paintings, not pictures, four of them specifically identified as scenes from the artist's own farm. A day before the opening, the *New York Herald-Tribune* previewed the doings at Galerie St. Etienne. Who was this mystery painter of Kallir's? "Mrs. Anna Mary Robertson Moses, known to the countryside around Greenwich, New York, as Grandma Moses, began painting three years ago, when she was approaching 80."[33] From that day forward, she wasn't Sissy anymore. Or Anna Mary. Or even Mother Moses. She was Grandma Moses! A reporter for the *Journal American* tracked her to Eagle Bridge. When was "Grandma" coming to New York to meet her public? "As this is Monday morning on the farm," she had informed Kallir, "you will excuse me and my haste."[34] She wasn't coming to the city. It was Monday. Wash day. It was October. Putting-up season. And there was work to be done.

6. From Farm Wife to Media Darling

"What a Farm Wife Painted" opened in the autumn of 1940 with a one-page, typewritten "catalog"—a checklist of thirty-four oils (owned by Louis Caldor). Otto Kallir, who had not yet met the lady of the hour in person, had reason to be pleased with the show, despite its improvisational air. There were enough press notices to make a modest smash, and the opinion-makers were kind, on the whole. The critic for the *New York Times,* no fan of the "primitive" art so much in evidence in his bailiwick in recent years, praised Mrs. Moses' works for their "simple decorative effect" and seemed relieved that her pictures were small and modest in scale. He liked a maple sugar picture, a floral still life, cows in a meadow. "This is a very creditable show of its kind," he concluded.[1]

Art Digest was seduced by the story of Grandma Moses. And she was "Grandma" now (mostly without the quotation marks), plucked from her kitchen as if by the hand of fate when Louis Caldor happened to pass her way. As for her yen to paint, it all began one day when she thought it would be easier to make a picture than to slave over a hot stove to bake a cake for the mailman. So homey! So picturesque! An "untaught primitive" whose clear colors came straight from the palette of a needleworker's floss. An old woman steeped in "the simplicity of the rural country." "Land's Sakes!" to quote a phrase often attributed to rural females of a certain age.[2]

This first spattering of notices did not include reproductions of Grandma Moses' work. But what was a reader to think when the subjects mentioned were cows and sap buckets? What was a critic to

The farmhouse of Anna Mary and Thomas
(d. 1927) Moses in Eagle Bridge, New York.
April 1957. Photograph by Otto Kallir.

think when confronted by Kallir's checklist: *Turkey in the Straw, Bringing in the Sugar, Apple Pickers, The Village by the Brookside, Backyard at Home?* Or those five pictures specially marked by asterisks— "Scenes from Mrs. Moses' own farm"? In fact, the implications of Grandma Moses' iconography could not have been plainer in the fall of 1940. The New York World's Fair, in all its hyperbolic futurism, had finally closed after a second disappointing season, its promises of utopia undercut by the mounting horrors of war in Europe. France had fallen to the Germans. In August of 1940, eight hun-

dred Nazi planes bombed London by night; the Battle of Britain was brought home to Americans in the measured baritone of Edward R. Murrow, broadcasting from the thick of the action over the CBS radio network. As the Galerie St. Etienne show was closing, the Jews of Warsaw were being herded into the ghetto. The Holocaust had begun.

In a world gone mad, the simplicities of home—whether real or imagined—were as powerful as German bombs. In a world of murderous machinery, of marching millions, the very notion of one sweet old lady baking a cake for her faithful postman fell like a drop of cool water on a fevered brow. Little Dorothy Gale headed down the Yellow Brick Road in search of Kansas in 1939, when Mother Moses' first pictures hung in the Museum of Modern Art. In *The Wizard of Oz*, Dorothy was trying to find her dear old Auntie Em—a Grandma Moses look-alike—and the safety of a rickety farmhouse on the prairie, with its supporting cast of pigs and chickens. Although Hollywood's version of home was located a bit farther west than Eagle Bridge, the sentiments conveyed by the movie and the paintings were very much the same. Both answered a yearning in the souls of their respective fans—a wish for peace and order, simplicity, community, and grace.

When the United States finally entered World War II late in 1941, the Office of War Information set as the theme for official propaganda the slogan "Why we fight!" While a goodly share of American war posters featured bloodthirsty caricatures of the enemy, more of them depicted the American home and family—and peaceful country landscapes of the sort that might have come from a book of sentimental scenes by Wallace Nutting. The most popular song of the era was the Bing Crosby version of Irving Berlin's "White Christmas," with its evocations of home, pine trees in the snow, Christ-

From Farm Wife to Media Darling

White Christmas. 1954. Oil on pressed wood.
23″ x 19″. Kallir 1162. Private collection;
formerly owned by Irving Berlin.

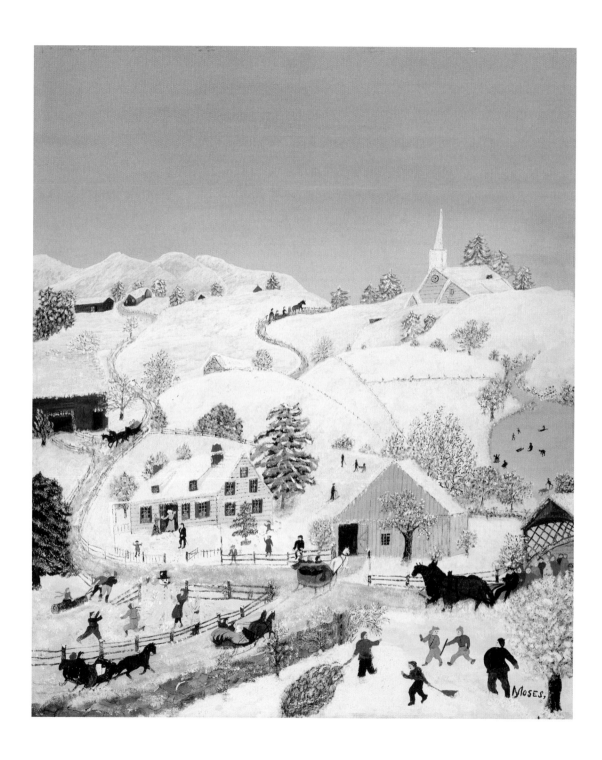

mas cards, purity, and the warmth of the family circle—everything the GI on some distant battlefield longed for. Grandma Moses' red sleighs dashing through snow-covered fields set the scene for the dearest dreams of the troubled American heart in the early 1940s.

There is no doubt that the magnetism of her subject matter helped to account for Grandma Moses' enormous popularity in the years immediately following "What a Farm Wife Painted." Even the title of the exhibition played on what would shortly be the real strengths of her appeal: the farm, a vanishing American past, and a woman—a wife, a mother, a grandmother, a female who accepted her proper place in the scheme of things. The show cast Grandma in a specific mold of conformity to expectations: she was an American myth come true. But in the simplicity of which the critics spoke there is also a clue to why the so-called "primitives" found a place in the New York art world of the 1930s and 40s.

Modern art eschewed the fuss and feathers of academic art—the rules of perspective, the conventions of light and shadow—in favor of a deliberate, direct manner of execution. In that sense, a Picasso is more like a Grandma Moses than not; the flattening of complex geometric solids makes her farm buildings resemble his Cubist constructions. The economy of means that characterized much of modernism during the 1930s helped to earn Grandma Moses and her peers the attention of the Museum of Modern Art. So did the belief that Grandma's art was a direct, unmediated utterance, the painterly equivalent of an exasperated "Land's sakes!" But it was the content of those simple, even minimal designs that eventually won her the affection of millions.

Otto Kallir recalled that even before his exhibition closed, Gimbels Department Store had requested the Moses paintings for their annual Thanksgiving Festival. There were advantages to the arrange-

From Farm Wife to Media Darling

ment. The auditorium at Gimbels was far larger than Kallir's gallery, so more of her work, including many of the worsted pictures, could be shown. Splashy newspaper ads for the event dwelt on the domestic side of Grandma's career, in an effort to attract the middle-class female audience from Queens and Westchester expected to flock to Manhattan for an afternoon which also included a table-setting contest.[3] In that cozily domestic context, her "wool paintings"—the works that Caldor had collected in quantity—were a big part of the draw. But the most compelling reason to make the trek to 33rd and Broadway was the prospect of meeting the celebrity of the hour, Grandma Moses, "the biggest artistic rave since Currier & Ives hit the country," "the American girl who made good at 80."[4]

Somehow, after declining to appear at Kallir's show, Grandma Moses had been persuaded to come to Gimbels. Perhaps it was the setting—a store, an environment which, though constructed on a grander scale than the emporiums of Troy and Albany, was still familiar territory. Besides, Gimbels was famous! "Does Macy's tell Gimbels?" was the shopper's catch phrase of the day. The Herald Square establishments of both firms represented the "Adamless Eden" of every woman's desires, as one nineteenth-century store owner described the dream palaces of American retailing.[5] And palaces they were, with their costly decor—marble and gilt everywhere—and their free-of-charge amenities like rest rooms, child care, and elegant picture galleries.

Marshall Field's of Chicago had an in-house art gallery as early as 1902. John Wanamaker's Philadelphia store showed works from the owner's collection. World-famous musicians played under Tiffany glass domes. During the Christmas and Easter holidays, store interiors were transformed into cathedrals, with no sense of incongruity.[6] Nor was it just big cities in which "art" played a major role in sales;

Grandma Moses Going to Big City. 1946.
Oil on canvas. 36" x 48". Kallir 577.
Private collection.

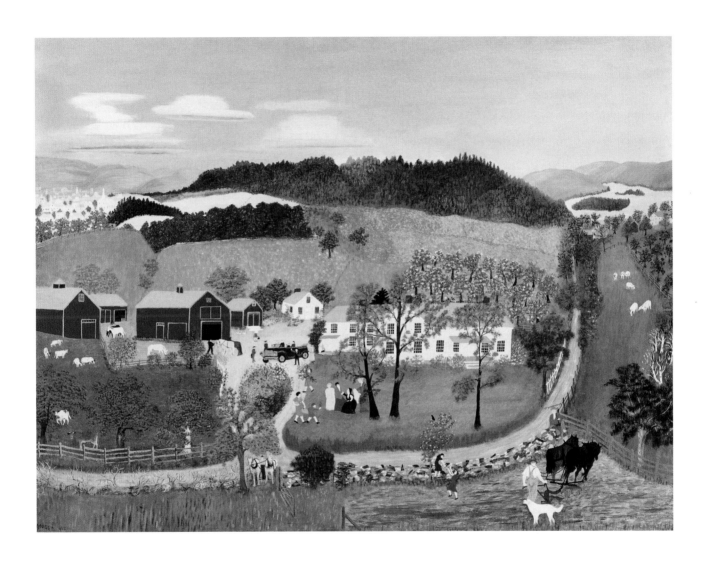

most department stores displayed and sold original works of art as a part of their mission to serve as civic institutions. The galleries at Famous-Barr (St. Louis), Higbee's (Cleveland), Dayton's (Minneapolis), and Gimbels' Philadelphia outpost remained important venues for

art in the 1940s and 50s. Like comparable businesses in the middling towns of upstate New York, the Sibley, Lindsay & Curr department store in Rochester used its auditorium for exhibitions of both local and national import until the company changed hands in the late 1950s.

Art was good business. And Gimbels had sold culture for a long time. After the controversial 1913 Armory Show, for example, Gimbels became a staunch supporter of advanced modern art, showing the work of Picasso, Cézanne, and other so-called radicals at their in-store galleries from New York to Cincinnati. The savvy retailer was always one step ahead of the latest fad and the newest trend in fashion—and in this case, in art. With Grandma Moses, Gimbels had hitched its 1940 Thanksgiving business to an ascendant star who had an added advantage. She was an artist, of course. But even more important, she was an artist who painted in wool, like the ladies who shopped at Gimbels. "She's more than a great American artist," proclaimed the ads for her personal appearance in the annual Gimbels Thanksgiving Forum. "She's a great American housewife. The sort of American housewife who has kept the tradition of Thanksgiving alive. Fussing with cranberry sauce may seem a bit useless in these turbulent times. It's not. A woman . . . *can* fight to make the world a pleasanter place by perfecting her cranberries. As long as American housewives busy themselves with cranberries and chrysanthemums there'll always be a Thanksgiving!"[7]

With a stroke of the copywriter's pen, Grandma Moses became a "great" American artist. But she also became a symbol of the Thanksgiving holiday, housewives everywhere, American women, and women whose contribution to the gathering war would be their service on the home front. The cloying homeyness of the Gimbels event was probably inevitable once *Time* magazine's picture-article

on Grandma appeared in late October of 1940, full of folksy language and un-artistlike details of the old lady's innocence about the wicked ways of the gallery world. In the collegiate-ironic prose that made *Time* famous, the editors used her domestic situation to tweak the pretensions of the Madison Avenue set. At the same time, however, it was clear that the anonymous writers thought Grandma was pretty funny, too, with her "speckled snowstorms [and] shutter-green mountains."[8]

Time's illustrations added to the impression that the Grandma phenomenon was something of a joke. "The Widow Moses," as her photograph was titled, sits bolt upright in a straight chair like one of Grant Wood's Victorian ancients, clothed in a spotted garment of indefinite age and provenance. Alongside Mrs. Moses' photo is *The 'Gardin Angle'* (1940), a painting copied from a syrupy devotional image showing a winged angel shepherding two lost children through a perilous landscape. The quaint misspelling (quietly corrected by Otto Kallir in his checklist) identifies the artist as a country bumpkin, while the holy-card representation itself—popular even today in a variety of permutations and combinations—conveys a kind of vernacular sentimentality presumably foreign to the well-bred Manhattan gallery-goers mentioned elsewhere in the article as potential buyers of her work. *Time* was having a sly laugh at the expense of Grandma Moses.

But Gimbels was perfectly serious about the guest of honor at the Thanksgiving Forum. For one thing, Thanksgiving was a key event in the world of retail sales, the kickoff to the Christmas season during which the lion's share of the year's sales would be registered. For that reason, under heavy pressure from the business community, President Franklin Roosevelt had set the date of Thanksgiving earlier by a week in 1939 to extend the so-called "shopping season."

Opponents—traditionalists, church groups—ridiculed the new "Franksgiving," and the controversy continued to rage until Roosevelt restored the holiday to the last Thursday in November in 1941. Gimbels' invitation to sweet old Grandma Moses, a woman apparently untroubled by profits and losses (and stunned by the $300 to $400 price tags on her own works), took the curse off "Franksgiving."

While department stores tried hard to appropriate Thanksgiving for their own commercial uses, at bottom it remained a home festival, a woman's day, much as Sarah Josepha Hale had intended when she lobbied for a fixed national observance in the 1860s. There were few commercial products directly associated with conducting a proper Thanksgiving dinner; instead, the holiday honored the Pilgrim practice of setting aside special days in gratitude for the year's blessings. Associated with the much-told tale of the Pilgrims' deliverance from starvation by the intervention of friendly Indians, the regional cuisine of Thanksgiving was one more sign of the pervasive influence of New England in the nation's affairs—a day for commemorating the joyous feast of America's forebears with pumpkin pies, turkeys, and cranberry sauce.

For Grandma Moses, born just three years shy of Lincoln's first Thanksgiving proclamation, the occasion would become a kind of childhood landmark in her memoirs when they were eventually published in the 1950s. Thanksgiving remained a special day for her, if not for the unfortunate barnyard bird with whom she empathized. "Poor turkey," she wrote. "He has but one life to give to his country." Why not some other ritual food? she wondered, half in jest. The Pilgrims ate turkey because that's what they had. "Now we have abundance of other kinds of meat." But with the coming of World War II, Mrs. Moses was quick to grasp the renewed significance of gathering

Mrs. Moses and Mrs. Thomas at Gimbels Forum, Thanksgiving, 1940. Photograph by Louis J. Caldor.

together with loved ones for that day and that meal. "In some homes this year will be rejoicing. In others there will be sorrow. But we that can give thanks should . . . for the aboundance [*sic*] of all things."[9]

When Grandma Moses came to New York City for the big Thanksgiving Forum, she brought some of that country abundance with

her. Prompted by Louis Caldor, who reveled in the folksier side of his new folk artist, she toted along some samples of her own foodstuffs: there were loaves of bread, cakes, and the homemade preserves that had taken the ribbon at the Cambridge Fair.[10] These were set out on a long table underneath her various paintings and wool pictures, much as they might have been at the fair. The difference was that her pictures went unnoticed at the fair. In New York, somewhat to her surprise, they—and Grandma herself—were the focus of attention.

She went to Manhattan in the custody of Mrs. Carolyn Thomas, wife of the Hoosick Falls drugstore owner and Grandma's self-appointed guardian angel. "What anticipation and vexation, what commotion and confusion," Mrs. Moses later wrote. There were the preserves and the cakes. There were four hundred people (mostly women), all looking right at her. When the two women were called to the podium, "someone handed me one of those little old ladies' bouquets and then someone pinned something on me." A black bug, she thought at first. No, a microphone. Grandma Moses was on the air! "They took me by surprise, I was in from the back woods, and I didn't know what they were up to. So while I thought I was talking to Mrs. Thomas," she was actually addressing the ladies of the greater New York area on the subject of her baking and canning, the truly important arts of Thanksgiving Day.[11]

The rest of the trip passed in a blur. Did she want to go sightseeing? To see the Empire State Building? "Land's, in this rain you couldn't see a thing." If the rain stopped? "Well, yes. I'd sort of like to have the name of it." How did she like all the uproar? "Well, people tell me they're proud to be seen on the street with me, but I just say, well, why weren't you proud to be seen with me before? But if people want to make a fuss over me, I just let 'em." Which one of the

paintings on display did she like best of all? "Well, I guess it would be the sugarin'-off scenes. I know them so well."[12]

That was Otto Kallir's favorite among Grandma Moses' offerings, too, and on the morning after the Gimbels appearance, Mrs. Moses and Mrs. Thomas called at the Galerie St. Etienne, where the painter met her patron for the first time. Although Otto Kallir, his gallery, his staff, and his family would become the primary guardians of Grandma Moses' legacy, in some respects her place in the culture of the twentieth century had already been determined when she arrived at his office that rainy November morning. Whatever the aesthetic merits of her work—and they were many—Grandma Moses was already a celebrity to whom certain simple notions had attached themselves like paper chains on a Christmas tree. One of them was her age: as Gimbels' perky publicists put it, "She's the white-haired girl of the U.S.A. who turned from her strawberry patch to painting the American scene at the wonderful age of 80."[13] She was old. Benign. Not strange or off-putting, but as familiar as your own Grandma. She turned her hand to painting with the same degree of seriousness that she brought to making preserves. No more. No less. And she was as American as, well, Mom's apple pie or your Grandma's homemade strawberry jam. That was the lady who charmed the crowd in the auditorium at Gimbels.

In 2001, when a new exhibition of Grandma Moses paintings was on the road, a critic for the *New Yorker* took exception to that "wretched 'Grandma' business," arguing that the familial sobriquet was an impediment to seeing her worth as a painter. "'Grandma' entrenches the artist's mid-century status as a popular icon and a runaway marketing phenomenon," he complained.[14] But it is equally important *not* to dismiss the hoopla, the stereotypes that won her a secure place in the affections of art lovers and picture lovers alike.

The subject matter of her art, which played a major role in her sudden popularity, is what Anna Mary Robertson Moses was about: the beloved New England themes, the familiar poems, the little houses nestled in the snow, the rituals of Thanksgiving Day. Her self-chosen iconography in the 1940s and 50s—what Grandma Moses (and her admirers) brought to the groaning table of her own day along with the fresh-baked bread and jam—is as important to the meaning of her pictures as their formal properties. Everybody needed a feisty, funny Grandma from the country to remind them of what really mattered in the complicated, violent world of 1940.

First of all, in Grandma's pictures you could go home again even if you had never seen a farm before. There was room at the table, a welcome at the door. Much of her early imagery concerned that joyous moment when the prodigal first caught sight of the old home place. *Home for Thanksgiving* (c. 1940; called *A Winter Visit* in the first Kallir show) is a good example of the type, a winter scene closely copied from a Currier & Ives print of the same name after a painting by George Henry Durrie. The Durrie, in turn, belongs to a whole class of popular prints responding to peace—to the hoped-for restoration of serenity after the Civil War. The rural New England flavor of these nineteenth-century works reflected the victor's point of view; thereafter, the story of the American people would be the story of the Northern Colonies, New England, the Pilgrims' Thanksgiving dinner. Under the pressure of another looming war, it is not surprising, then, that the old images were suddenly new again and fraught with meaning for the urbanites of the early 1940s. In imagination, if not in fact, it was time to go home to a place that looked suspiciously like a tourist's-eye view of the rolling hills between Bennington, Vermont, and Eagle Bridge, New York. A beloved daughter returns. A young man leaps from his horse in a cold,

Thanksgiving Turkey. 1943. Oil on pressed wood. 16″ x 20″. Kallir 293. The Metropolitan Museum of Art, New York. Bequest of Mary Stillman Harkness. This work entered the collection in 1950.

snowy farmyard. And there on the porch on Thanksgiving Day, his family assembles to welcome him home: the ancient father, the old mother, the wife, the baby. Is it 1867 or 1940? Or both?

Not surprisingly, the painting Gimbels chose to use in ads for the Grandma Moses Thanksgiving gala was called *Turkey in the Straw* (c. 1940). Shown hanging above a fine old mantelpiece amid an assortment of dishes, glassware, and candlesticks for sale, the paint-

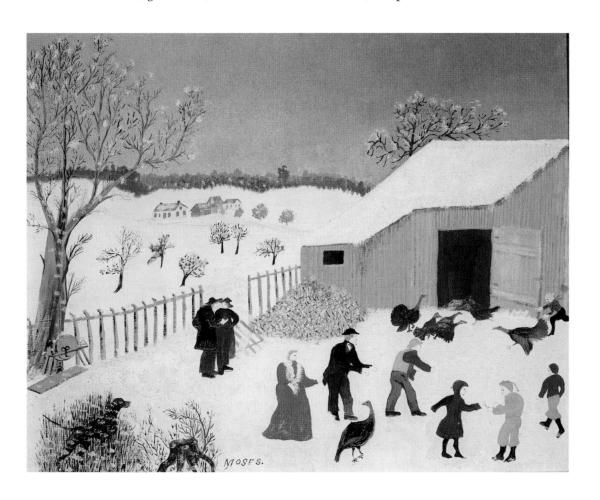

The Daughter's Homecoming. Oil on pressed wood. 12" x 14". Kallir 1514a. The Lauren Rogers Museum of Art, Laurel, Mississippi.

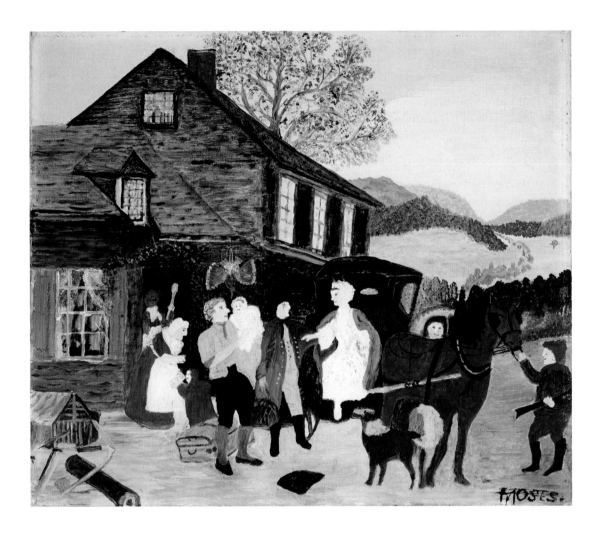

ing seemed to be a relic of a bygone time on display in some historic Yankee home. The subject was in keeping with the occasion: in a snow-covered barnyard, a family has cornered a plump turkey. A grindstone at the ready portends its fate. On the far right edge of the picture, the daughter of the family is the only one who de-

clines to take part in the incipient slaughter. Perhaps she is a younger Grandma Moses, determined to spare the Thanksgiving bird. Arms raised in distress, she faces the viewer as if to beg for intervention to save old Tom from a hasty demise.

"Turkey in the Straw" is also the title of a venerable American folk song (as well as a quilt pattern and a square-dance set). Musicologists have various explanations for the origin of the lively fiddle tune, one of America's earliest minstrel songs. Popular during the presidency of Andrew Jackson, it was first published with words in 1834 as a number called "Old Zip Coon." Somewhere along the line, the Southern-inflected adventures of Mr. Catfish, Mr. Bullfrog, and Miss Toad faded away, leaving behind only one intact verse—"Sugar in the gourd / Honey in the horn / I was never so happy / Since the hour I was born!"—and a few lines of the chorus: "Turkey in the straw, turkey in the hay . . ." In the late nineteenth century, ragtime versions kept the melody alive, and when the movies began a search for cheap, uncopyrighted scores in the teens and twenties, "Turkey in the Straw" was suddenly heard everywhere. Mickey Mouse was one of many cartoon characters to perform his antics to the cheerful rhythms of the old tune. Along with "Over the Hills," the song became the musical signature of Thanksgiving Day.

Otto Kallir was surprised when he turned over Grandma Moses' paintings for the first time in 1940, he said, because the backs were almost always inscribed with titles—and often, with lines of poetry or song lyrics as well. But with or without inscriptions, many of her works, including the Mother Goose pictures, allude to or frankly derive from such sources. *Turkey in the Straw* was another folk-song title applied to a painting, and in the 1940s songs that Sissy Moses had known, songs that seemed to reclaim the essence of the American past, were being sung again with great purpose and enthusiasm.

Alan Lomax and the poet Carl Sandburg were avid collectors of old songs. Burl Ives, whose first album was released in 1949, had been making 78-rpm records of half-familiar ballads since 1940; "Jimmy Crack Corn" and his other sprightly children's ditties bear a family resemblance to "Turkey in the Straw."[15] But it is in her *Over the River* series, which begins around 1940, that the connection between image and song becomes crucial to an appreciation of Grandma Moses' work.

Under a variety of titles, the song known colloquially as "Over the Hills" or "Over the River" is almost as old as "Turkey in the Straw." Or at least the lyrics are. The verses come from a poem—"The New England Boy's Song About Thanksgiving Day" (1844)—written by the Salem-born intellectual and early abolitionist Lydia Maria Child, the editor of *Juvenile Miscellany,* in which it first appeared. Child, one of the only American women of her generation to earn her living through her writing, knew the Alcotts and Sarah Josepha Hale. Like them, Child was one of the pillars of literary New England in the nineteenth century. In the twentieth century, although her name was rarely attached to the poem anymore and the title was long forgotten, her dozen stanzas of Thanksgiving excitement had become part of the nation's holiday ritual. In 1946, when Otto Kallir published his first collection of Grandma Moses' writings, her handscripted commentary on a version of the picture she called *Over the River to Grandma's House* (1942) consisted of six of Child's verses.

Unusually for Mrs. Moses, the text is letter-perfect in spelling and punctuation, suggesting that she had consulted a published source. What is distinctively Grandma Moses, however, is the rearrangement of the sections of the poem. In the Grandma Moses retelling, Grandmother comes first—not Grandfather. And the important parts of the story are the fun of the sleigh-ride, the sense of anticipa-

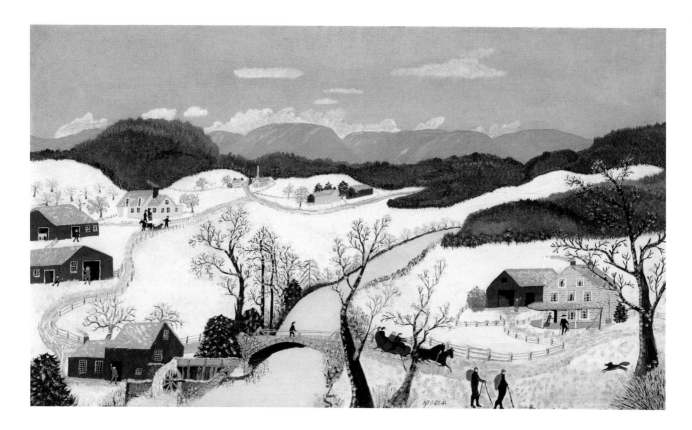

Over the River to Grandma's. 1944. Oil on pressed wood. 19″ x 33″. Kallir 368. Private collection.

tion, and the good things to eat: "Hurrah for the fun! Is the pudding done? Hurrah for the pumpkin pie!"[16] The original verse, by contrast, ends with Grandmother and the pie. From the very beginning of her version, Mrs. Moses takes the side of the goodwife—another Grandma, like herself—who has literally made Thanksgiving in her own steamy kitchen.

More than any other holiday, Thanksgiving was (and is) a culinary event. It is about a feast and its consumption. As editor of *Godey's Lady's Book,* Sarah Hale helped to write the menu and set the table for an appropriate New England dinner. Her novel *Northwood* (1827)

From Farm Wife to Media Darling

147

Over the River. 1944. Oil on pressed wood.
14″ x 28″. Kallir 433a. Private collection.

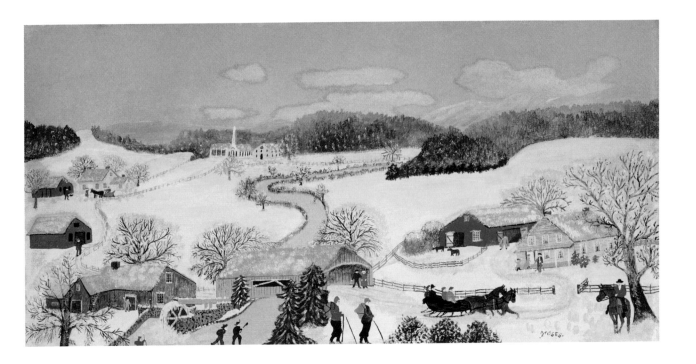

dwelt on the sensuous properties of the meal: the snowy linens, the savory turkey, the pickles, the fresh-churned butter, "the celebrated pumpkin pie," the plum pudding (a leftover from Olde England), the cakes, the homemade ginger beer.[17] Harriet Beecher Stowe later made much of the "harvest home and . . . [the] gathering of families about the home-table to consider the loving-kindness of the Lord."[18] In a set-piece entitled "How We Kept Thanksgiving at Oldtown," Stowe laid out in detail the joyful anticipation with which the children awaited the day and the secrets that bubbled out of the sculleries where preparations were in full swing a week before the table was to be set. At last, "when all the chopping and pounding and baking and brewing . . . were gone through with, the eventful

day dawned. All the tribes of the . . . family were to come back home to the old house, with all the relations of every degree, to eat the Thanksgiving dinner."[19] A fat tom turkey, cranberries in all their disguises, and pumpkin pies.

The classical Thanksgiving scene of women chopping and pounding—and testing the turkey—was recreated in a kind of pseudo-nineteenth-century style by artist Doris Lee in 1935. The painting, *Thanksgiving* (also known as *Thanksgiving Dinner*), showed everything that the New England writers had described, but now replicated in a Midwestern farm kitchen. Lee's picture won that year's Logan Prize at the Chicago Art Institute in a controversial decision. Mrs. Frank Logan, wife of the honorary president of the museum and donor of the prize, took one look at *Thanksgiving Dinner* and pronounced it "Atrocious! Fancy giving a $500 prize for an awful thing like that! The most pathetic part is that we cannot withdraw the award."[20] Her angry outburst marked the beginning of a short-lived "Sanity in Art" movement opposed to the strange shapes and aggressive colors of modern art. Lee, ironically, qualified as a modernist because she made use of the conventions of a newly fashionable primitivism. Even though her picture paid homage to the domesticity of the American past, her depiction of that familiar subject was suspect in some circles in Chicago.

But nobody needed to be told what Lee's bustling kitchen signified. The New England Thanksgiving—the all-American Thanksgiving—had become basic to the nation's domestic know-how over the years. During World War II, grocers and national food processors were quick to assure housewives that the necessities (or viable substitutes) would be available despite shortages and rationing. Illustrator Norman Rockwell, an adopted New Englander, knew just what Thanksgiving ought to look like, even in wartime. In his famous

Doris Lee. *Thanksgiving.* c. 1935. Oil on canvas. 71.3 x 101.8 cm. Mr. and Mrs. Frank G. Logan Purchase Prize Fund. The Art Institute of Chicago.

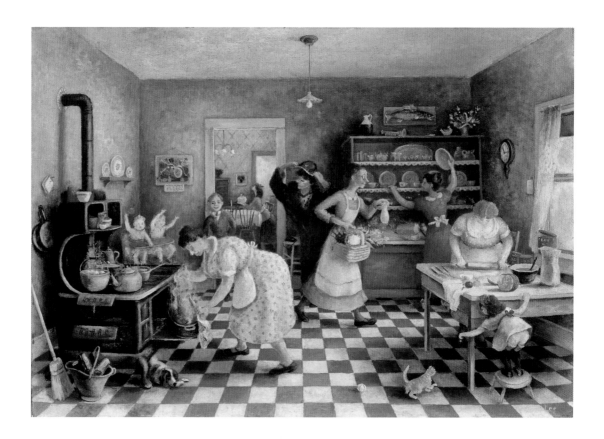

Four Freedoms series of 1943, Rockwell represented the universal right to "Freedom from Want" in a painting showing a traditional family dinner for Thanksgiving Day, complete right down to the jellied cranberries and the stalks of hothouse celery resting on their own cut-glass plate.

In her capacity as a celebrity of note in the 1940s, Grandma Moses was often called upon for her predictably unpredictable opinions on one thing or another—but especially on Thanksgiving. What did it mean? How did it used to be observed, in the good old days of

Catching the Thanksgiving Turkey. 1943.
Oil on pressed wood. 18″ x 24″. Kallir 260.
Private collection.

sleigh rides and old-fashioned grandmas who roasted turkeys in cast-iron ranges? In 1945, *Collier's* seized on the words of the old Thanksgiving song for the title of an article on Mrs. Moses: "To Grandmother's House We Go."[21] The phrase referred to the lead paragraph—and a reproduction of *Catching the Thanksgiving Turkey* (1943)—which insisted that Louis Caldor had "discovered" Grandma on Thanksgiving Eve, 1939. But it was only with the end of World War II and the nation's collective homecoming that Grandma and

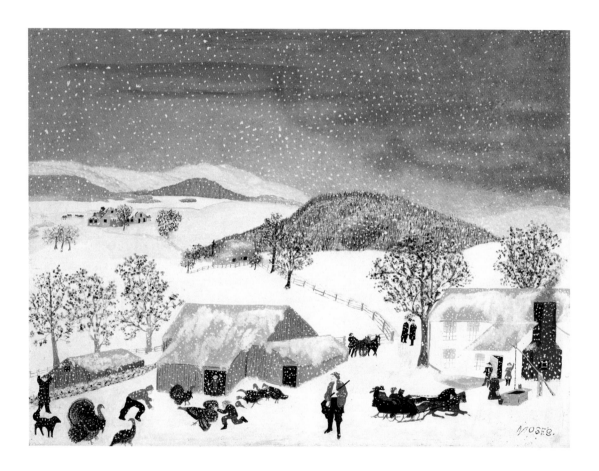

Catching the Thanksgiving Turkey. c. 1943.
Oil on pressed wood. 12" x 16". Kallir 325.
San Diego Museum of Art, California.

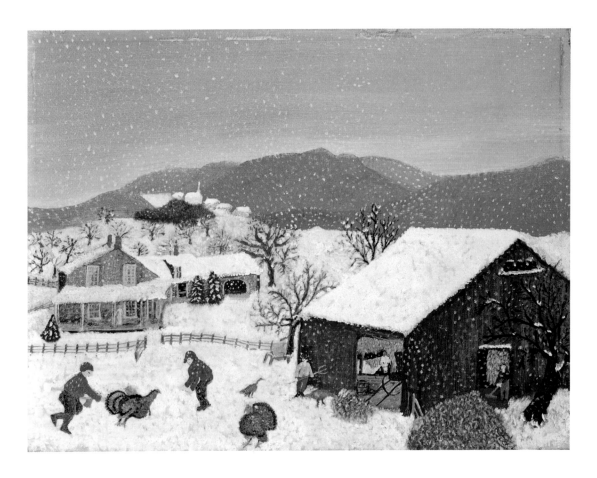

her snow-covered holiday paintings became irrevocably associated with the season.

On the occasion of her ten-year anniversary as an artist, observed with an exhibition at the Galerie St. Etienne in November of 1948, the *New York Times Magazine* asked Grandma Moses to look back over 88 years of "Turkey and Trimans," starting from the time when a disappointed little Sissy didn't get her red dress in 1864. Most of her best stories had already been told many times by then. The years

as a hired girl, when there were sleigh bells and snow most Novembers. Church sometimes. A big dinner. Pies. The turkey and the stuffing, even in Virginia where it was apt to be warm. But Grandma's best memory was a recent one—1946. Four generations gathered around her table that day. A sleet storm had just passed through, and the hills looked "like fairy land." "It was a real happy thanksgiving, now that the war is over, and we were all together, again, yes, we have much to be thankful for, while we sing 'over the River and through the snow to Grand mothers House we go.'"[22]

Every magazine in those early years of peace tried to outdo all the rest in celebrating Thanksgiving with recipes, features, and giveaways. But the Cold War, and later the growing conflict in Korea, soon colored the season of rejoicing. The same *New York Times Magazine* which feted Grandma Moses offered traditional holiday recipes that saved wheat, since supplies were still limited in 1947.[23] In November of 1950, shortly after the Korean War began in earnest, General Mills advertised its flour products in a variety of national periodicals under a reproduction of Grandma Moses' *Catching the Thanksgiving Turkey* (1943). The ad was titled "The 90 Thanksgivings of Grandma Moses." It was true that "the 90th Thanksgiving of Grandma Moses isn't the happiest America has known," began the essay under the picture. "Yet despite the shadow that hangs over the world today, we in America have much to be thankful for." Among the nation's blessings, the ad goes on to say, are the high standard of living and the modern conveniences which have led to even bigger and better Thanksgiving dinners.[24]

In times of crisis and uncertainty—the 1940s and early 1950s—the Thanksgiving pictures of Anna Mary Robertson Moses carried with them a particular resonance, a pang of heartache and hope that helps to account for her great and sudden appeal to the American

eye. In 1956, when she had already become a national monument, *McCall's* magazine called upon Grandma Moses to paint a special rendition of the Thanksgiving theme for their holiday issue. Titled *Thanksgiving,* the work is one of her rare interior views, important in this context for emphasizing Thanksgiving as an in-gathering of kin (and occasionally a passing tramp): the old and the young, workers and watchers, cooks and trenchermen, a cat and a dog, all together in an indefinite space defined by an old iron stove, a pie safe, and the framed landscapes on the wall. Significantly, the right foreground is taken up with a big, comfy chair, unoccupied, as if inviting the viewer to come in and join the family circle. "As I painted this picture," Grandma Moses wrote, "my mind traveled back to when I was a child of five years of age, ninety years ago. When Thanksgiving came we were all expected home to dinner. There were many young people like ourselves, and we would have a grand time in playing—sports of all kinds—as we were of different ages, some old some young." And so they are in her picture, dashing about, half-mad with the smell of roasting turkey. "As I painted the stove, I recalled how wood had to be chopped by hand, and to roast our turkey, the wood box had to be kept full of dry wood. Our butter had to be churned by hand." And so the old lady with her churn. The boy at the door with his pile of wood. The turkey, half out of the oven for basting. The painting depicts a memory so pertinent to American women ninety years later that it commands the cover of a national publication.

"How times have changed," she concludes. "We had no electric stoves, no super markets yet we were happy and on Thanksgiving the entire family would gather and give thanks for what we had. In this modern age we should be more grateful for what we have," said Grandma Moses.[25] And the readers who saw her lively memory pic-

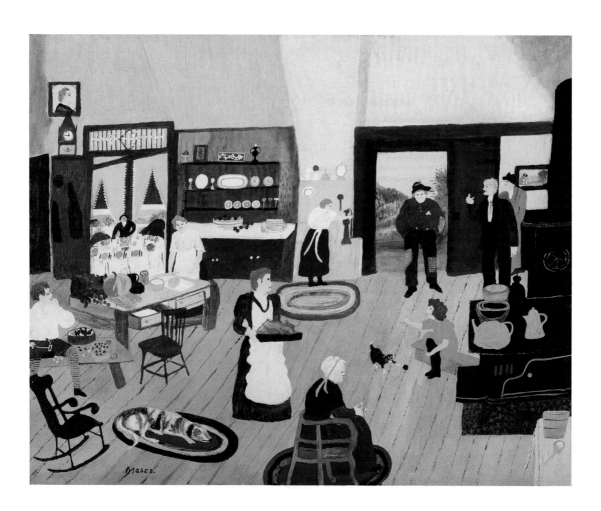

A Tramp on Christmas Day (also known as *A Tramp on Thanksgiving Day*). 1945. Oil on pressed wood. 16" x 19⅞". Kallir 595. The Shelburne Museum, Vermont.

ture in *McCall's,* in among the ads for new electric ranges and packaged convenience foods, could only agree—and dream along with her of that magical country still alive in their imaginations and in the heart of America's Grandma.

7. A "Primitive" Artist

After the burst of publicity created by the Gimbels appearance, Mrs. Moses was inundated with what she regarded as "orders"—requests for pictures just like the ones reproduced in the newspapers. People who didn't head straight for Eagle Bridge pressured New Yorkers in the art business to get them a real "Grandma." She professed to hate the whole process of repeating herself and, by 1943, was so overwhelmed with requests that she despaired of being able to "keep up." This was one of the unforeseen hazards of her newfound professional career. Even an artist of the stature of Georgia O'Keeffe was distressed by an apparently insatiable demand for more flower studies in the 1940s, when her own interests had turned toward abstract paintings of the Southwestern desert. With Mrs. Moses, the topic in demand was Thanksgiving, followed closely by sugaring off—snow subjects which, to the potential buyers who saw them, seemed to embody the spirit of the whole winter holiday season.

Sensing her frustration at being turned into a virtual mimeograph machine, Otto Kallir began to suggest variations on the type. Perhaps Thanksgiving could be represented by something other than the execution of the turkey. So Mrs. Moses did the occasional arrival ceremony, with old-fashioned coaches drawn up at the front door and glimpses inside, where preparations for the meal are in full swing. Numerous variations on the "Home for Thanksgiving" theme followed, some based on Currier & Ives, others incorporating details from the Thanksgiving song she so fondly remembered.[1]

But certain things—figures, actions, apparatus—were *always* re-

quired for certain pictures. *Catching the Turkey* (1943) wasn't right without the grindstone and the old folks bending intently toward the bird. *Maple-Sugaring* (1943) wasn't complete without the same pair of oxen, the man with the yoke of two buckets, the children clamoring for a taste. The vignettes clipped from magazines and newspapers had to remain constant, despite variations in the layout or color, because that was the way it was done. As with the Thanksgiving mincemeat recipe, even though one might add raisins or walnuts on occasion, certain ingredients simply had to be present.

To Otto Kallir, her attitude was typical of "children's drawings and . . . other primitive works of art."[2] In the perceptions of someone outside the world of galleries and collectors, however, art was a matter of recipes. There was a proper way to make a pie or a picture successfully. When Grandma Moses went to Gimbels for a ladies' forum in her respectable little hat (with veil), her gloves, and her black stockings, she was following the recipe or formula for any women's social gathering: etiquette demanded a presentation of the self in one's Sunday best. But by those outside the context of the Gimbels Forum, it was regarded as a personal eccentricity or another sign of her unspoiled "primitivism" that, instead of talking about her paintings, she would talk about her recipes for jam, just as Betty Crocker or a radio homemaker might. Was she a farm wife or an artist? But why couldn't she be both? A woman *and* an artist.

To Mrs. Moses, there was a right way to make a jar of jam or a painting: properly executed, that method would result in success every time. She had no doubt of that, and she didn't shrink from describing the "recipe" for paintings to anybody who asked. For a painting, you needed last year's mail-order catalog and a Bible to sit on, a sheet of masonite (painted white), a collection of old jam-jar lids for mixing colors, a little turpentine, and a nice frame. You could

paint 'em by twos and threes, if you wanted, skies up, fields down. She made paintings just the way she, or any diligent housewife, made a cake, and in just about as much time. You got together the flour, the eggs, the vanilla, the sugar, as specified in the recipe. You measured and stirred according to the instructions. And you took rightful pleasure in the cake, fresh from the oven and ready for frosting. It was easy, although if you had to do it over and over again, it could become a little tedious. Thanksgiving scenes and sponge cakes were much the same in that respect.

For the moment, however, being a painter was exciting for the newest member of the art fraternity (and it was a fraternity!). In the spring of 1941, at 81 years of age, Mrs. Moses had taken a $250 prize for *The Old Oaken Bucket*. The prize was offered by Thomas Watson of International Business Machines, who posed for publicity photos with Mrs. Moses in front of her winning picture.[3] In the 1930s and 40s, Watson and his company had become prominent art patrons. In displays at the New York and San Francisco World's Fairs in 1939 and later in a gallery in Manhattan, Watson insisted that art and locale were inextricably related—that every state had talent worth recognizing. He selected artists whose connection to place was demonstrated by their readable images of their surroundings.

Although the IBM collection of the late 1930s encompassed a great range of styles and subject matter, the common denominator was the "American Scene." That loosely defined scene could range from a conventional Nebraska landscape to a "modernistic" representation of a totem pole from the state of Washington by Clyfford Still.[4] The only requirement was that the layman should be able to look at the painting and readily comprehend the subject matter. Watson's enterprise seems subversive by today's standards because it puts the focus squarely on the viewer, the man or woman in the street who

was primarily interested in art for the subject matter depicted and for the color and forms used to define that iconography. In other words, the IBM Collection promulgated a legible American art which the hypothetical housewife could readily enjoy—and, in the case of Mrs. Anna Mary Moses, create. Although there were no actual rules barring abstraction, this was the working aesthetic of the New Deal art projects as well, while the Regionalists of the Midwest, led by Thomas Hart Benton, insisted in no uncertain terms that art ought to be a readily shared experience, a public text "arguable in the language of the street."[5]

Wearing her little black hat, Grandma Moses had attended the awards ceremony. When the winning picture was announced, said her daughter-in-law, "there was terrific applause, and everyone arose to honor Grandma, who graciously was asked to step upon the stage. Everyone tried to shake hands with her or to ask her about her paintings, until we finally decided she was getting tired from the attention and excitement—we almost had to carry her away from her many admirers."[6] Her admirers had no trouble understanding the green spring landscape of *The Old Oaken Bucket,* with the well-worn path between the houses of the ill-starred lovers, especially if Grandma Moses could be coaxed to tell the story which had so impressed her as a girl. According to Mrs. Moses, one of her first renditions of *Checkered House* was on exhibit in Syracuse, too. Like the turkey and maple syrup pictures, this cheerful, quaint motif also became something everyone wanted, so she painted the old inn in her mind's eye as it might have looked in the winter, the summer, the autumn, and spring as the mood struck her, over and over again.[7]

Every exhibition led to a thick stack of articles, another potential exhibition. And another cute Grandma Moses story. An interviewer who pursued her to Eagle Bridge after the Syracuse show heard her

story of "The Old Oaken Bucket" and a new one about *Checkered House.* "The stages went lickety-split and changed horses every two miles," Mrs. Moses explained. "I always knew I was near Grandpa's house when I reached the checkered house. I never stopped there because they sold whiskey, but (and her eyes light with that coquettish smile)—but sometimes Grandpa did." Whether her yarn was true or half-true, the devilish glee with which she recounted it explains why Grandma Moses was such a favorite with the press. She was always good copy—good for a story that was bound to please because it presented an old woman as a quirky, self-reliant individual, and one not easily impressed with her own fame. When she went to New York City for the big Gimbels doings, she told her questioner, she met celebrities, talked on the radio, posed for a movie camera, and even saw the show at Radio City, "and was thoroughly unimpressed" by it all.[8]

Meanwhile, the exhibitions continued: Washington, California, Pittsburgh's Carnegie International for 1945 and 1946, two major shows at the American British Art Center, more "one-man" outings at Otto Kallir's gallery. Grandma Moses' work was borrowed for almost every major theme show of self-taught artists or primitives in the 1940s. She was included in the prestigious "Portrait of America" exhibition organized by the Metropolitan Museum of Art in 1944, under the auspices of an organization called "Artists for Victory."[9] Weren't neat little grandmothers in aprons another good reason for the nation to fight to protect what was truly American?

It was inevitable, perhaps, that Anna Mary Robertson Moses would be taken up by the fashionable set. In December of 1942, she was the subject of a holiday feature in *Harper's Bazaar.* On one page, there was a typical "Grandma"-style picture of the type already much in demand—a color reproduction of a country scene in

the snow, with children on sleds, a horse-drawn sleigh, a frozen stream, and a farmhouse with the family gathered on the porch, about to welcome a visitor. On the facing page was a large-format photograph of Grandma Moses at home, apparently working on a painting. In her lap lies *Pouring the Wax* (1942), unfinished; with a tiny brush in her right hand, she seems to have paused for a moment to greet a visitor. The photograph is vitamin-enriched Americana, a study in busy, folkish patterns, ranging from the lace of Grandma's cuff to the giant lilies printed on the draperies, the flowered wallpaper, the tatted doily on the nearby table, and the busy carpeting at her feet. But noteworthy among all the bits and pieces is her apron, an elaborate affair of strings and straps done in a big flower print set off with a contrasting trim of bias tape. Aprons of this sort were a staple of the Sears catalog—cover-ups, apron-dresses meant to protect the wearer's "good" clothes from kitchen disasters, and patterned to hide the spots. And Grandma Moses sat for a formal portrait of the artist in an apron.

It's one thing to be old. To be somebody's "grandma." A farmer's widow. A primitive, even. But to wear an apron? Do artists wear aprons?[10] Did Georgia O'Keeffe? One of the keys to the subsequent reputation of Grandma Moses and her art is surely that apron, a symbol of female domesticity, of physical work which may on occasion be messy. Did Jackson Pollock wear an apron? No. But Grandma Moses, for whom painting a picture and making a kettle of soap remained fundamentally similar operations, always wore her apron when she sat down to paint. Was that apron, in the end, what made Grandma Moses a "primitive"? Someone who belonged in a special category because she was a housewife, a farm wife, and unashamed of it?

In 1946, Otto Kallir put together a book on Grandma Moses—the

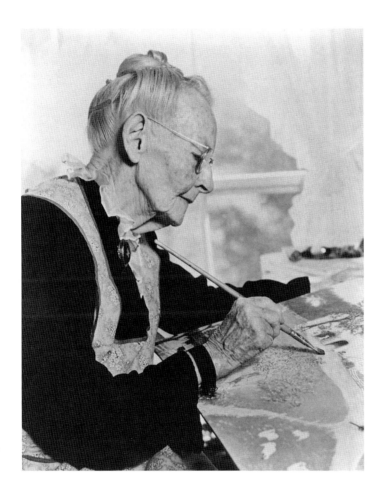

Portrait of the artist as a farm wife: Grandma Moses paints while wearing an apron. Photograph.

first such book. It consisted of introductory essays by Kallir and the writer Louis Bromfield, comments by her daughter-in-law, the first tentative version of Mrs. Moses' autobiography ("My Life's History"), and forty plates with commentary by the artist in her own handwriting. Originally published in November of that year, the popularity of the book was such that it was taken over by Doubleday

Window display of *My Life's History* at Scribner's Bookstore, New York, 1952.
Photograph by Otto Kallir.

and rereleased with extra color plates in the spring of 1947. The reviews of *Grandma Moses: American Primitive* were for the most part uncritical descriptions of the contents, which assumed that the reader liked Grandma already. "The simplicity and pictorialness will appeal to those who enjoy the New England landscape," wrote one newspaper scribe, fumbling for suitable words. "Above all, the contentment implicit in the best kind of America life shines from each reproduction."[11] "The results are American," claimed another reviewer unaccustomed to artsy terminology.[12] "Misspellings [in her commentaries] parallel the technical illiteracies of her paint-brush," said the *Christian Science Monitor.* "Both defections heighten the delectability of Grandma Moses' pictures."[13]

The few negative comments came from important figures in the art world who took issue with Kallir's use of the term "primitive" and especially with a passing rhetorical swipe at Picasso in Bromfield's essay. Indeed, the selection of Bromfield to write the essay that opened the volume was a tacit declaration that Mrs. Moses belonged in a category distinct from other artists of her time. For one thing, Louis Bromfield was not closely associated with the visual arts. A novelist who had won the Pulitzer Prize for fiction in 1926 (he also served on the founding staff of *Time* magazine), Bromfield was a well-known *bon vivant,* a fixture on the social scene in New York and in Hollywood, where several of his books had been adapted for the movies.

During World War I, Bromfield had been among the American expatriates driving ambulances in France, and in the 1920s he took up residence there, hobnobbing with the Hemingways, Gertrude Stein, Mainbocher (the fashion designer), and Pablo Picasso. At the age of 40 he returned to the United States and bought a farm in Ohio, close to his birthplace, and began a second career as an advocate for sus-

tainable agriculture. Soon, however, his Malabar Farm became a rustic guest house for the rich and famous, crammed with eighteenth-century furniture and flowing with good Scotch. The papers were full of Bromfield stories: Kay Francis, in movie-star garb, stirring apple butter with a garden hoe on Malabar's back lawn; Joan Fontaine in a negligee and satin mules witnessing the birth of a calf, subsequently named in her honor. On May 21, 1945, Humphrey Bogart married Lauren Bacall in the entrance hall, between the twin stairways leading to the upper reaches of the fabled "big house."[14]

It was probably no surprise, then, that Bromfield's breezy essay began with mention of his fashionable friends who loved Grandma's pictures and went on to develop the thesis that hers were fine pictures because she lived the rural life they depicted. "A good farmer looking at most of the farm pictures and landscapes painted in our time might say 'a pretty picture' or 'no farm ever looked like that' and move on to the next one," Bromfield decided. "In front of a Grandma Moses he would stop and chuckle and smile and sigh, for in it he would find not only every detail painted with satisfaction and understanding, but he would know at once that Grandma Moses understood his whole small world with its glories and hard work and those quick, deep inarticulate gusts of emotion which sweep over him at the sight of a newly born calf or a blossoming pear tree . . ." And so forth. She was Pieter Bruegel in an apron: "His pictures have the robustness and earthiness of a Flemish male. Those of Grandma Moses are infused with the quality of a New England woman."[15]

Bromfield's insistence that people in the know liked Grandma Moses was more than justified by the list of her current patrons. By the time the book was released, she was the darling of the New York theater scene. Lillian Gish, Helen Hayes, and Katherine Cornell all owned pictures. So did Cole Porter and Mainbocher. Bromfield him-

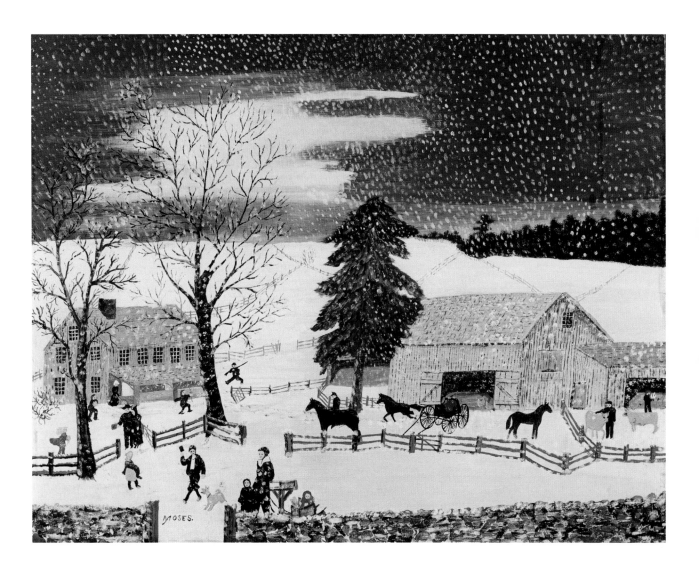

The Mailman Has Gone. 1949. Oil on pressed wood. 16″ x 21″. Kallir 818. The Shelburne Museum, Vermont.

self owned *The Postman* (1946).[16] In his syndicated column for January 17, 1946, Bob Hope boasted that he had just bought a wintertime barnyard scene by the eminent G. Moses. "It's so real that every time I walk through the living room I can smell wood-smoke," he

quipped. "She knocks out a work of art faster than a chorus girl can put on her lipstick."[17]

Hope's remark sustains Bromfield's belief in the authenticity of Mrs. Moses' work. But that was a layperson's opinion, of course, and one readily dismissed by James Thrall Soby, head of the Department of Painting and Sculpture at MoMA, writing in the *Saturday Review*. In a nasty aside, he called Bromfield's contribution "one of those blue-jean forewords." So much for the gentleman farmer! But what really offended Soby was Louis Bromfield's offhand contrast between Grandma Moses and Picasso—between Grandma's knowing explications of the rural scene and what Bromfield called "the assembly line abstractions of the later Picasso." Soby allowed that Grandma Moses was an amiable painter of modest quality. But not an important artist, like Picasso. "To understand the full banality of [Bromfield's] statement," Soby fumed, "you need only look at Sidney and Harriet Janis's *Picasso: the Recent Years*." The plates in that book, he continued, showed "the extraordinary creative power of an artist who . . . has gone on for fifty years with unrelenting vigor."[18] Grandma was "amiable" but merely old.

It is ironic that Janis, MoMA, and Grandma Moses should have come together again in this context—along with Picasso (Mrs. Moses' slightly younger contemporary). Soby's brief article illustrates how hard it was for Grandma Moses to get a fair hearing in the increasingly insular and professionalized world of art in the later 1940s. And not just Mrs. Moses: popularity among laymen was becoming a virtual impediment to respect by many critics and connoisseurs. And so, frankly, was gender. (Even Bromfield, in his effort to pay Grandma Moses a compliment, found it necessary to compare her with "a Flemish male.") A cheerful old woman in an apron simply could not be a serious artist.

In October of 1948, sensing a shift away from the catch-as-catch-can egalitarianism of the New Deal era, *Life* magazine convened a "Round Table" on "the strange art of today"—on the meaning of "modern art" and the question of why the general public seemed to find it ugly and/or difficult. The discussants included Soby, along with a brace of other heavyweights: curators, academics, dealers, and writers. The group included Clement Greenberg, whose condemnation of "kitsch" and vigorous espousal of Abstract Expressionism would change the complexion of New York's art history for the next twenty years.[19]

As transcribed by *Life*, the back-and-forth dialogue among the participants was not particularly enlightening: the high point was a clever Art 101 analysis of a Picasso nude. Greenberg had little to say, except to defend Jackson Pollock's *Cathedral* (which others on the panel compared to wallpaper or a good design for a necktie).[20] But what is shocking in retrospect about *Life*'s symposium is the absence of women, either as speakers or as subjects of discussion—and the undisguised contempt for the general public, for the casual reader or viewer whose tastes, the experts seemed to be saying, needed to be educated lest he (not she!) make a fool of himself by liking something unapproved of by these selfsame experts. In such an atmosphere, Grandma Moses' survival as a beloved American artist must be taken as an outright rejection of the new, exclusive cult of modernism. The old lady in the apron, the Grandma who painted "pretty" pictures of snowscapes and rural frolics and bygone times, was a living repudiation of all that the savants held dear.

James Thomas Flexner, art historian and editor of the *Magazine of Art*, also took issue with Bromfield—"the best publicized of our rich, part-time farm boys"—in his review of *Grandma Moses: American Primitive*. And he resented the invidious comparison to Picasso. But

Flexner's real quarrel was with the title of the book—with the whole business of "primitivism." He took Otto Kallir to task for implying that primitive art—Grandma Moses' art—had nothing to do with the modernism the public seemed so reluctant to embrace. In fact, as he reminded Kallir, the Museum of Modern Art had given Mrs. Moses her first exposure, and the work of the so-called "primitives" had been a major source of inspiration for both European and American modernists.[21] To pretend otherwise, Flexner reasoned, was an exercise in marketing: he was convinced that Kallir had deliberately framed his presentation of the artist in order to make Grandma Moses into an oppositional figure, thus ensuring her popular success.

Other writers sensed that the book had been tailored to present an appealing, likable figure, regardless of the merits of her art. The director of the Philadelphia Museum of Art pointed out that *Grandma Moses: American Primitive* tended to mix up her paintings with her preserves, her irresistible personality with her art.[22] The venerable Henry McBride, writing in the *New York Sun,* questioned the choice of Bromfield as lead essayist—Bromfield, a "best-seller . . . who will doubtless produce more gold for all concerned." "The rise of Grandma Moses into the higher realms of publicity," he suggested, "is significant of the times we live in."[23] In the 1940s, the gulf between gallery art and the art that readers of *Harper's* (or picture books on Grandma Moses) enjoyed looking at had never been wider.

As the *Life* symposium shows, the rift was growing wider by the day, to the apparent delight of an elite whose disdain for middle-class taste knew no bounds. Otto Kallir's carefully framed text took notice of the existence of that fault line and located Grandma Moses on the other side, with skill and deliberation. Grandma and her jam, Grandma and her apron, belonged to a world that wanted to see pretty things, to think good thoughts about America, to remember,

to wish, to love. It was a world that had room for women, for unabashed pleasure, for fun. "Quaint" was a legitimate category of experience there. "Primitive" meant something beyond the reach of the Sobys and the Greenbergs.

Up in Eagle Bridge, there had already been some discussion about Grandma's status as a "primitive." In a 1941 letter to Louis Caldor, she complained that her sons were up in arms about newspaper stories using the term. "One of their neighbors asked if it was so that I could not read or write, being a primitive."[24] By 1947, however, it was clear that primitive meant *not modern.* It meant a person whose life was accessible through her pictures and was full of incidents and ideas shared by many others, if only vicariously. Grandma's little quirks were delightful. Everybody liked to hear about the old-fashioned tip-up table on which she painted, perched atop a stack of old books. The table, Grandma Moses said, was a present from an aunt, thirty-five years before—and it was something of an antique, built by the eldest son of Phinious Whiteside of Washington County, back in the eighteenth century.

When the younger Whiteside reached his majority and donned his freedom suit, he "went into the 200 acres of heavy timber" adjacent to his father's farm, cut down some trees, and built a cabin. Then he built the furniture—primitive furniture—out of pine planks: a bed, a trundlebed, and a "tip-back table, so as when the trundlebed was run out, there would be enough room to move about." Under the table top, between the uprights, was a box for storing the dishes, and the box had a lid, so the table could also serve as a chair. The ingenious tip-up was a sturdy piece; it had lasted for a century or more in the basement of a fine new Whiteside house, where it served as a milk table. Finally, it came to Grandma—to use for a plant stand. "I have painted scenes on the standards," she wrote, "and covered the

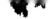

Grandma Moses working at her famous tip-up table, June 1948. Photograph by Otto Kallir.

top with postal cards, and now use it for my easel."[25] Like her apron, the table was a mark of her difference from other artists in the public eye. It was old, like Grandma herself—a relic. It was domestic, the sort of thing a "farm wife" might cherish. It was eccentrically her own, painted and pasted and prettified just as she desired, with big, exuberant "lamb scapes" brushed in summery greens on every upright surface. It was crude (even primitive) in design and execution.

In the spring of 1946, with Kallir's book poised to appear, Mrs. Moses was interviewed on the front porch in Eagle Bridge on the state of her health and well-being at the age of 85, going on 86. She was eating pretty well, she said: boiled cabbage and corn mush were her favorites. She was painting pretty well, too. Lots of orders. But the tip-up table and the painting room were off limits for the day: Grandma, it seems, had poured six bushels of walnuts on the floor to dry them out. Just as the conversation was about to conclude, Grandma started talking about lipstick, of all things. "You know, a cosmetic firm sent me lipstick and rouge for a present after my last exhibit. I was going to try to put it on me, but Dorothy here wouldn't let me," she laughed. "At your age," countered the younger Mrs. Moses, "do you want to be like those grandmas in the city, always showing off?" Just to get the last word—and much to the delight of the reporter—Grandma suggested that she might try a cigarette next.[26]

The origin of the mysterious lipstick-and-rouge set rapidly became apparent. In April, May, and June of 1946, coinciding with the appearance of *Grandma Moses: American Primitive,* the Richard Hudnut Company of New York launched a splashy, expensive ad campaign for its brand-new color: "Primitive Red," or Grandma Moses red. The news stunned the defenders of high culture. *Art Digest* reprinted in its entirety a letter from representatives of the firm announcing that the packaging for the product—Du Barry brand lip-

"Primitive Red" ad for Richard Hudnut cosmetics. 1946.

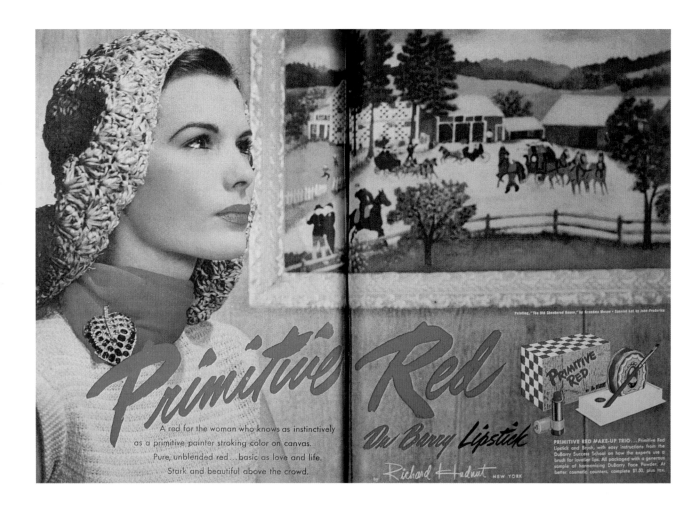

stick boxed with a sample of harmonizing face powder—"was inspired by a Grandma Moses painting called 'The Old Checkered House.'"[27] The package was an oblong box, covered with big, bold red-and-white checks on three surfaces. On the remaining sides, it said "Primitive Red" in a slapdash script that must have suggested primitivism to an imaginative Madison Avenue adman. In any case,

the marketing people sent a set along to the editor of *Art Digest* so he could see for himself "Richard Hudnut's cosmetic interpretation of the growing interest in contemporary American Primitive painters."

The editor—a man—was properly flustered. The ad was merely odd—an over-rouged model posing in front of a cropped and somewhat out-of-focus shot of *Checkered House in 1860* (1945) in an elaborate frame, hanging on a wood-paneled wall. The model's costuming was peculiar, too: a snood-like headdress called a "Spaniel hat" designed by noted milliner John-Frederics and a large leaf-shaped pin studded with "jewels" (point of origin, unknown). The girl was not actually looking at the painting, either. Instead, she gazed past it pensively, allowing the reader to examine a flawless profile enhanced by the application of "Primitive Red" in its several forms.

Although there were many versions of the ad, all of them used the same compositional elements, whether the magazine was *Vogue, Charm, Glamour, Good Housekeeping,* or *Life.* The copy remained inviolate throughout: "'Primitive Red,' a red for the woman who knows as instinctively as a primitive painter stroking color on canvas. Pure, unblended red . . . basic as love and life."[28] The words, in their ungrammatical suggestiveness, raise the question of just what the woman—or the primitive painter, for that matter—knows. But the implication is that, whatever it may be, it's probably basic, impulsive, instinctual, or just plain sexy. And whatever else has been written about Grandma Moses, nobody has ever suggested that she was a sex goddess, nor that her paintings induced such emotions, even when her audience consisted of heavily made-up young models wearing "Spaniel hats."

After a long hiatus, a brilliant, crimson red—and sex—were back in full force in the cosmetics industry. Revlon, often cited as a leader in the postwar field, had begun to use exotic names for its colors in

the 1940s. But Revlon's breakthrough came in 1952 when, all wartime restraint abandoned, the "Fire and Ice" campaign got underway with a scarlet lipstick (and matching nail polish) emblematic of the new sensuality of the decade. The model may have been wearing cool, cool silver, but her lips were a smoldering hot red.[29] "Fire and Ice!" Even while women were expected to return to a suburban version of the Victorian domesticity of their grandmothers' day, advertisers insisted that underneath that kitchen apron beat the heart of a temptress with the instincts of a primitive.

The Richard Hudnut ad was a prelude of things to come in the lipstick business. Department stores saw "Primitive Red" as a way to sell other "folksy" products (or simply red items in their inventory). B. Altman, the high-end Fifth Avenue retailer, used the $1.50 Hudnut package as the focus of its newspaper ads, omitting the painting but crediting the color itself to Grandma Moses and her *Old Checkered House.* Red is "daring," says an ad awash in checkerboard and picket-fence patterns—especially when lavished on a rayon scarf ($4.00 in a choice of "primitive red," green, blue, or black on white) designed by Wesley Simpson and worn as a daring kind of halter top, for maximum exposure at the beach.[30] In the annals of advertising hype, an old lady in an apron, a woman who never used a lipstick, became the grandmother of the just-named bikini bathing suit.

It was easy to quail in pious horror at the spectacle of Grandma Moses among the philistines, being sold to the public like a box of cereal—or a department-store lipstick. In fact, the lipstick deal was one of the only real lapses in the history of licensing products adorned with Moses imagery. And Mrs. Moses was by no means the first major figure of the era to offer up art for commercial purposes. In the 1930s and 40s, federal programs aimed at bringing art into

daily life spilled over into alliances between artists and industry. In one famous instance, Georgia O'Keeffe, at the instigation of the N. W. Ayer agency, which handled the Dole account, got a free Hawaiian vacation in 1939 in exchange for pineapple-themed paintings subsequently used in corporate ads. The Regionalists, whose ideological goal was to reach the broadest possible audience, welcomed the chance to paint works that served as ads for the American Tobacco Company. Dali and the Surrealists lent their talents to ads for products ranging from steel and light bulbs to Schiaparelli lipsticks. And IBM, one of Grandma Moses' early patrons, assembled a collection of paintings specifically to enhance the prestige of the company's name.

The coy flirtation between art and business represented by the "Primitive Red" campaign was not a matter of corporate altruism either. If there had been any doubt about the profit motive behind the use of art in advertising, Russell Lynes, an editor at *Harper's,* set the record straight in 1949 in an influential book called *The Tastemakers.* The book grew out of a *Harper's* article that broke the American public down into three distinct classes: Highbrows, who were apt to espouse leggy modern furniture and Calder mobiles; Middlebrows, who ate iceberg-lettuce salads and liked movie musicals; and the hapless Lowbrows, beer-guzzlers with a fondness for Westerns and souvenir pillows stuffed with pine needles.[31]

A couple of weeks after the article ran, *Life* boiled down Lynes's lighthearted and sympathetic overview of American consumers' taste into a series of three memorable images. Each of the three types was seen from behind, examining the object of his desire. The Highbrow, as might have been predicted, was admiring a Picasso, not unlike the painting *Life*'s experts had dissected in their recent art roundtable. The Lowbrow stared at a Brown & Bigelow pinup calendar, a staple

of every gas station in the land. And the typical Middlebrow contented himself with a reproduction of the famous *American Gothic,* Grant Wood's seriocomic study of a typical Iowa farm couple, solemnly looking back at Mr. Middlebrow.

In the meantime, back in Eagle Bridge, Grandma Moses was being questioned by the *Hoosick Falls Standard,* her hometown paper. Most of the piece was taken up with details of how a big radio network had come to the Moses house and set up their equipment so that the voice of Grandma, describing her pictures, could be heard nationwide for exactly three minutes and ten seconds. The program was called "We, the People," and the substance of what she said was almost as important to the writer as the cake and ice cream served after the interview. The most notable fact revealed during the exchange was that "sixteen of Grandma Moses' most acceptable paintings have been selected as Christmas cards for the coming season." 16 pictures. A million reproductions of each one. "16 million in all."[32] Grandma Moses, American Primitive, was about to become a Middlebrow entrepreneur deluxe.

8. Cakes and Cards

In the later 1940s as her celebrity stock rose, it seems suddenly to have occurred to the press that Grandma Moses was very old. That other people's birthdays might come and go, but hers were increasingly precious. In September of 1947, when Mrs. Moses turned 87, newspapers from Troy up to Hoosick Falls waxed eloquent about her party, an open house thrown by the family for relatives and close friends. The cake, homemade and a little tipsy, was layered in tiers; Grandma had done that for her own children when they were growing up, adding a layer for every year. In this case the bakers stopped at three, put the candles in a circle around the plate, and decorated the cake with pink flowers from the garden.

The guest of honor presided over the serving tools in a black dress with tiny white ruffles at the wrists and neck and an antique cameo brooch at the throat: she might have stepped straight out of a nineteenth-century daguerreotype. The grandchildren and great-grandchildren were wild with excitement. Grandma was puzzled but pleased by the piles of cards and gifts (lots of pretty candy boxes!) sent by strangers from all over the country. "Just think of people who don't even know me sending me these lovely things," she laughed. "See this, an apron! Just what I need when I'm painting."[1]

The story of the party was typical of social notes in small-town papers everywhere. What was not typical was the description of the newfound wealth and fame of the guest of honor, thanks mainly to her Christmas card business. Reproductions of Grandma's paintings had been marketed nationally during the previous year with great

success, according to the article in the *Troy Record,* but her main concern was that she wanted a blind man who lived nearby and supported himself by selling greeting cards over the phone to get an ample supply of her cards. Grandma Moses was sublimely indifferent to the art business otherwise. Visitors to Eagle Bridge reported seeing Grandma's sugar bowl stuffed with uncashed checks, sent in return for the use of her images. She apparently never grasped that she was entitled to such funds; for the artist, the pay came with the sale of the picture itself, and for her, $3.00 seemly plenty for most of them. "At that [price] I was making a profit!" she once insisted.[2]

The first batch of sixteen Christmas cards, manufactured by the little-known Brundage Greeting Cards Inc., went on sale in 1946. As the Christmas season approached that year and the sales figures began to trickle in, Grandma's cards were pronounced a hit. According to one well-informed source, the initial order was for 750,000 cards but after word spread, orders soared and the firm was unable to keep up with the demand. Paper supplies were still short after the war; printing facilities could only turn out half the number needed. But even so, Grandma Moses set an amazing record for card sales. What was the reason? Why had her snow scenes suddenly displaced Charles Dickens–style revelers as the symbol of what Christmas was all about?

In a way, her success was an ironic one. Mrs. Moses had once used greeting cards as her source material and, if the stories are accurate, began her late-in-life career in art because she wanted to make a nice picture as a small Christmas gift for her mailman. In the days of her youth, cards had been a happy answer to the dilemma of how to share the goodwill of the season with those for whom a more substantial gift might be inappropriate. In the nineteenth century, Louis Prang's elaborately trimmed color lithographs *were* gifts, collected

as works of art and often used as elements in household decoration. But the explosion of card-sending in the 1940s was another consequence of the end of World War II—the formation of new families, the mushroom growth of suburbs, and the simple desire to keep in touch with a far-flung collection of friends and relatives.

The question remains, however, of why Grandma Moses' pictures were especially well suited to the purpose. Was it because they were overtly non-sectarian (except for the occasional church steeple)? Was it because they depicted quiet, happy yesterdays in the midst of a turbulent world of change and danger? Because a quiet, snow-muffled New England was the secret dream of her fellow Americans, or their secret wish for those they wished well? A Thornton Wilder small-town New England, with background music by Aaron Copland? In other words, precisely what the critics hated about Grandma Moses. Emily Genauer, reviewing the story of Caldor and the miraculous discovery of Grandma for the *New York World-Telegram* in 1946, just as the first Christmas card deal was being struck, dismissed her pictures outright. Those who snapped up the paintings at gallery prices, she said, were being seduced by "the blandishments of picturesque subjects. They're of a piece with James Whitcomb Riley and the other poets of our childhood." Mrs. Moses' simple, easy-to-grasp pictures were Currier & Ives all over again, nostalgic imaginings of "the flavor of life in New England."[3]

On the other hand, Americans took their Christmas cards pretty seriously—at least as seriously as art critics took their reviews. The average sociable home, according to those who made it their business to know, received seventy Christmas cards a year in the late 1940s. Post offices were clogged with holiday mail as the system absorbed 50, 70, and then 100 million cards and more over a frenetic two-week period. Grandma Moses herself sympathized with people

who could afford her cards but not the pictures that hung in galleries. "If you put shellac over the [card]," she advised, "no one can tell it from a real painting. It will give just as much pleasure—perhaps even more."[4] Was a Grandma Moses Christmas card—and all Grandma Moses art—offensive to the critics because the dreams and good wishes and memories and outright falsehoods it contained were antithetical to what "Art" was currently supposed to be? Apparently, on her tip-up table in Eagle Bridge, she was making something else, some species of non-art.

Grandma Moses shared the non-art label with another prominent American painter of the 1940s and 50s: Norman Rockwell. Rockwell, the greatest illustrator of his century, rarely strayed into the confines of fine art where Mrs. Moses' dealers had ensconced her. Instead, until very late in life, he stuck with the commercial scene, painting more than 300 original covers for the *Saturday Evening Post* along with countless calendars, posters, ads, and greeting cards. In 1938 Norman and his wife, Mary (whose ancestors came from Vermont) settled in Arlington, Vermont, just over the state line and only twelve miles from Grandma Moses' farm in Eagle Bridge, New York. Thanks to his wife's friendship with local writer Dorothy Canfield Fisher, Norman became a full-fledged Vermonter in short order. Most of his subject matter from 1938 through 1953 was based on the life of his small New England town. Although his style of quasi-photographic realism had nothing in common with Grandma's, and his tone was more often wryly humorous than utterly sincere, the pair shared a common dilemma. They were beloved artists in the eyes of most Americans—and terrible artists in the eyes of most critics.

Fate or canny salesmanship brought them together in the flesh in 1948, when both were featured in a new Hallmark campaign to sell

Christmas cards as fine art prints. Throughout the previous year, Grandma Moses cards had been in the news, along with ads for *Grandma Moses: American Primitive* ("a memorable Christmas gift!" according to one prominent advertisement).[5] Her winter scenes—perfect for card designs—had begun to adorn the covers of middle-class magazines, including *House & Garden* and *Holiday.*[6] 1947's Hallmark cards had been a great hit. An article in *House Beautiful* argued that greeting cards were actually revealing self-portraits, and thus the sender ought to take care to send the right message. A card from "the sentimental school," for instance, suggested that the person who signed her name had a well-lived-in house, lots of lovely memories of Christmases past, and a tree bedecked with old family ornaments. "You mistrust bleached woods and chromium." So send a "Grandma Moses scene on a Hallmark card."[7]

Hallmark Cards, in the meantime, launched a massive campaign to sell those Grandma Moses Christmas cards by means of a brochure featuring a montage of recent Moses headlines and covers (including the *Holiday* magazine snow scene) and a biography. "She has had more newspaper publicity and magazine articles written about her in the past few years than any contemporary artist," it read. Her work had been "acclaimed by critics and plain folk alike."[8] The plain folk were clearly the audience for the cards, which came in boxed assortments of a dozen: the winter box was suitable for standard Christmas greetings, while the summer box carried with it the promise of seasonal renewal. Hallmark promised retailers vigorous sales support, including radio spots, window displays, and lots of other unspecified publicity.[9]

Meanwhile, back in Kansas City, Joyce Hall, the president of the company, was plotting strategy. By his own admission, Hall suggested to Norman Rockwell, the latest addition to the Hallmark sta-

Ad for Grandma Moses Christmas cards by
Hallmark Cards of Kansas City. 1948.

Select your Christmas greetings from

the beautiful paintings
of Grandma Moses_

the Grand Old Lady of American Art

*Reproduced exclusively—and exquisitely—
by the makers of Hallmark Cards,
these Christmas Cards by Grandma Moses are
part of that new treasury of priceless art
—the Hallmark Gallery Artists Collection*

Grandma Moses

YOU HAVE SEEN the works of Grandma Moses in many magazines. You have admired the primitive quaintness, the homespun simplicity, that have made her the grand old lady of American Art.

So *this* year make paintings by Grandma Moses your personal Christmas cards. Or select—in the Hallmark Gallery Artists Collection—from the works of 49 other great painters of the past and present.

The original canvases of many of these art treasures have been exhibited in the world's great art galleries. Others have been painted especially—and exclusively—for this unique collection.

And Hallmark craftsmen have reproduced them as Christmas cards with the elegance they merit.

Ask to see the Hallmark Gallery Artists Album at leading stores in your community. Also, all the *other* lines of Hallmark Cards. They are widely varied in design—in appeal—in price. There are Hallmark cards especially for men, Hallmark cards for sophisticated tastes—or conservative tastes.

There is, in short, a Hallmark Card that will appeal *particularly to you.*

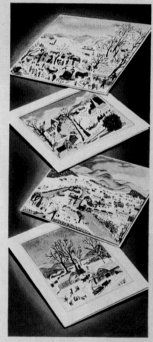

The Hallmark
Gallery Artists Collection
includes the works of:

CATHERINE BARNES
DOROTHY BLAHIN
MARY BLAIR
PAUL CEZANNE
MADYE LEE CHASTAIN
F. S. COBURN
SALVADOR DALI
ROBERT DOARES
ANGNA ENTERS
PAUL GAUGUIN
ESTHER GOETZ
DOUGLAS GORSLINE
EL GRECO
FANNY HOLTZMANN
LYNN BOGUE HUNT
CALDWELL JAMES
MERVIN JULES
LYLE JUSTIS
MARION KOHS
FRITZ KREDEL
MARIE LAURENCIN
SAUL LEVINE
MANLY MacDONALD
EDWIN MEGARGEE
CLAUDE MONET
GRANDMA MOSES
JON NEILSON
GUY de NEYERAC
GEORGIA O'KEEFFE
PABLO PICASSO
CAMILLE PISSARRO
TINA RABNER
NORMAN REEVES
AUGUSTE RENOIR
J. LASSELL RIPLEY
NORMAN ROCKWELL
EDITH SACHSEL
EMILY SARTAIN
ALICE SCHLESINGER
A. SHERRIFF SCOTT
NED SEIDLER
HENRY STOESSEL
DORIS STOLBERG
OTTO STORCH
NAHUM TSCHACBASOV
VINCENT VAN GOGH
MARCEL VERTES
LYND WARD
EDWARD WARREN
MAX WEBER
and selected subjects from
Currier and Ives

Hallmark
Gallery Artists
Christmas Cards

"When you care enough to send the very best"

Copr. Hall Brothers, Inc., 1948, Kansas City

You will enjoy the Hallmark Radio Program, 10 o'clock (EST) each Thursday night over the CBS nation-wide network. Be sure to listen.

ble of Christmas card artists, that he arrange to visit Grandma Moses in nearby Eagle Bridge on the occasion of her 88th birthday.[10] The pairing was the publicity bonanza that Hallmark had pledged to America's stationers. Newspapers from coast to coast were full of wire service photos showing Grandma, Norman, and Grandma's son and daughter-in-law, lips pursed, about to blow out the candles on a gigantic birthday cake topped off with a pair of dolls in characteristic Grandma Moses poses. But the center of attention was the cake itself, seven feet across and decorated around the sides with a sort of adaptation of a Grandma Moses snow scene—sleighs, horses, stiff little fir trees—by Norman Rockwell: *Out for Christmas Trees* (1946) done in buttercream icing. The cake was baked by his friend Frank Hall (of Frank Hall's Green Mountain Pine Room in Arlington), and it was Norman's unenviable task to get the cake to Grandma's house in one piece and to get it inside without tipping off the birthday girl!

The story Rockwell told about his struggles with the cake was pure Laurel and Hardy. By the time he and Hall arrived at the farm with the cake in the back of his station wagon, it was almost time for the festivities to begin. Enlisting a couple of visiting newspaper editors and a p.r. man as helpers and Hugh Moses as supervisor, Rockwell tried door after door, only to find that the cake was too big to fit into the house. Measurements were taken. Openings that ought to have been wide enough were not. There were false starts. Once they made it as far as the kitchen, only to be foiled by another narrow doorway. Finally, sweating and cussing, they dragged it around the house, through the side yard, up onto the porch, and into the front room, without denting the frosting or dropping a single one of the 88 candles.[11] By that time, nobody cared if Grandma's cake was a surprise or not.

Grandma Moses' 89th birthday party, with a smaller cake decorated by Norman Rockwell. Photograph. The Norman Rockwell Museum, Stockbridge, Massachusetts.

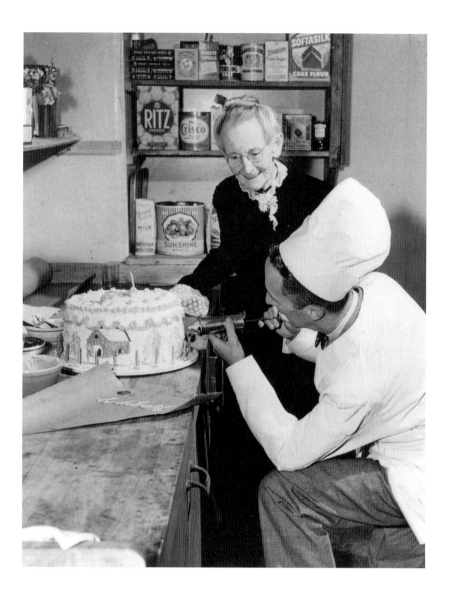

The guests at Grandma's party were a distinguished bunch: Otto Kallir, Rockwell, Mr. Hall (the baker), Grandma's doctor, and the usual corps of newsreel and newspaper functionaries. Governor Dewey sent a wire of congratulations. Rockwell was overheard telling a newsreel cameraman for Paramount about Mrs. Moses' new line of Hallmark cards. Someone let it slip that Hallmark had picked up the bill for the outrageous cake. And a famous photographer from New York City quietly circulated among the guests, taking pictures for a feature in *Life* magazine. Accompanied by a text that rehashed the story of Grandma's rise from dairy farming to fortune, the *Life* spread concentrated on two issues: her newfound wealth and her best-selling Hallmark cards. One card, *Winter Is Here* (1945), was a snow scene with a church; the other, a familiar *Sugaring Off.* Both were shown in *Life* alongside original poems written by the painter and reproduced in her own handwriting. "Oh, the snow. the snow. the beautiful snow," exclaimed the free-form verse accompanying the first picture: "Ringing, Swinging, dashing we go over the snow. dancing, flirting skimming along. / Beautiful snow it can do no wrong." The poet herself was something of a character. When asked if buying her pictures was a good investment, she advised buying chickens instead because they "will multiply."[12]

Afterward, the fortunes of Hallmark, Norman Rockwell, and Grandma Moses were intertwined, at least for a while. At the instigation of Joyce Hall, Rockwell had already paid an impromptu visit to Grandma's house and, although she worked in an upstairs bedroom which was usually off-limits to male visitors, got a firsthand look at her tip-up table. Mrs. Moses, that day, had no real idea of who Rockwell was but welcomed him anyway as an interested party and a fellow artist. Later, she would visit his studio in Arlington, curious about his brushes, his paints, and how he used photographs in

Norman Rockwell. *Christmas Homecoming.*
Cover design for *The Saturday Evening Post,*
December 25, 1948. The Norman Rockwell
Museum, Stockbridge, Massachusetts.

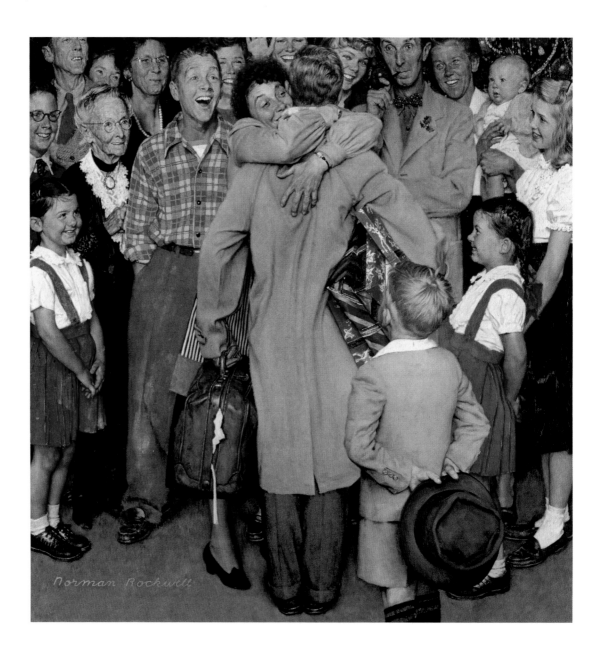

Designs on the Heart

planning his pictures. She couldn't do this herself, she said: photographs (and live, outdoor scenery) interfered with the flow of memory and imagination from which her works emerged.[13]

Whatever his professional motivations may have been in coming to Eagle Bridge, Rockwell was charmed by Grandma Moses. He drew her at that table in the upstairs studio, perched on a cushion, painting away, surrounded by her favorite spindly houseplants and her ubiquitous coffeepot. And in 1948, in his Christmas cover for the *Saturday Evening Post,* he put Grandma Moses (and himself, his wife, and his sons) in a crowd of Vermonters welcoming a local boy home for the holidays. In one hand, the young fellow clutches a suitcase full of dirty laundry; under the other arm, a stack of gaily wrapped presents. Grandma on the left and Norman on the right look on thoughtfully, as though considering the theme of "homecoming" for their next Christmas cards.[14]

The Hallmark ad blitz for the 1948 cards had been without precedent. In *Vogue, Life,* and the *New Yorker,* full-page layouts urged readers to buy "the beautiful paintings of Grandma Moses—the Grand Old Lady of American Art," on cards, of course.[15] Her scenes were spotlighted, but the Hallmark Gallery of Artists Collection also included a dizzying array of other painters, running the gamut from Disney stylists like Mary Blair to Pablo Picasso. There were Salvador Dali cards. Georgia O'Keeffe cards. Van Gogh and Renoir cards. Currier & Ives cards—cards, as the ads said, for every taste and budget. "There is . . . a Hallmark Card that will appeal *particularly* to you."[16]

The featured artists varied from magazine to magazine. In the plain-as-an-old-shoe *Post,* for example, Norman Rockwell and Grandma Moses were the stars. But in the more upscale *Harper's Bazaar,* Grandma appeared in the company of Dali and Picasso. In the realm of the Christmas card, then, the opinions of *Life*'s sophisti-

Cakes and Cards

189

cated tastemakers did not register in the slightest. What mattered was the possibility of picking out exactly what one pleased, even if that involved charm, sentiment, and sleighbells in the snow. Joyce Hall could scarcely contain his pride in having assembled a collection of cards by what he termed "the 50 foremost artists" of his time: "This marks the largest concentration of artistic talent ever mobilized for a single medium, and technical progress in graphic arts insures faithful reproduction."[17]

During the late 1940s, pumped up by mass marketing, popular art came into its own with the help of picture magazines and the new, more accurate techniques of color reproduction of which Joyce Hall was justly proud. With an enormous range of possibilities spread out before them, Americans were now free to exercise their own taste at bargain-basement prices, whatever the curators and the critics might say. Indeed, the prestige that once attached to critical opinion—and thus to people who followed the critics' advice—was undercut by the sheer volume of material available for purchase in the postwar museum without walls. Picasso. Grandma Moses. Dali. Except for those deeply involved in the art game, the stakes were no longer very high either. Reproductions were cheap and good. Class issues dependent upon a veneer of art were increasingly unimportant to Americans with the means to buy what they liked and the exuberance to enjoy what they enjoyed.

Rockwell, meanwhile, had become the unofficial cake decorator for the official annual birthday party of Anna Mary Robertson Moses. In 1949, the celebration moved to Arlington at the instigation of Dorothy Canfield Fisher, whose books on Vermont had helped to sustain the tourist industry in that state. The party was held at Frank Hall's restaurant, and Norman Rockwell, who flew in from Hollywood for the occasion, put the finishing touches on a somewhat

smaller cake in honor of Grandma's 89th birthday. The usual crush of photographers and journalists turned up, along with the members of the Arlington art colony—famous commercial and magazine artists, for the most part, including Rockwell's friends John Atherton, Mead Schaeffer, and George Hughes (whose works adorned the inside of Hall's Green Mountain Diner). When Grandma Moses blew out the candles, the crowd sang "Let Me Call You Sweetheart" over a national radio feed. And Grandma stayed up until 10 o'clock, before heading back to Eagle Bridge at the end of a long day.[18]

Whether or not the two popular celebrities of the hour ever paused to consider the fact, they had a great deal in common, the old lady and the dapper guy who flew in from Hollywood. Although his covers had been adored by millions since the 1920s, Rockwell came into his own during World War II with works that captured the American spirit in an especially direct and memorable way. His images of the home-front factory worker (his *Rosie the Riveter*) and the hometown boy in the Army (the *Willie Gillis* series) made reading the *Post* a patriotic duty during the 1940s. But more important, perhaps, were *The Four Freedoms* (1943), a group of images meant to interpret the lofty rhetoric of Franklin Roosevelt's recent radio address in easy-to-understand terms.

The speech reiterated the Atlantic Charter, a document promulgated by Roosevelt and British Prime Minister Winston Churchill in 1942, setting forth the basic human rights for which the Allied powers were committing their men and arms. These were the "Four Freedoms": freedom of speech and religion, freedom from fear, and freedom from want. In a group of paintings over which he agonized for months, Rockwell showed precisely how these abstract notions affected the lives of ordinary Americans on a day-to-day basis. His *Freedom of Speech,* for instance, shows a man rising to address a New

Cakes and Cards

Here Comes Aunt Judith. 1946. Oil on pressed wood. 18″ x 23″. Kallir 581. Private collection.

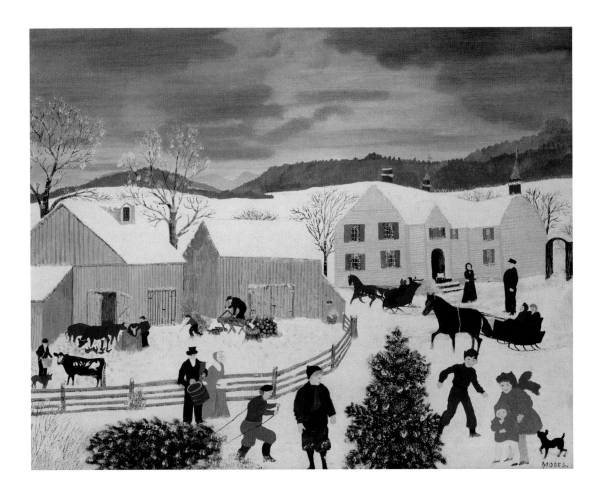

England town meeting, as his fellow citizens look on respectfully. The most popular of the grouping, *Freedom from Want*, shows a typical American family—three generations, several Rockwells—gathered around the table for Thanksgiving dinner.

Later, when the government turned the paintings into posters and the posters found their way to Europe, Norman Rockwell regretted that he had made the big turkey and all the "trimans" quite so promi-

The Dividing of the Ways. 1947. Oil on pressed wood. 16″ x 20″. Kallir 701. American Folk Art Museum, New York.

nent. It seemed cruel, in retrospect, when those caught in the teeth of the conflict often had little to eat. But like the famous "This is America" war posters, with their photos of iconic scenes worth fighting for—a New England farmhouse, a steamboat on the Ohio River, the mountains of Yosemite—Rockwell's pictures found the times and places that resonated deeply in the hearts of his countrymen.[19]

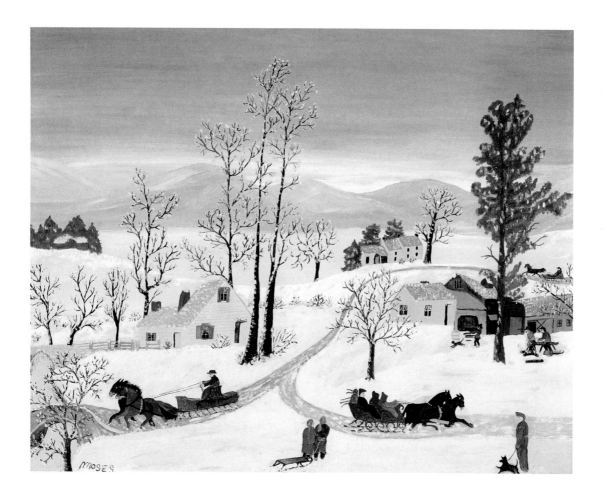

Cakes and Cards

It Snows, Oh It Snows. 1951. Oil on pressed wood. 24" x 30". Kallir 971. Private collection.

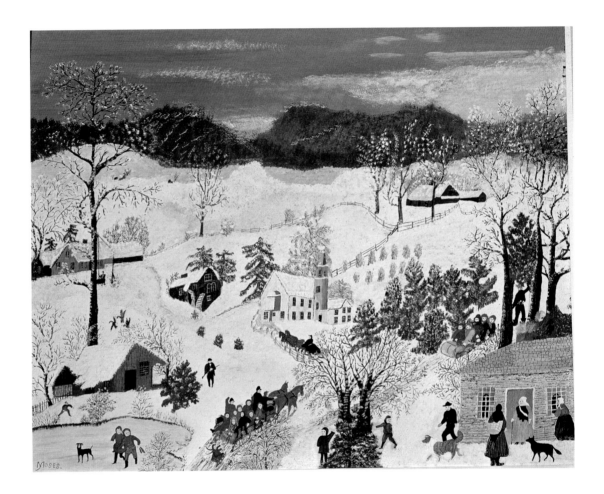

And so in her own way did Grandma Moses' scenes, when she tapped into the stream of memories of joyous holidays and home—memories that lent her work a credibility beyond the power of words alone to express.

As the demand for her Christmas cards grew, the number of

happy winter scenes in her repertory increased accordingly. The Christmas turkey needed catching. The first snow covered the farm. It was time to get out the ice skates, have a snowball fight, cut a Yule log, bring in wood for the stove and a tree for the parlor. A 1949 survey indicated that, of all the holiday mementos Americans could elect to send, they liked Norman Rockwell and Grandma Moses cards best.[20] *Look* magazine's weekly "photoquiz" asked readers if one of Grandma's snow scenes had been painted by (a) Norman Rockwell, (b) John Marin, or (c) Grandma Moses.[21] It hardly mattered to people who liked pictures of things they understood and enjoyed. "Grandma Moses, when she paints something, you right away know what it is," wrote a self-styled "former art lover," exasperated by abstraction.[22] For viewers tired of arcane jargon and critical airs, the Rockwell and Moses cards were well on their way to becoming "an art gallery for all the people" (at only $1.00 a box).[23] This was especially true for those who lived outside urban centers and far from New York City. As one New Mexico ad for the latest Hallmark assortments by Grandma and Norman gushed, the pictures were absolutely "unforgettable!"[24]

But the market for affordable versions of Grandma Moses' art went far beyond the Christmas card business. Given the familiar, domestic contours of her personality, the moment was ripe for Grandma's imagery to translate itself into formats more congenial to everyday use in the home. Beginning in the spring of 1950 (as no less a figure than Sir Winston Churchill was joining the cadre of Hallmark Christmas card artists), a well-coordinated national ad campaign announced a new line of licensed Grandma Moses fabrics— printed cottons, "faithfully and beautifully" reproducing her work on a textured surface that resembled museum canvas. The yard goods were versatile, too. Frame a length as a painting! Make it into slip-

Grandma Moses poses in a sunny window with a sample of Riverdale's "Williamstown" fabric, based on one of her paintings. Photograph.

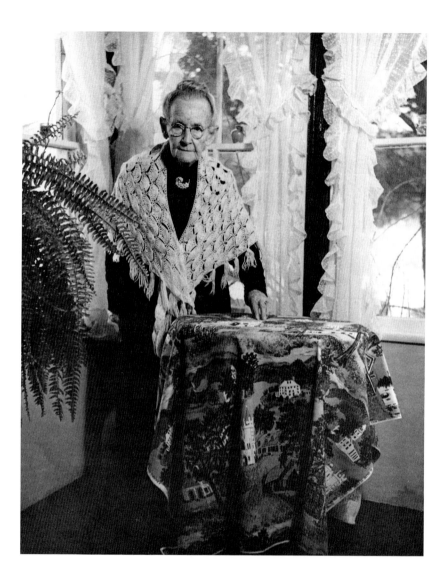

covers or draperies! "It's perfect for practically every type of home decor."[25] And inexpensive, at $2.50 a yard.

There were two patterns available early in 1950. "Williamstown," in darkish tones, showed "a quaint village scene" based on the landmarks of nearby Williamstown, Massachusetts. The other, "Childhood Home"—identified on the selvage edge as an "authorized Grandma Moses design from the original painting"—was an exuberant spring landscape, a giddy pastorale executed in a pastel palette of greens and pinks. The new fabrics were big news. Carson Pirie Scott, Gimbels, Famous-Barr, the J. L. Hudson Co., the Boston Store—all of the nation's premier department stores took full-page ads recommending ways in which the designs could be shown off to best advantage in *your* house. "Williamstown" did best, the decorators thought, against white brick walls in simple settings: "A modern . . . room is warmed by its detail, enlivened by its quaint precision." The Maytime landscape, with its animals and figures and "the freshness of true Americana," was ideal for upholstering pine furniture in the French provincial style.[26]

Norman Rockwell, who was no stranger to the practice of slipping art into the public arena on consumer products, paid homage to Grandma Moses' new enterprise in the autumn of 1950. His *Post* cover for November 18 showed a chubby redheaded boy wrestling with his trumpet lesson in a capacious armchair slipcovered in Grandma Moses' "Childhood Home" material. Rockwell found the little boy in North Bennington, Vermont. The fabric was made by Riverdale Manufacturing Co. and was available almost anywhere. It was enormously popular. By 1952, five more designs had been added to the Riverdale line, including two snow scenes (nice for kitchens). Entrepreneurs bought up these yard goods and manufactured unauthorized ready-to-hang curtains, drapes, and lampshades

Cakes and Cards

Out for Christmas Trees. 1946. Oil on pressed
wood. 26″ x 36″. Kallir 606. Private collection.

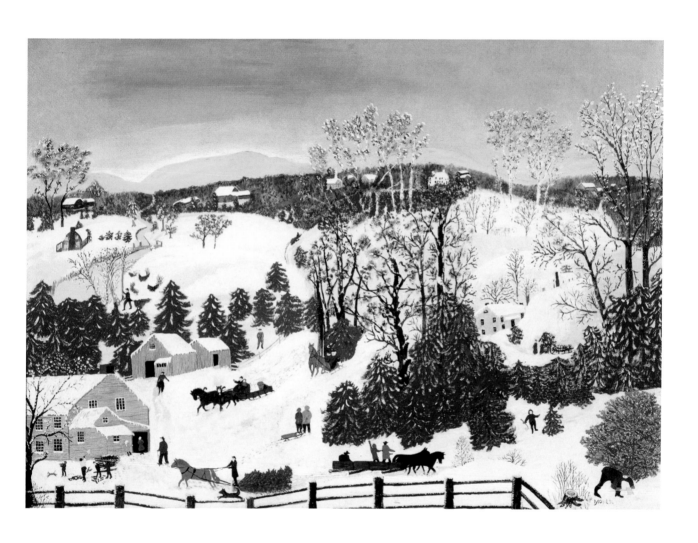

(the bases were made of discarded sap buckets!). The venerable
Middlebury Inn redecorated its formal dining room in "Grandma."
Homemakers' columns in daily newspapers heralded the use of
Grandma Moses cloth to make the faddish gathered skirts that teen-
agers craved.[27] Or dresses for the stylish matron. Mrs. Moses' own

granddaughter-in-law wore a homemade "Childhood Home" jacket to Grandma's 90th birthday party (there was another outsize Rockwell cake), held at the Albany Institute of History and Art and co-sponsored by Whitney's Department Store, where a nice selection of Moses products had just gone on sale.[28]

But there was more to come: plates in a "limited edition" series, each one with a scene on the front and a Grandma Moses poem in her own handwriting on the back. The plates came four to a set, and the subjects offered something for everybody: *Catching the Thanksgiven [sic] Turkey, The Red Checkered House, Out for Christmas Trees,* and *Jack 'n Jill.*[29] Less than $12.00 for the set at Macy's. The plate line, produced by the Atlas China Company, well known for durable kitchenware, was launched in a flurry of hoopla and press photos. Atlas sent representatives to Eagle Bridge bearing the very first set and brought along the usual gaggle of photographers, who posed Grandma on a Victorian loveseat, stiffly holding up one of the plates.[30] Macy's sold sets as bridal gifts, destined for the mantelpiece of a suburban ranch house. Using eighteen colors in the firing process, the plates were clearly intended to be decorative "art" items, but stores hastened to remind customers that Grandma-ware could also be used at the table.[31] There was, it seemed, no occasion, no part of the home, no time of day for which a picture by Grandma Moses would be inappropriate. Grandma aprons made from lengths of her fabric. Grandma knitting bags. Sewing boxes. Slipcovers. Sofa pillows. The list went on and on.

Advertisers of other products were quick to grasp the appeal of Grandma Moses in the marketplace. Sometimes, the connection between product and painter was somewhat tenuous. Lorillard cigarettes, for example, marked Christmas in 1950 with a large-scale reproduction of Grandma's *Out for Christmas Trees* surmounting a

carton of "Old Golds." Usually, however, there was a clear affinity between Mrs. Moses and the item being advertised. A case in point was the Thanksgiving promotion for General Mills products. In November of 1950, shortly after her 90th birthday, the company marked Thanksgiving Day with a reproduction of Grandma Moses' *Catching the Thanksgiving Turkey* (1944). The picture ran in a number of magazines and newspapers with a display of the company's home baking products, including Gold Medal Flour and "Bisquick" mix.

As would soon become apparent, there was a fine irony to this admittedly third-hand relationship between Grandma Moses and General Mills. In 1949, in a ceremony that prompted intense interest, the Women's National Press Club of Washington, D.C., held a ceremony honoring its choices for the six outstanding American women of 1948. The awards were bestowed by President Truman himself, and the honorees included Eleanor Roosevelt, Grandma Moses, and Marjorie Child Husted. The notion that accomplishment is gender-specific was so fundamental to the thinking of the period as to escape remark. So Eleanor Roosevelt, then chair of the United Nations Commission on Human Rights and one of the most influential figures in American life in the twentieth century, often found herself in popularity lineups with actresses or, in this case, with the very first female mayor of a town with a population of more than 500,000 souls. Grandma (nonplussed, as usual, by mingling with the famous) was an easy choice for the Press Club: in terms of sheer lines of type devoted to her rise, she was a major newsmaker of 1948. But Mrs. Husted was different. In "real" life, she had recently been named "consultant in advertising, public relations, and home service" for General Mills, "with duties similar to those of a vice-president."[32]

She was, in fact, the woman behind Betty Crocker, the friendly, fictional lady in red who knew everything about cooking, baking,

Ad for Old Gold cigarettes. 1950.

"Out for the Christmas Tree" from the original painting by Grandma Moses

Again...as we have every year since 1760, the makers of **Old Gold** cigarettes wish you a Merry Christmas and a Happy New Year.

P. Lorillard Company
Established 1760

Flanked by Bess Truman and Eleanor Roosevelt, Grandma Moses receives the Women's National Press Club Award from President Harry Truman, May 14, 1949. Photograph.

and entertaining—the logo for General Mills' direct-to-consumer products. The publicity surrounding the awards never questioned why Marjorie Husted did a vice-president's work without the corporate title. But Grandma's appearance in a General Mills Thanksgiving ad in which home cooks—America's Bettys and Grandmas— were engaged in holiday meal preparations speaks volumes about the domestic context in which Grandma Moses' art appeared on lampshades, plates, and slipcovers.

In Washington, dressed in her usual black velvet and lace and wearing a bunch of violets on her dress, Grandma Moses was invited home for tea (she asked for coffee) by Harry Truman, who played the piano for her because she asked him to. "He's just like

one of my boys," she declared. "I can't make him seem like the President."[33] Although this meeting was one of the major events in the career of Grandma Moses, it was as cozy as any Sunday visit in the front room at Eagle Bridge. The same sense of living-room intimacy also dominated a major exhibition of the art of Grandma Moses mounted in 1952 by the Dayton Company of Minneapolis, the city in which General Mills was headquartered. Dayton's department store, in the heart of downtown, was a cherished local institution and a respected innovator in window display, promotion, and community service. Even given that history, however, the Moses show held in the Assembly Room at Dayton's during the month of April was another milestone in the ongoing relationship between the art of Grandma Moses and the fortunes of American business. Like the Gimbels Forum years before, the Dayton's show celebrated her work, her longevity, her femininity, and the perceived connections between her work and the ideal American domestic scene.

In its announcements of the exhibition, Dayton's publicists stressed the comprehensive nature of the enterprise: there were sixty-one paintings borrowed from a variety of private lenders (in addition to her several dealers), including some of her most famous images. *Grandma Moses' Childhood Home* (1942; the prototype for the fabric design), *The County Fair* (1950), and *Grandma Moses Going to Big City* (1946) were the featured works—all spring landscapes themed to the season and reflecting the strong emphasis on seasonal merchandise in the retail trade. But Dayton's ads also acknowledged the importance of the 25 million or so Grandma Moses Christmas cards sold during the previous year. Two entire floors of the store were devoted to cards and other products that used designs taken from her work.[34] The big show windows along Nicollet Avenue were draped in Grandma Moses fabrics. They covered a chair, filled in a picture

Cakes and Cards

Show window at Dayton's department store in Minneapolis decorated for a spring display of Grandma Moses paintings and licensed products, 1951. Photograph.

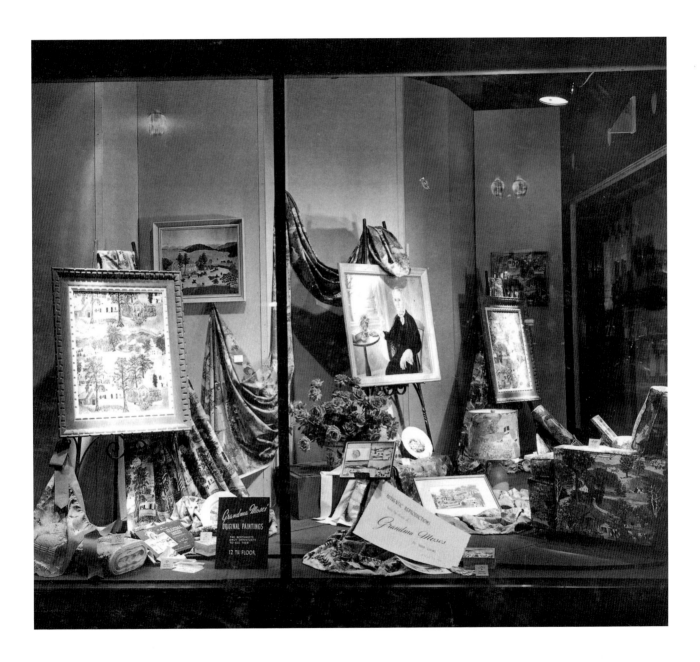

frame, and cascaded in swags over a picture of Grandma herself, mounted on an easel. Plates, lamps, and books completed the display, which resembled nothing so much as a comfy Minnesota living room in which the lady of the house had gone a little overboard with her Dayton's charge-a-plate.

In an effort to inject a note of urgency into the proceedings, Dayton's added a little caveat to each ad: "Today, at 91, her brush is idle and her days are numbered, but the well-wishing of millions is hers to cherish." In truth, during most of the 1950s Grandma Moses continued to churn out a credible amount of work, despite her advancing years. She kept up a steady round of public appearances. Dorothy Canfield Fisher persuaded Mrs. Moses to contribute paintings to the annual Community Chest "Red Feather" campaign and joined her on radio programs to aid the cause. Whenever the announcer handed Grandma a script, though, she tossed it aside and spoke her mind. "Nobody was making up answers for Grandma," said Mrs. Fisher.[35]

And she launched at least one "brand new business." A friend in the neighborhood had introduced Grandma to tile painting in 1951, knowing of Mrs. Moses' interest in embellishing her own little home. As a hobbycraft, tile painting was popular in the 1940s and 50s, especially among women. The tiles themselves were small in size, less demanding than full-scale compositions, and quickly finished. Within the space of a year, Grandma Moses had painted some eighty-five tiles enlivened with vignettes—quick sketches of small motifs. A church, a hill, a few trees. A colonial lady with a spinning wheel, two kids, some decorative daisies. A bird, a butterfly, a branch. Less than a year after that, inexpensive reproductions of the Grandma Moses tiles hit the stores in time for Christmas giving. "Simple Charm." "Glowing colors." "Priced to sell at $2.50 each." By

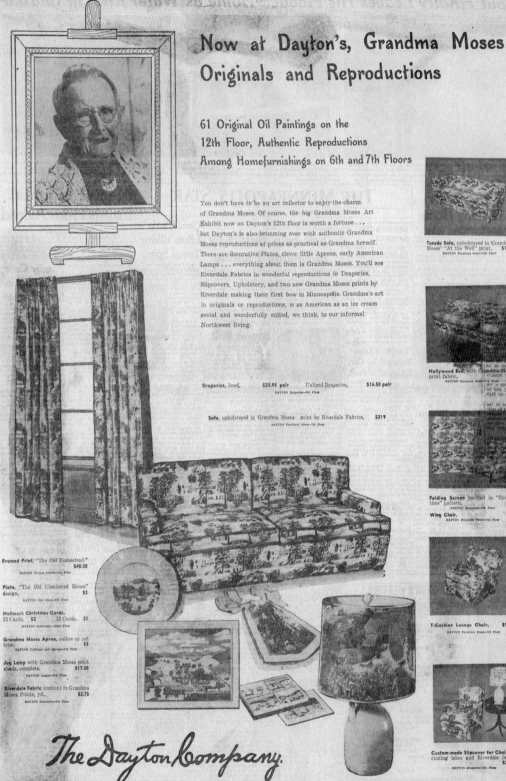

Now at Dayton's, Grandma Moses Originals and Reproductions

61 Original Oil Paintings on the
12th Floor, Authentic Reproductions
Among Homefurnishings on 6th and 7th Floors

You don't have to be an art collector to enjoy the charm of Grandma Moses. Of course, the big Grandma Moses Art Exhibit now on Dayton's 12th floor is worth a fortune . . . but Dayton's is also brimming over with authentic Grandma Moses reproductions at prices as practical as Grandma herself. There are decorative Plates, clever little Aprons, early American Lamps . . . everything about them is Grandma Moses. You'll see Riverdale Fabrics in wonderful reproductions in Draperies, Slipcovers, Upholstery, and two new Grandma Moses prints by Riverdale making their first bow in Minneapolis. Grandma's art in originals or reproductions, is as American as an ice cream social and wonderfully suited, we think, to our informal Northwest living.

Draperies, lined, $25.95 pair Unlined Draperies, $16.50 pair
DAYTON Draperies—6th Floor

Sofa, upholstered in Grandma Moses print by Riverdale Fabrics, $219
DAYTON Furniture Store—7th Floor

Tuxedo Sofa, upholstered in Grandma Moses' "At the Well" print. $179
DAYTON Furniture Store—7th Floor

Hollywood Bed, with Grandma Moses print fabric, $77
DAYTON Furniture Store—7th Floor

Folding Screen covered in "Springtime" pattern, $36
DAYTON Draperies—6th Floor

Wing Chair, $89
DAYTON Furniture Store—7th Floor

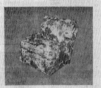

T-Cushion Lounge Chair, $98.50
DAYTON Furniture Store—7th Floor

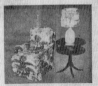

Custom-made Slipcover for Chair, including labor and Riverdale fabric, $34.75
DAYTON Draperies—6th Floor

Framed Print, "The Old Homestead," $40.50
DAYTON Picture Studio—6th Floor

Plate, "The Old Checkered House" design, $3
DAYTON Gift Shop—6th Floor

Hallmark Christmas Cards,
25 Cards, $2 12 Cards, $1
DAYTON Stationery—Main Floor

Grandma Moses Apron, yellow or red trim, $3
DAYTON Uniforms and Aprons—6th Floor

Jug Lamp with Grandma Moses print shade, complete, $17.50
DAYTON Lamps—6th Floor

Riverdale Fabric (cotton) in Grandma Moses Prints, yd., $2.75
DAYTON Draperies—6th Floor

The Dayton Company.

the end of 1952, thousands and thousands of American kitchens were brightened with rows of tiles by Grandma Moses, dishes by Grandma Moses, tie-back curtains by Grandma Moses. "Some folks say Grandma is always painting the same thing," Mrs. Moses complained to a visitor. "But there are no two rivers the same, no two trees, no two skies. And no two grandmas."[36]

Newspaper ad for Dayton's exhibition, April 1951. Target Corporation.

9. G. Moses, Inc.

Five years after her debut, Anna Mary Robertson Moses still tended to denigrate her artistic efforts. She just "turned 'em out," she told a sympathetic listener in 1946. "Since I've started countin' about three years ago I've done 1,093. That's not so bad, is it?. . . . I look on my paintings more as a fad. Don't see so much beauty in them."[1] Her private correspondence with Louis Caldor suggests that sudden popularity had brought with it increasing pressure to produce. "I am very busy, more and more each day," she confessed to him in 1944. "There seems to be no rest for the weary."[2] Both the volume of her pictures and the prices they commanded were matters of more than passing interest to unsympathetic critics. Emily Genauer, in a review of a Moses solo show at the American British Art Center in New York in 1946, implied that painting forty-four brand-new canvases for the occasion was quite a feat—especially at prices of $2500 or more (Genauer's figure was inflated for effect!) for works whose best quality was that "they'd look dandy over the fireplace."[3] Grandma Moses worked too fast. She painted too much. Even before she became big business in the 1950s, her work was seen in some circles as a product, a commodity, like the chickens that she herself so often advised would-be artists to tend instead of their easels.

Increasingly, as her popularity soared, charges that Grandma Moses was being commercialized (or was part of the racket herself) grew along with her list of radio appearances, awards, much-photographed birthday parties, and celebrity patrons.[4] Cole Porter, it was

said, never went on the road without a big Grandma Moses snow scene to make his hotel suite seem like his home on the forty-first floor of the Waldorf Towers, where another winterscape by Grandma always hung in the place of honor over the piano.[5] Her name was mentioned in a Broadway review staged by George Abbott in which a blow-up of one of her pictures served as scenery. At a Waldorf-Astoria Ballroom charity "do," fashion models primped and slinked before a backdrop of *Hoosick Valley (from the Window)* (1946).[6] She was a definition in the morning's crossword puzzle. The outstanding "Grammaw" of 1949. A presence in a *New Yorker* cartoon, where the scene is a sparsely furnished garret with a painter sitting dejectedly before an empty canvas. His irate wife provides a running commentary: "Grandma Moses doesn't get into a funk. . . . Grandma Moses isn't hamstrung by the tensions of her time. Grandma Moses knocks them out one after another."[7] Grandma. Grandma. Grandma.

A self-styled "hobby expert" told whoever would listen that Grandma Moses was being "exploited too much" by her dealers—that she was, essentially, a Sunday painter trapped in a clever scheme to milk her popularity for profit: "[She] must follow a 9 A.M.–8:30 P.M. schedule to meet the demands of the salesmen."[8] The claim was absurd but it took on a life of its own, especially in New England. Another "expert" was equally certain that Grandma had been "nastily commercialized—transformed from an untaught old lady who painted for fun into a decade-long sensation" commanding $3000 prices.[9] With every article, reports of her current prices rose stratospherically! For good or ill, hers was a reassuring version of the classic farm-to-fame-and-fortune story.

The skeptics found some vindication in a press release issued in the fall of 1952, announcing the creation of Grandma Moses Prop-

Hoosick Valley (from the Window). 1946.
Oil on pressed wood. 19″ x 22″. Kallir 611.
Private collection.

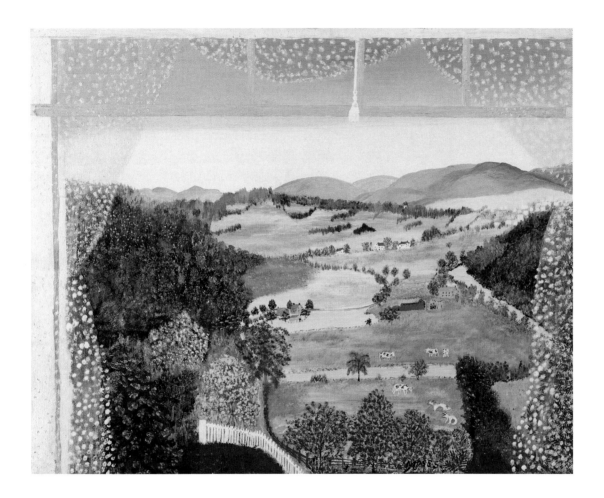

erties, Inc. Set up by Otto Kallir and his Galerie St. Etienne, the new corporation existed for the protection of valuable copyrights governing the reproduction of her work. According to the officers of the company, it had taken shape two years earlier when lucrative contracts for greeting cards and textiles were first under consideration. The goal was to protect the assets of a woman so indifferent to the

G. Moses, Inc.

dollars-and-cents aspects of her profession that she was apt to keep her earnings stuffed in the sugar bowl or the closest bureau drawer.

The moment was ripe for new financial arrangements. Grandma Moses china now came in complete sets with coffeepots, sugar bowls, platters, gravy boats, and the like, decorated in brightly colored "fadeproof" scenes guaranteed to be dishwasher-safe.[10] Every season, vendors found some new use for Grandma Moses Riverdale fabrics. Department stores from coast to coast featured "Art-Gallery" skirts boasting "vivid, exact reproductions of Grandma Moses' famous paintings," in a variety of patterns all guaranteed to be "washable and colorfast" and authentic in color down "to the tiniest Brush Strokes." By Mack Sepler. Usually, $10.95. Only $6.95, on sale in Stern's Basement on West 42nd Street ($7.95, that same season, in Colorado Springs and Billings, Montana).[11]

The curtain business likewise showed no signs of abating. For the giftware trade, Crown Potteries of Evansville, Indiana, added teapots, pitchers, tumblers, and cake plates to their existing Grandma Moses line.[12] Christmas gift suggestions from the women's pages of 1954 included Grandma Moses fabric-covered sewing buckets that could double as makeup cases.[13] Grandma place mats, napkins, tea towels, and pot holders were big holiday items in St. Louis that year.[14] Four box tops from Post Grape-Nuts Flakes could get you four 5×7-inch Grandma Moses reproductions in full color early in 1955. "These prints reflect the Early American scene in a style that is simple, colorful and nostalgic," it said on the mail-in coupon. "Original paintings by Grandma Moses are exhibited in the finest museums, and sold for thousands of dollars." But now art worth thousands could be yours for the price of a skirt, a sugar bowl, a napkin. Or absolutely free from C. W. Post, a division of General Foods.[15]

1955 also brought Grandma Moses wallpaper.[16] In 1956, at Easter-

Child's Grandma Moses dress, c. 1956.
Fuller Fabrics for Cinderella Frocks.

time, Macy's of San Francisco introduced its annual spring flower show with a series of show windows depicting famous artists painting pictures composed of live blossoms: Van Gogh, Renoir, Grandma Moses, Gauguin.[17] Heady company for an old lady simultaneously being honored with a display of fabrics, a lampshade, china, some clippings, and a sewing box at the home of the president of the Warsaw, Indiana Clio Club.[18] There were scrubbable Grandma Moses murals from the Easy Apply Corp.—a Williamstown landscape eleven feet wide, suitable for kitchen or playroom.[19] "I can't rave too much about them," gushed the women's page editor for a Roanoke, Virginia daily. "A marvelous way to give originality to a room!"[20]

And then there were the pretty spring dresses for little girls by

G. Moses, Inc.

213

Cinderella Frocks. "A quaint look," said one trade paper, describing a print called "Moss Rose, bearing the signature of famous Grandma Moses." A pinafore—for that old-fashioned Victorian look—came in several different printed cottons: landscapes, roses, an "Old Mill." The patterns, said the retailers, had been "adapted from authentic Grandma Moses paintings."[21] As ads for the dresses by Cinderella Frocks began to pop up in newspapers everywhere in 1957, they subtly implied that Grandma herself had been involved in the tailoring process—but she had not, as the fine print would show. "In a three-way collaboration," stated a New York press release, "designers selected suitable excerpts from four of her best known paintings"; using their dominant colors, the designers created wash-and-wear outfits around them.[22] Demure and frilly, with high lace-edged collars and flaring skirts, the dresses were a kind of imaginative, "nostalgic" throwback to the kinds of store-bought dresses that little Sissy Robertson might once have longed for. But the skirts were short and modern—the kind of clothes that a real live 1957 grandmother might buy for her favorite granddaughter. "One more field is invaded by energetic Grandma," read a typical headline.[23]

In the meantime, the Grandma Moses, Inc. of the ads was also Grandma Moses, the public figure whose doings made front-page news. Wearing a lace collar that could have served as the model for one of her children's dresses, Grandma Moses was *Time*'s cover person for the Christmas issue in 1953. Late December was traditionally a slow period for news outlets, one often given over to human interest stories. Yet the selection of the nation's favorite Christmas card designer (the background of the Boris Chaliapin portrait was a Grandma-like church in the snow) was not without significance.[24] In the 1950s, cover "girls" were a rarity: *Time*'s America was the world of men. The elderly seldom made an appearance either, unless they

were statesmen whose wrinkles indicated their night-and-day concern for the good of mankind. Grandma Moses was an anomaly: an artist of note (but not without controversy), a female, a wit, and an entrepreneur—a phenomenon, who cheerfully posed in funny hats to the delight of the press corps.

In June of 1954, her hat was the mortarboard she donned to receive an honorary degree from Russell Sage College in nearby Troy, New York. Her only complaint about that event, she said, was that "they didn't let me keep the cap."[25] She was fond of peculiar headgear. For her 90th birthday party in Albany, she turned up in a photogenic little hat she had made herself, a bonnet that resembled a black pie plate (lined in pink, of course) held in place with a velvet chin strap.[26] When she turned 100 in 1960, famed photographer Cornell Capa took her picture for the cover of *Life* decked out in a sublimely silly little number composed of blue and purple artificial roses.[27]

Grandma Moses was also something of a political figure, despite her steadfast refusal to favor one candidate over another. A 1952 *Life* feature on interior decorating posed Harry Truman's daughter Margaret in front of a Grandma Moses painting to represent the "American Look."[28] Grandma's meeting with a kindly and attentive President Truman in 1949, she often remarked, had been one of the highlights of her life. Truman was a Democrat. In 1956, a Republican President's cabinet commissioned a Grandma Moses painting as a gift to the boss in honor of the third anniversary of his inauguration, when "Salute to Ike" dinners were being organized around the country. Eisenhower, an enthusiastic amateur painter, had already expressed his admiration for Mrs. Moses' work and now, at a ceremonial unveiling attended by the First Lady, Secretary of State John Foster Dulles, and other dignitaries, pronounced himself delighted

with the present. The new picture, he said, "would be helpful to him in developing his own style." For her part, Grandma Moses had sent a letter along with the painting, admitting her pleasure at undertaking the task of painting Ike's new farm at Gettysburg from twenty-odd photographs supplied by the White House (something she had never done before). "Although most of my paintings are memories and imagination," she wrote, "I tried to do this for you and I hope it will please you."[29]

Eisenhower had recently suffered a heart attack. The world situation was tense. In this atmosphere, the formal unveiling of the painting offered a great opportunity for jovial interaction with the press corps. Eisenhower made the most of it, pointing to the unusually large putting green Grandma had added to his front lawn and the too-generous allotment of Holstein cows she had sprinkled across his acreage.[30] Some journalists made fun of her several deviations from reality. (Others questioned the frivolity of an event manufactured to order for the papers while more pressing business was at hand.) But an editorial in the *New York Times* praised the gift, "mistakes" and all. Grandma Moses' departures from the visual facts in the photographs, the writer speculated, were deliberate efforts to "paint happiness and peace. And this, in spite of H-bombs and high water, wars and rumors of wars, an impending election and a difficult decision, she has done."[31] Grandma, in her heyday, had become a symbol of nonpartisan good will.

Grandma Moses was celebrated not only for being perky, old, and just plain famous; she was also a figure of some importance in the art world. In that rarefied milieu, where Christmas cards and wallpaper styled after one's paintings were more apt to earn scorn than praise, her position was more problematic. Few ventured to say out loud that she was a *bad* painter, yet much of the criticism damned

The Eisenhower Farm (at Gettysburg). 1956. Oil on pressed wood. 16″ x 24″. Kallir 1205. The Dwight D. Eisenhower Library, Abilene, Kansas.

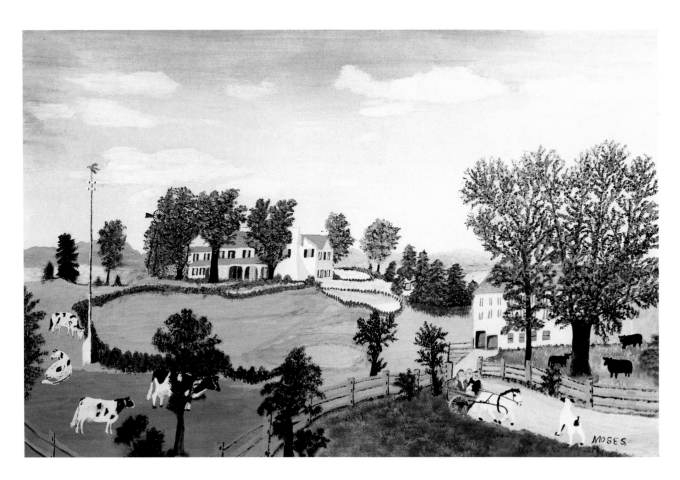

her with faint praise. She was tolerated, patronized. Her pictures were "charming" or pleasant; her world of memory and imagination was seen as lacking the high seriousness expected of important American painters. Her iconographic interest in communal labor ran counter to the emphatic individualism of Abstract Expressionism. That her dealers were able to keep her work before a gallery-going public during the 1940s and 50s and to garner respect for her paintings abroad was a major accomplishment.

G. Moses, Inc.

217

The Eisenhower Home. 1956. Oil on pressed wood. 16" x 24". Kallir 1204. Private collection.

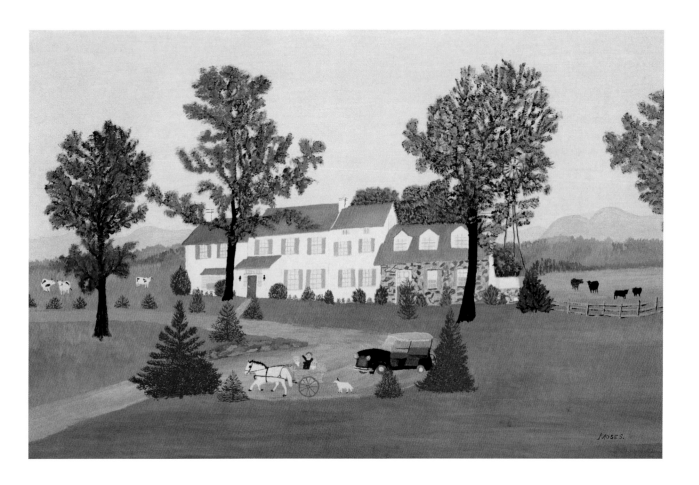

One key figure in the campaign to sustain the reputation of Grandma Moses-the-Painter was Ala Story. The Austrian-born Story had come to New York from London in 1940 to direct the American British Art Center on West 56th Street. Steered to Mrs. Moses' work by Otto Kallir, Story attended the Syracuse exhibition at which

Grandma won the New York State Prize and came away the proud owner of a $35 Moses original. "I decided that the illusion of her world pleased me immensely," Story wrote in 1953, "and that I happily liked to enter it."[32] At Kallir's urging, she made the drive to Eagle Bridge and came away with an agreement to show thirty-two Moses paintings at the British Center in 1942. Thereafter, Ala Story became part of the Moses inner circle—a birthday party regular. She was a member of the entourage when Mrs. Moses made her celebrated excursions to Radio City and the Metropolitan Museum; she was with her when Grandma met Eleanor Roosevelt.

It was Story who urged the old lady to try larger formats and indoor subjects, and she who arranged for the documentary filmmaker Erica Anderson to spend time with Grandma at Eagle Bridge, in hopes of one day making a movie about her life and work. And in the decade between 1942 and 1952, Story mounted no fewer than five major Grandma Moses exhibitions at her New York establishment. Assembled with the cooperation of Kallir and his gallery, these shows gave Grandma Moses and her work added exposure in the city and greater credibility. Although both Story and Kallir dealt in Moses paintings, thanks to the former's efforts Grandma Moses no longer seemed to be the private crusade of a single agent.

The exhibitions at the American British Art Center redoubled the impact of Grandma Moses' art. In the late 1940s, as the Cold War began in earnest, the State Department set up several modest exhibition programs aimed at winning overseas support by showing Europeans that the United States was not a nation of soulless materialists. The first of these touring shows, assembled in 1947, consisted of American art in corporate collections—most notably, work from the 30,000-item IBM Collection put together by Tom Watson, Grandma Moses' patron and supporter. The second, a show of recent Ameri-

can art purchased by the State Department and previewed at the Metropolitan Museum in 1946, was called "Advancing American Art."[33]

"Advancing American Art" touched off a firestorm of protest among public officials and editorialists opposed to both "modern" art and federal subsidies to the arts. Much of the nasty rhetoric that greeted the show amounted to Red-baiting, belated New Deal-hating, or Truman-bashing (although Harry Truman was no fan of "ham and eggs" art). The art itself, some of it mildly abstract, was labeled "junk" by enemies of the project. It was "infected by Communists." "Trashy."[34] The show was an insult to the taxpayer and a confirmation of foreigners' worst fears that Americans were utterly without culture. In this atmosphere of rancor and confusion, Grandma Moses prospered, almost by default. She became the American artist most likely to emerge unscathed from the bitter art wars of the decade and was positioned to become one of her nation's best Cold War ambassadors abroad.

In a footnote to poet Archibald MacLeish's catalog essay for the 1948 Moses show at the British Center, it was noted that Mrs. Moses had been invited to exhibit her work in Europe. For his part, MacLeish (former Librarian of Congress and Assistant Secretary of State) concentrated on the Americanness of Grandma Moses, even while denying that he was doing so. "Her paintings are a pure delight," he wrote, "cool and sunny and clear as a Mason Jar full of spring water. . . . She has been praised as an American painter and so of course she is—more American than most with her paint brushes from Sears Roebuck, and her first show in the window of Thomas' drug store. . . . Those who think to patronize her would do better to begin with a stone wall or a maple tree or the green mountains over

the state line in Vermont."[35] In other words, Grandma Moses was as American as Sears, New England, and Mom's apple pie.

The catalog essay for Ala Story's 1950 Grandma Moses show, although written by a far less distinguished figure, echoed the sentiment: "Her work has an undeniable American flavor which strikes a responsive chord in her fellow countrymen and at the same time engages the attention of her foreign admirers."[36] At home, however, the British Art Center shows met with a mixed reception. Carlyle Burrows, the longtime art critic for the *Herald-Tribune,* was always favorably disposed to "kindly Grandmother Moses" and delighted by "the variety of pleasant rural scenes" she conjured up, whatever the season.[37] But others, to whom "pleasant" was the antithesis of what art ought to be, were vehement in their insistence that her nostalgia was a retreat from the harsh facts of the day—that *real* art in this modern world was called upon to be unpleasant, or at least non-pleasant.[38] In light of Clement Greenberg's belief that art should retreat from the political involvements of the 1930s—the virtue of the new abstraction he championed was that it dispensed with the heroic farmers and workers of the Depression era—the dismissal of Grandma Moses because she *was* disengaged is typical of the critical confusions of the postwar era. Perhaps she was just too optimistic about humankind to suit the poison-pen Torquemadas who demanded sterner stuff of American painters.

As for Grandma Moses and her dealers, the late 1940s were a time of honors heaped upon triumphs. Her work hung in the Met. She was the toast of the prestigious Carnegie Annuals. One of her paintings of Williamstown, Massachusetts, was even chosen as the cover picture for *Art Digest* in 1947. Moreover, Otto Kallir's scrapbooks were brimming over with clippings culled from European news-

papers and magazines, expressing curiosity about this latest American phenomenon in advance of a planned 1950 tour.[39] That tour of fifty pictures, organized by Kallir and circulated under the auspices of the U.S. Information Service (U.S.I.S.), began at Kallir's Neue Galerie in Vienna. "At last," cried a member of the opening-day crowd, "a happy world!" Professional critics were more analytical, wishfully looking for traces of Bruegel and Flemish miniatures in her New England landscapes. But the consensus was that "there's something for everybody to enjoy" in the works of Grandma Moses.[40]

The tour rolled on to the Netherlands, Germany, Switzerland, and finally to Paris. At every stop, interest was keen; in Europe, the "peintres naïfs" had long been accepted as legitimate talents in their own right and important sources of inspiration for avant-garde modernists.[41] In Paris the French "primitive" Camille Bombois turned out for the invitation-only reception, along with Jean Cassou, the chief curator of the Musée National d'Art Moderne. Much to the chagrin of American intellectuals eager to witness a hoped-for triumph of the New American Abstraction in Europe (where "cocacola-ism" had already carried the day),[42] a Grandma Moses became the first contemporary American painting purchased by Cassou's museum. Other public collections followed suit.

The Grandma Moses show in Paris (hung in the ornate Rothschild Mansion) came at an exceptionally fraught moment in the postwar drive by determined supporters of Abstract Expressionism for parity or outright superiority over Europe in matters artistic. The American display at the 1950 Venice Biennale, which included a one-man show by John Marin as well as works by de Kooning, Gorky, and Jackson Pollock, had been greeted with what amounted to a resounding ho-hum, much to the chagrin of those who championed

the painters chosen for the U.S. pavilion. According to the *New York Times,* European critics found little in American abstraction that differed markedly from what was going on in their own countries—except, perhaps, for Pollock, whose paintings had already been vigorously promoted for several years by Peggy Guggenheim from her palazzo on the Grand Canal in Venice. But Pollock's methods, his canvas-on-the-floor paint-dripping, had been so thoroughly discussed already that there was little real excitement about the latest display of his work.[43] The Biennale was a bust.

Its failure, many feared, would only confirm Europe's belief that Americans were cultural barbarians, mired in smug materialism, incapable of "keeping up" with advanced ideas in the international arena of art. Given an already strained relationship between the invading promoters of Abstract Expressionism and a French establishment wary of colonization, a small painting hanging in the Musée Nationale d'Art Moderne in Paris (its placard read "Grandma Moses, École Americain") was enough to arouse dire suspicions of Gallic irony at *Art Digest.*[44] Their scathing editorial on the subject of the Grandma purchase elicited a sharp reply from Otto Kallir,[45] who pointed out that the French had purchased *The Dead Tree* (1948) by Mrs. Moses simply "because the museum appreciated the *quality* of the work"—and not, as some feared, to make mockery of the United States by suggesting that Sunday painting by little old ladies was all the nation had to offer. Although a major London critic reviewing the Paris show called Mrs. Moses "an artist whose paintings reveal a quality identical with genius," the critics back home were, for the most part, either sullen or silent.

The exception was Robert Goldwater, Paris correspondent for the *Magazine of Art* in the early 1950s. A highly respected art historian, Goldwater in 1938 had published a seminal work on the rela-

G. Moses, Inc.

223

The Dead Tree. 1948. Oil on pressed wood. 16″ x 20″. Kallir 792. The Musée National d'Art Moderne, Paris.

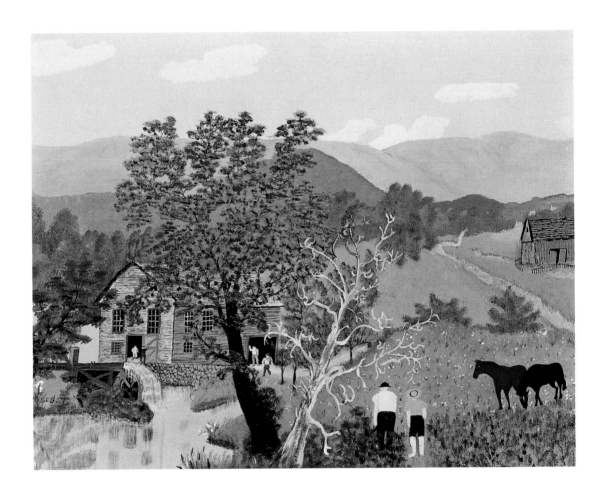

tionship between "modernism" in early twentieth-century Europe and primitive art, including ethnographic art, child art, and contemporary "naïfs" or Sunday painters.[46] Given his scholarly interests, then, Goldwater might have been expected to cut the Moses show a little slack. Instead, he lamented the fact that the Embassy was so strapped for funds that it could "do no better than Grandma Moses." Just "leave bad enough alone" next time, he advised. "What is

needed is more . . . of Pollock and de Kooning." Quality rather than supposed displays of the national character. And as if that weren't enough, Goldwater concluded his diatribe by dismissing the U.S.I.S. show out of hand as ill-advised propaganda, a "grand style exhibition which seeks to impose a country's preconceived notion of its art."[47]

The French, on the whole, *did* believe that Grandma Moses' pictures represented qualities deeply embedded in the American spirit. *Le Monde* spoke of her "serene sweetness" and the pleasure Americans took in recognizing themselves in her images. *Paris-Presse* saw in her skies and her groups of limber little figures evocations of "the greatest realistic painters of the past." But as one American in Paris observed, the critics' views were not very important in the long run: "She is bound to mean the most to everyday people living in an unhappy world who, during the few minutes they look at Grandma's pictures, drink in her memory of a happy world."[48] Yet the contempt of American critics for the sheer popularity of Grandma Moses both at home and abroad puts her on the front lines of the aesthetic wars of the mid-twentieth century, in which intellectuals parted company with the popular culture with extreme prejudice. Like her friend Norman Rockwell, Grandma Moses became a national treasure abroad—and a guilty pleasure at home.

Not much of the agitation over the 1950 Grandma Moses tour ever reached the ears of the Americans in Bennington, Vermont, or Eagle Bridge, New York. What they did learn was that Uncle Sam, at the end of 1949, planned to send a "Merry Christmas" to the world via an exhibit of the paintings used on Hallmark cards.[49] The stars of the show were Grandma Moses and Norman Rockwell, of course. Circulated to embassies and information centers under the auspices of the State Department, the display managed to stay under the radar

of congressional critics of art diplomacy because Hallmark owned the pictures.

Art critics to whom the card business was anathema stayed disdainfully mum on the subject of the Hallmark "art" show. And that non-response set the pattern for an ongoing series of touring exhibitions featuring the art of Grandma Moses. In 1954, for example, the U.S. Information Agency, with the curatorial assistance of the Galerie St. Etienne and the Smithsonian, sent a sampler of American primitive art to nine European cities. The survey began with seventeenth-century paintings and concluded with five works by Grandma Moses. As with her earlier solo exhibition, attendance set new records, hard-bitten foreign critics lauded the notion of a show devoted to universal human sentiments, and the bureaucrats behind the idea emerged from the tour unscathed.

Grandma Moses tapped into the yearnings of battle-weary Europe for the serenity, the continuity, and the peace inherent in her work. If Americans feared that they were seen abroad as intellectual babies, playing with the gadgets they loved so much, Grandma showed the Swiss and the Austrians and the prickly French the other side of the coin—the elemental sweetness of this brave little soul, so American in her freedom and optimism yet so like their own dear grand-mères. "I believe this exhibition brought more good will for America than any other single effort we have made," cried a jubilant State Department functionary at the conclusion of a Grandma Moses show in his venue.[50] Like a one-woman Marshall Plan, Grandma had become an emblem of all that was right about the United States.

From the mid-1940s until long after her death in 1961, there was hardly a year in which major collections of the art of Grandma Moses were not on tour at home and abroad. Grandma Moses exhibitions hung in department stores, churches, commercial and public

galleries. Crowds saw her work in person in California, Vermont, and Texas. In Boston, Cincinnati, and Dallas. In Salzburg and Stockholm. Terre Haute. Racine. The Ronald Reagans, about to visit a Glens Falls, New York manufacturing plant in his capacity as host of television's "General Electric Theater," posed for publicity shots reading Grandma's biography in front of one of her pictures.[51] Irving Berlin, composer of "White Christmas," let it be known that he owned a Grandma Moses painting of the same name.[52]

But the splashiest Moses show of the 1950s was the "Tribute to Grandma Moses . . . on the occasion of her 95th birthday"—an exhibition stage-managed by her old friend Tom Watson of IBM in his firm's gallery space on East 57th Street during the 1955 holiday season. The substantial catalog contained a fulsome tribute by Watson, a little essay by Mrs. Moses herself, her commentary on the famous "tip-up table" (on display in the show), a brief biography (including mention of her Christmas card successes), and a facsimile of a Christmas card to Grandma Moses from Dwight Eisenhower (a tribute to a "real artist, From a rank amateur"). There was also a list of the distinguished lenders to the exhibition: Joyce Hall of Kansas City, the Trumans of Independence, Missouri, the Metropolitan Museum of Art, Louis Bromfield, and the White House.[53]

Grandma Moses came to New York for the IBM Gallery opening, delighting reporters by claiming to be a year older than she was. Photos taken at a tea for five hundred invited guests show her posed unconvincingly, pretending to paint a framed and finished picture.[54] She had not been particularly well during most of 1955. For the first time, the usual birthday articles failed to include a photograph of a beaming Grandma and a giant-size cake surrounded by celebrity well-wishers. Her family and a few neighbors gathered in Eagle Bridge for an "old-timey," low-key celebration instead. Her

G. Moses, Inc.

Grandma Moses and actress Lillian Gish at the IBM Gallery, New York, 1955. Photograph by IBM.

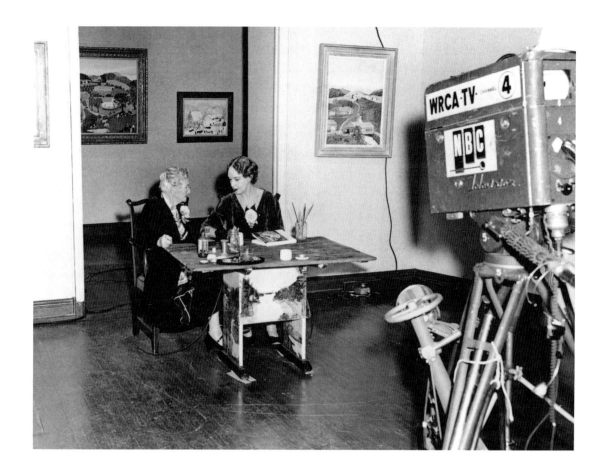

fans were told a typical "Grandma Moses-y" story: she had tripped over a table while trying to turn off a boxing match on TV, and her knee had been giving her trouble ever since. The plain truth was that at 95, Grandma Moses had finally begun to slow down a little. Her doctor thought it was time for a rest. And she longed to sit and think for a while "as soon as all this fuss about my birthday is over," she said through an intermediary. "You don't get to be 95 without

based on the soundtrack—and inspired another, a collection of folk songs with a Grandma painting on the record jacket.[3]

Substantive discussions of the content of the Jerome Hill film were few, however. Bosley Crowther, the veteran reviewer for the *New York Times,* liked its simplicity and the images of the old lady in the real-life landscape of her farm. The voice-over narration, written and intoned by Archibald MacLeish, Crowther said, "glows with the homey sentiment of the poetic concept of rural life. The narrative probably suits the subject."[4] Others disagreed. The *Magazine of Art* called the film "corny . . . with the ingenuous corniness of a better-grade Bing Crosby or Bob Hope feature" and took issue with the homespun rhetoric of MacLeish's commentary, which equated the artist with the "American way of life."[5] Here was the nub of serious professional disdain for Grandma Moses in the late 1940s and early 50s: that by being made to stand for an essential, immutable Americanness, her work was preventing recognition of other forms of American art—notably, Abstract Expressionism—as worthy or more worthy of notice. In this politicized and anti-populist atmosphere, even Mrs. Moses' innocent excursion to see the folk art collection of the Fenimore House Museum at Cooperstown in the fall of 1950 could be interpreted as a retrograde and faintly sinister attempt to undermine the forces of cultural progressivism.

To eyes educated in the techniques of late twentieth-century filmmaking, the short documentary seems more period piece than masterpiece. The color footage of Grandma Moses enacting the labors of the agricultural year smacks of the visual rhetoric of New Deal–era cinema, with its shots of haywagons and field hands poised against dramatic, cloud-filled skies. The MacLeish narration seems especially dated, full of portentous repetitions and verbal pyrotechnics that all but overwhelm the spry little cricket of a woman pictured on

10. Grandma Is Very Old

The rumors started in 1949, when she was a mere 88 years old: Grandma Moses was going to Hollywood. A film deal was in the works, a "biopic." "Grandma Moses May Become Movie Star!" Louella Parsons said so.[1] It was M-G-M. Or Twentieth Century Fox. A big studio, anyway—and a big deal. Was Mrs. Moses well enough to travel to California? Maybe not, said Otto Kallir. Arthritis had kept her from her most recent New York opening. But she had seen it all on TV in her own living room, over a live NBC hookup that allowed her to talk to gallery-goers in the city. Viewers from Boston to Richmond listened and watched as she put the finishing touches on a new picture. And she was as lively as ever. Her best advice for living a long life? "Don't Act Your Age."[2]

In 1950, in honor of her 90th birthday, director Jerome Hill and A. F. Films, Inc. of New York released what could best be described as an "art film," a documentary on Grandma Moses following her through the cycle of the seasons as a metaphor for the stages of her long life. Much of the color footage was shot by Erica Anderson, an Austrian native introduced to the family by Ala Story. Hill, the heir to a great American railroading fortune, was often unfairly dismissed as a millionaire who dabbled in movies. But his Academy Award–nominated *Grandma Moses* was hailed in its day as one of the most beautiful color films about art and artists ever made. Throughout the decade, in limited release, the film was screened at libraries and museums wherever a Moses show opened. It spawned at least one record, "The Grandma Moses Suite" from Columbia Records,

having some sad memories and knowing ugly things. But I don't believe in painting ugliness. I paint pretty pictures. If I put in something that was not pretty, I make it look a little better. If people can't get pleasure out of looking at a picture, what's the use of painting it?"[55]

Although she hadn't touched a brush in several months, and had spent most of her days in bed lately, she rallied for the IBM tribute.[56] Knee or no knee, game as ever, with all eyes upon her, she posed for the cameras one more time—and in fascinating company. In addition to the solicitous Watson (he would die the following year, at 81), who gravely escorted her from the room when her energies flagged, Lillian Gish, the famous silent film star, hovers near her side in most of the photographs taken that day. In March of 1952, in the course of reviving her career, Gish had portrayed Grandma Moses in a television drama series, "Playhouse of the Stars," as a last-minute replacement for Helen Hayes, who was then appearing on Broadway.[57] In the months that followed, as much from personal interest as from the demands of publicists, Gish became a regular at "Grandma" events; eventually, in a decade in which the notion was far from popular, she became one of the more prominent voices calling for the creation of an official American agency charged with the promotion of the arts.[58] In the warm détente between Grandma Moses and Lillian Gish, art met show-biz. Already a celebrity, Grandma was about to become a star.

the screen. This is, says the poet in best poetical form, a portrait of "the old woman as an artist . . . and the Artist as American."

In MacLeish's reading she is an earth mother, some elemental creature of the soil: "Grandma Moses came out of the valley and the people who made the valley, people who thought as they pleased and spoke as they thought and made their own lives with order and duty and decency, . . . people who loved the earth and the beauty of the earth and lived by the fruits of their labor."[6] There is some nugget of truth in this litany of high-minded wordsmanship. (Order was Mrs. Moses' long suit, and her memories of the Cambridge Valley were central to her art.) But when all was said and done—at tedious length—MacLeish comes across as something of a populist windbag.

His words ring false on the ear. Carl Sandburg, MacLeish's friend, versifier, biographer of Lincoln, and self-styled goat farmer, popped up on TV frequently in the 1950s, with his homemade haircut and his guitar, acting the part of the great national poet for NBC or Edward R. Murrow. He almost always began with a folk song, as if to declare his passion for Americana, and then launched into oracular, "poetic" monologues that seem both forced and badly rehearsed, as if he needed to convince the viewer that he was, somehow, authentic. An observer of these antics once remarked that Sandburg on television was too "pat and professional—something . . . like those Grandma Moses paintings transferred to greeting cards."[7] The Jerome Hill film—especially the long segment in which Grandma Moses tells four dressed-up great-grandchildren about her ancestors—feels the same way.

On the other hand, James Thrall Soby, whose attitude toward Grandma Moses (and her Christmas cards) had never been judicious, thought that MacLeish's narration was full of conviction—but

wrongheaded. His commentary on the film in the *Saturday Review* (later anthologized as one of the magazine's "truly outstanding articles") disputed MacLeish's contention that Grandma was particularly American. She wasn't, Soby insisted, despite her old age and obvious connections to the land. "The blunt truth is that nationality, sex, age, ruralism, and long identification with region do not in themselves, either separately or in combination, assure the artist a lasting place."[8] Grandma was popular in 1950, as Hill's film richly demonstrated. But in Soby's view, there was nothing to suggest that the misguided "geriatric romanticism" of MacLeish and his ilk would carry her much farther than that.[9]

In Hill's film Grandma Moses sometimes shows her 90 years, especially in a scene shot from above in which she struggles uphill through a field, plucking flowers as she goes. And neither Soby nor MacLeish was quite sure how to react in the presence of great age. Did longevity demand respect in its own right, as it had in the rural communities of the past? Was old age an infirmity to be overcome, a deformity to be hidden away from the camera's probing vision? Grandma Moses was an anomaly in so many ways: her gender, her lack of training, her life on a farm. But her outsider status was most apparent in her advanced age. Titian may have lived to 99. Picasso, who was almost 70 when Jerome Hill made his documentary about Mrs. Moses, was 92 at the time of his death. At 90, Grandma Moses was still going strong, and determined, she said, to paint on to her 100th birthday and beyond. Did age render her immune to rigorous criticism? Did it make her faintly ridiculous? Heroic? What did it mean to be old in America in a postwar epoch of new beginnings, the baby boom, and teenagers?

Extreme old age was rare at the dawn of the postwar era. In the year 2000, in the midst of a medical revolution in the treatment of

the aged, there were an estimated 72,000 centenarians in the United States; in 1960, however, there were only 3,000. And even more modest longevity was cause for wonder then. In the 1940s, designer Coco Chanel and financier Bernard Baruch were thought remarkable for continuing their careers after the age of 70. Toscanini and General MacArthur were also invoked alongside Grandma Moses as examples of the new adage that "life begins at 50."[10] Medical science was slowly coming to believe that mental acuity peaked between the ages of 40 and 70; and wartime experiments with older fliers had suggested that it would be unwise to dismiss one's seniors out of hand at any age, provided the oldsters embraced some form of "useful activity."[11] Nevertheless, the growing numbers of the elderly were seen as a potential burden to society, draining away millions in pensions and health care costs.[12]

As old age suddenly became a social problem, Grandma Moses became the poster girl for living well indefinitely through vigorous mental activity, good humor, strong family ties, and lots of rest. Gayelord Hauser, the long-life-and-wellness guru of the day, took Grandma Moses' awakened interest in art and her penchant for keeping busy as the prerequisites for her happy negotiation of the perils of getting old.[13] That and a diet rich in fat-free yogurt, liver, and fresh vegetables. (No martinis, chocolates, or whipped cream!) When the lady herself was asked for the secret of her success, she said the key to a long life was "forgetting about myself and thinking of others." But she was quick to add on her 90th birthday, when she had just partaken of a healthy slice of her 79-pound cake, that she had already planned a big dance in honor of her 100th.[14] Looking forward was just as important as any pious sentiment about self-abnegation.

In her homemade dresses and lace collars, however, Grandma

Moses presented an image not frequently seen in the American media in the 1950s. When "Busy Grandmas" were mustered for inspection by the press, they were usually glamour girls like Marlene Dietrich and Gloria Swanson, shown in old publicity shots from their Hollywood days; only Grandma Moses looked like the little old lady that she was.[15] And it is difficult to find a comparable figure in the advertisements of the period, which provide an index to desirable, salesworthy types. Older folks in the latest fashions, with fashionable touches of gray in their hair, do appear in self-congratulatory ads touting corporate pension plans. Otherwise, the elderly are depicted in ads as quasi-feeble "old folks" coming to visit the younger generation by bus, train, or air; the white-haired woman giving household advice to the blushing bride; the ideal buyer of a new sewing machine or a good stiff corset; the one member of the family who worries that the others are neglecting their vitamins. In cartoon form, offering a recipe for tuna loaf to the readers of the *Ladies' Home Journal* in 1947, the stereotypical American Old Lady is a virtual caricature of Grandma Moses—lace collar, pie-plate hat, eyeglasses, wrinkles, and all.[16]

Cooking and baking products were the exception to the unwritten rule relegating old ladies to virtual invisibility in the national portrait sketched by Madison Avenue. Ads for "Grandma's Old Fashioned Molasses" were always topped off with an artist's rendering of the classic little old lady: spectacles, black dress, lace collar, white hair, and pleasant smile (and a free recipe).[17] Wilson's canned meats deployed a similar granny, the symbol for culinary wisdom and tradition in an era of cake mixes and flash-frozen TV dinners. But the

Goodyear ad: the American "grandma" type. 1950.

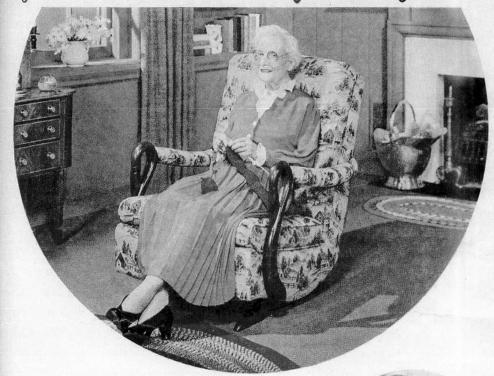

Long-term investment in comfort— and good looks!

uch comfort as Grandma never knew
ours in this modern platform rocker,
hioned with **Airfoam.**

perb restfulness, beauty, incompara-
long wear — you'll always find them
smart new furniture cushioned with
buoyant latex material.

foam cushioning adjusts *its* shape
yours — cradles weary muscles with
pletely uniform support. It's cool
fort, too, because air circulating
ugh a million cells keeps **Airfoam**
sant even in sticky weather.

what a blessed work-saver! You
r have to plump it back to shape —
never leave an impression on it. It
its resiliency, its "company looks"

for years and years. It doesn't attract
dust, or excite allergies.

So it's no wonder you'll discover this
magic cushioning in a host of conven-
tional, modern and decorator pieces.
You can bring new life, looks and com-
fort to old furniture, too, by reuphol-
stering with **Airfoam.** Don't overlook
this miracle cushioning—it's the smartest
buy of this or any year! Goodyear,
Akron 16, Ohio.

Airfoam

SUPER-CUSHIONING BY

GOODYEAR

THE GREATEST NAME IN RUBBER

Airfoam—T. M. The Goodyear Tire & Rubber Company, Akron, Ohio

*We think you'll like "THE GREATEST STORY EVER TOLD"—
Every Sunday—ABC Network*

best-known old lady in America—except for Grandma Moses herself—was Ma Perkins, a long-suffering widow and titular heroine of a radio soap opera that ran for twenty-seven uninterrupted years, more than 7,000 episodes, describing the day-to-day lives of Ma, Willy (her son-in-law), Shuffle (a family friend), Evey (Ma's stay-at-home daughter), and the more urbane Fay (her other daughter, much divorced).

Played by Virginia Payne with a warm cackle in her voice, Ma ran a lumberyard in the imaginary town of Rushville Center, a hamlet beset with every imaginable domestic tragedy. And yet Ma soldiered on. Every year until the series went off the air in 1960, she seemed a little older, slower of speech, weighted down by the years. But she persisted: "I give thanks that I have been given . . . this gift of time, to play my little part." Her loyal listeners knew the line by heart.[18] And they knew her sponsor: "Spry," the "pure vegetable shortening in the economical 3-pound can."[19]

"Spry" was represented by an old lady almost as well known as Ma Perkins herself, thanks to free recipe books featuring photos of an affable, apron-wearing Aunt Jenny, from whose lips sprouted cartoon-dialogue balloons praising the only "digestible" shortening. Taken together, Grandma Moses, Aunt Jenny, and Ma Perkins defined old-ladyness for their era: the humor and optimism, the wisdom, the persistence. Even though the Aunt Jenny pictured in the ads grew slimmer and more stylish in appearance as the young war bride became the magazine archetype of American womanhood, "Spry" and Grandma Moses maintained their bond of affinity.

In 1959, when Aunt Jenny had been retired to the home for outmoded product logos and Ma Perkins was headed for the rocking chair, Lever Brothers announced a special offer. For a limited time only, "Spry" would come in a tin can that could, when empty, double

as a canister or a cookie jar, decorated with a painting by Grandma Moses.[20] The product label was removable. What was left, "lithographed completely around the sides" of the can, was her picture *Over the River to Grandma's* (1947), described as a famous winter scene never before reproduced.[21] And as if that weren't enough, the special Grandma Moses canister was 5 cents cheaper than the regular tin of "Spry." And "spry," of course, was just what Grandma Moses was.

The best advice that anybody could give to older people seeking happiness and fulfillment was to be spry, to get busy. Idle retirement was no answer. Live "the New Leisure" to the fullest![22] In the name of productive old age, learned papers were delivered. Plays were written: Arthur Miller's Willy Loman, superannuated at 60, became a tragic American hero in *Death of a Salesman* (1949). Novels as well: Hemingway's *The Old Man and the Sea* sold 5.3 million copies in two days after it was serialized in *Life* in 1952. The grizzled, bearded "Papa" Hemingway, headed for the 1953 Pulitzer Prize for fiction, looked older than his 54 years. He, too, was held up as an embodiment of vitality and vigor at any chronological age. Conferences on old age were convened. Governor Averell Harriman of New York State invited Grandma Moses to the Executive Mansion in 1955 to talk over the problems of the elderly with a hand-picked panel of scientists, social workers, and business leaders.[23] In the end, everybody agreed: Keep your job. Fish. Garden. Get a hobby. Play the piano, like Harry Truman. Or paint pictures. And stay young forever.[24]

Although Grandma Moses was universally if sometimes reluctantly regarded as a professional artist, it was widely known that she had taken up painting as a pastime or hobby at an advanced age. Furthermore, she insisted that "anybody can paint," given a little gumption—even her own brother, Fred Robertson, who dab-

bled in landscapes and flower pieces.[25] Grandma's much-repeated story also held out a tacit promise of success beyond one's wildest dreams. Start to paint. Be a star. Like Sir Winston Churchill, the former Prime Minister of Great Britain, who became the model for Sunday painters everywhere after World War II—the male counterpart to Mrs. Moses. Churchill had taken up painting in his forties in a moment of crisis, but he came back to it during the war years as a way to relieve the tensions of office. While others—housewives, celebrities, Dwight Eisenhower in the early days—toiled in relative obscurity, Churchill's pictures (signed "Charles Marin") brought respectable prices whenever they came on the market. Like Grandma Moses, he was good enough, and famous enough, to turn a hobby into a profitable venture.[26]

Especially after the 1950 publication of his little manual called *Painting as a Pastime,* Churchill was regarded by critics who ventured to examine his work as a somewhat superior example of amateurism because he had praised the likes of Cézanne and Matisse.[27] Grandma Moses, on the other hand, in one of her rare remarks on the state of the arts, opined that abstraction was "good for a rug or a piece of linoleum."[28] But suddenly, in the spring of 1950, it was announced that Hallmark of Kansas City had signed Churchill to a three-year contract to put his paintings on Christmas cards. He was to become Grandma Moses' colleague and competitor, reportedly "delighted at the opportunity" to exhibit his work in the United States on greeting cards.[29] The deal was known in the trade as "the Churchill Coup."[30] The arrangement put Churchill's art, whatever its merits, in the same sub-artistic category previously reserved for Grandma Moses, Norman Rockwell, and all those involved in the production of Christmas cards. By 1953, the roster of household names attached to Hallmark products included Moses, Churchill,

Grandma Moses, her daughter Winona Fisher, and Otto Kallir at the *New York Herald-Tribune* forum on leisure activities. 1953. Photograph.

Rockwell, Edgar Guest (the "people's poet"), inspirational writer and speaker Dr. Norman Vincent Peale, and Huldah, the creator of the dark-haired "Huldah girl" seen on magazine covers.[31] Churchill's devotion to his hobby became one of the great, ongoing stories of the 1950s.

In 1953, the *New York Herald-Tribune* announced a forum for the discussion of "New Patterns for Mid-Century." Meeting in the As-

sembly Hall of the United Nations Building and in the grand ball-room of the Waldorf-Astoria Hotel, more than 2,000 delegates were to take up the general topic of modern-day living. The theme was broken down further in various sessions dealing with fulfilling uses of the leisure time created by technological advances, and others that examined the influence of design on everyday life. Participants included industrial designer Henry Dreyfuss, composer and musi-cologist Virgil Thomson, sociologist C. Wright Mills, *Life* photog-rapher Margaret Bourke-White—and Grandma Moses, discussing "Amateur Painting in America" with Otto Kallir.[32]

Widely broadcast and telecast, the Kallir/Moses session, entitled "Time on Our Hands," opened with the former's discussion of his client's triumph on the U.S.I.S. circuit. The sincerity and the ru-ral iconography of her work, he suggested, transcended national boundaries. If her kind of art—amateur, untaught—was "only a little sideline of contemporary American art," it was nonetheless a cru-cial one. A million Americans, including the current President, had taken up painting as a hobby in the recent past; sales of artists' sup-plies had increased tenfold since 1939. Without so much as men-tioning the "Paint by Numbers" craze that was sweeping the nation in the early 1950s,[33] Kallir made a convincing case for the impor-tance of artistic self-expression as a vital component of American life. Sunday painting was another demonstration of individualism and freedom in the U.S.A.

Grandma's remarks were framed as answers to a series of ques-tions about her painting and the products that reproduced her work. "Do you think . . . everyone can paint?" asked Dr. Kallir. "I do," she replied. "Anybody that's got two eyes can paint, even if they have to paint with their toes." What do you tell young people trying to get started? "Get their brushes. . . . They must have a little imagina-

tion and lots of ambition." Has your technique improved in the past few years? "I think it has, and also my brushes."[34] As she spoke, a young member of the forum audience stood enraptured just outside the ballroom, looking at one of Grandma Moses' winter scenes with its snow-covered fields, horse-drawn sleighs, and sense of utter peace. "That's absolutely the only kind of painting I understand," she sighed.[35] In the East Foyer, adjacent to the ballroom, the organizers had also arranged an exhibition of Grandma Moses textiles, alongside the pictures reproduced on them. Twenty-eight linear feet of "Early Springtime" and "Deep Snow" proved, if there were any remaining question about it, that American art—amateur art—was a part of everyday life.[36]

Meanwhile, as various locally-famous "grandmas" and "grandpas" with paintbrushes cropped up in every corner of the land, the benefits of turning to art as a hobby multiplied with each new article insisting that "You Can Be an Amateur Painter."[37] Grandma Moses maintained that talent and training were not prerequisites for success. And advice-givers of all stripes agreed. Draw on the tablecloth! Doodle on the edges of the phone book! If you don't have paint, try iodine or mustard! Or a store-bought kit. If America's great-grandmothers could work samplers and weave wreaths of hair with apparent satisfaction, why couldn't their descendants enjoy the creative side of life, too? In *Look* magazine, Grandma Moses urged Ike to "keep on trying. . . . I saw some photos of your paintings and I wish that I might do as good." If he stuck to it, by the time he was 93—her current age—he might be better than she.[38] Grandma Moses felt sure that painting helped Eisenhower forget the many worries of high office.

The pictures themselves helped brighten the lives of those fortunate enough to have them in the form of curtain fabric, Christmas

cards, or originals. When Edward R. Murrow, the host of television's "Person to Person," was forced to miss a scheduled visit to the Independence, Missouri home of former President Harry Truman and his family, daughter Margaret Truman did the honors in his absence. Truman was engrossed in the writing of his memoirs; his toughest decision in the White House years had been U.S. intervention in Korea, he told his daughter. But the discussion quickly turned to the Truman house, its contents, and the comforts of home. The camera zeroed in on an oil painted by Sir Winston Churchill, hanging just above the former President's shoulder—a gift from his old ally. And over the piano, where Harry Truman once gave music lessons to his little girl, was an original painting by Grandma Moses. Those intimate moments were the highlights of the TV show.

A year later, Edward R. Murrow came to Eagle Bridge to meet Grandma Moses. Part of his "See It Now" series (filmed rather than broadcast live), this was to be a network "special," a longer-than-usual program about two celebrated American artists subtitled "2 American Originals." The choice of interviewees was, at first blush, a daring one—a pair of outsiders: Louis Armstrong, the African-American trumpeter, and Grandma Moses, the self-taught painter. Neither Armstrong nor Mrs. Moses was universally lauded in the higher echelons of their respective professions. On the other hand, both were towering figures in American popular and indigenous culture, well known to Murrow's at-home audience through frequent appearances on television and in the media.

Moreover, both had served as ambassadors of American culture abroad. Armstrong, along with singer Marian Anderson, was a mainstay of the State Department's cultural exchanges with the Eastern Bloc; part of the Murrow show follows him on a goodwill tour of Europe. Similarly, Grandma Moses' paintings were welcome

and non-controversial staples of the disaster-prone American art circuit abroad. Armstrong and Moses (and television itself) were examples of what testy intellectuals were calling the "midcult," as opposed to more sophisticated forms of high culture.[39] As such, Moses and Armstrong were ideal subjects for an Edward R. Murrow TV special.

Early in 1955, a Moses-less exhibition of American art of the twen-

tieth century assembled by the Museum of Modern Art at the invitation of the French government (and financed by MoMA under the table, to avoid congressional displeasure) earned catcalls from observers on both sides of the Atlantic for its top-heavy representation of the Abstract Expressionists. According to some French critics, their work lacked serious technique; it was little more than "an explosion, an uncontrollable agitation."[40] In contrast, there was no chance that sweet old Mrs. Moses would start painting explosions on national TV. And Armstrong was universally beloved (except by some bigots in his own country) as much for his warmth and bubbling humanity as for his jazz. So, what seemed to be gutsy choices on the part of CBS and its ace newsman were safe ones after all. Everybody sent Grandma Moses Christmas cards. And when Murrow came calling, Louis Armstrong was about to co-star with Bing Crosby, Frank Sinatra, and Grace Kelly in a splashy, big-budget, technicolor Hollywood musical.[41]

In some ways, however, the Murrow show is an eye-opener, at least where Grandma Moses is concerned. As in the famous action photos of Jackson Pollock at work taken by Hans Namuth in 1950, the Murrow piece lays bare Grandma Moses' tidy working methods and, above all, her unhesitating sense of exactly what goes where on her sheet of masonite. If there are no explosions, there are no moments of doubt, either—no deviations from a mental picture as bright and clear in her mind as if it were already hidden just beneath the surface, waiting to be uncovered. The Jerome Hill film is perhaps the more innovative of the two projects in its use of an active camera, much as famed documentarist Ken Burns would do in the 1980s and 90s. Under Hill's direction, the camera wanders over the surface of Mrs. Moses' paintings, merging words and images, bringing pictures to life. But the Murrow show, in its own pedestrian way,

So Long 'Til Next Year. 1960. Oil on pressed wood. 16″ x 24″. Kallir 1461. Grandma Moses Properties Co., New York.

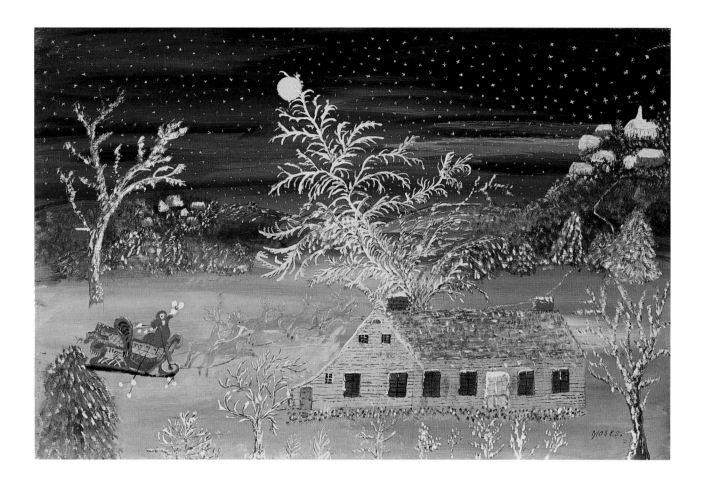

gives a better sense of her procedure and, above all, of her control. Despite age and infirmity, she is the master of her task. She breathes self-confidence. As an artist, Grandma Moses knows precisely what she is doing. Painting is not an act of discovery for her; each brushstroke, each color, has its own predetermined place. The act of painting is a triumphant confirmation of all that she remembers and believes.

Murrow's own performance in the TV special was less than stellar. With the smoke of his omnipresent cigarette drifting slowly across Grandma's face, he tried to play the hard-hitting newsman: "What would you say were the basic differences between the Eisenhower administration and the Lincoln administration?" Mrs. Moses looked up from her paints with a quizzical expression, as if she had never heard a dumber question. "I don't remember the Lincoln administration because I was too young," she shot back. She painted what she knew for a fact. And she spoke the same way. That's the way it was. Even the great Edward R. Murrow was not going to change Anna Mary Robertson Moses at this late date. But he tried again. "Why don't you paint Biblical scenes?" he inquired, as though she ought to. Same answer. "Because I never actually saw them and I don't think people ought to paint what they haven't seen."[42] Churchill? "I think he's trying to copy me!" Did she hate to see her pictures sold? "No. I'd rather see the money." When she turned the tables on the great interviewer, daring him to pick up her pencil and draw—"Anybody can do it!"—it was apparent that the befuddled Murrow had met his match.

There were several other revealing moments in the interview. One came when, in response to a question about what she planned to paint next, she said she didn't know. "I'm going to try to get into something different than what I have been doing," she said. "Something modern."[43] What Grandma Moses meant by "modern" is not entirely clear. No alarming changes in subject matter followed the Murrow show. But during the last several years of her life, her brushwork became looser—more painterly. And in 1960, she embarked on a new direction in her work with a series of paintings illustrating the Christmas classic popularly known as "The Night Before Christmas."[44] The project was a departure because Grandma had not been

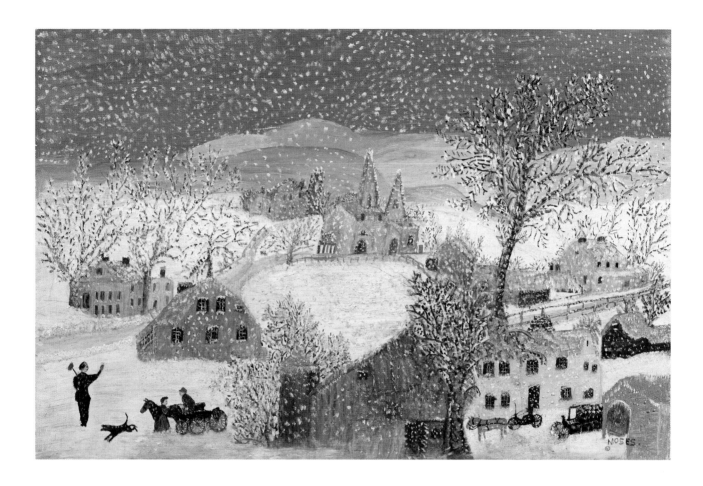

Get Out the Sleigh. 1960. Oil on pressed wood. 16″ x 24″. Kallir 1474. Private collection.

there when Clement Moore wrote his poem in 1822. It was a departure in terms of style as well, the scenes literally frosted with snowflakes, lush and fluffy, as if the clouds of heaven had swept over the frozen earth on the night when Santa made his rounds. The jolly Santas seem less and less important in comparison to the enveloping, embracing whiteness, as soft as the wing of what Grandma would have called an "angil."[45]

Rainbow. 1961. Oil on pressed wood.
16″ x 24″. Kallir 1511. Private collection.
This is the artist's last finished painting.

At the end of the show, Murrow timidly went where "angils" feared to tread. Sitting across the table from his oldest subject to date, he finally asked the big question. Was she afraid to die? Grandma's face lit up. No, she didn't worry about dying. All her dear ones were waiting for her: she was the last one left behind. Besides, there wasn't anything to be afraid of. "You go to sleep and wake up in the next world."[46] You won't even know it happened. She

looked at Murrow and then interviewed the interviewer. You never knew when you went to sleep, when the last thought came, did you? Murrow hemmed and hawed and finally agreed. Death was just like dropping off to sleep.[47]

In December, when the show aired, the reception was so bad at Grandma's little house that she turned the set off and went to bed. Finally, during the following spring, she got to wondering how it had turned out. Could CBS arrange for her to see the program? A projectionist was dispatched to Eagle Bridge with a 35-mm print. In May of 1956, Grandma got a chance to see herself, in full color, during a special showing at the town's community center. She dressed in her best, in a bright scarf and a hat a teenager might have worn, massed with artificial rosebuds. "Oh, there I am," she whispered, as the show began. When it was over and the lights came up, and the sixty or so relatives and admirers began to gather their own coats and scarves, her parting remark was pure, vintage Grandma: "It's a wonder I got through all that without once appearing in a kitchen apron!"[48]

"Work, for the Night Is Coming"

Grandma Moses died on December 13, 1961, in a Hoosick Falls nursing home. She was 101 and still feisty. According to her doctor, she routinely hid his stethoscope. "You take me back to Eagle Bridge," she'd say, "and you'll get [it] back."[1] But she was frail after a summertime bout with pneumonia and a series of falls. "She just wore out," said Dr. Shaw, when pressed for a cause of death. The end came pretty much the way she told Ed Murrow it would. Grandma had no sense that her time was near. She was looking forward to going home and painting. And then, she just went to sleep.[2]

Her last couple of birthday parties had been quiet affairs, too, although she predicted she'd live another hundred years, coyly alluded to a bevy of new boyfriends, and, at age 100, danced a lively jig with her 84-year-old doctor until ordered to take a rest. For her 101st, she turned out in a new dress of plum-colored satin brocade. She loved dressing up. When she went to Manchester, Vermont, in 1960 to attend a ceremony in her honor, she looked "as pert as a bantam hen" in a pink and black dress and shocking pink gloves.[3] Friends described her in old-fashioned metaphors. "Bright as a button." "Lively as a cricket."[4] She still worked at her pictures for three or four hours a day. "I just paint, sleep and eat," Grandma told a reporter. "When you get to be a millionaire—and people tell me I am—you're not apt to do much else."[5]

But she did have opinions on current affairs, even in advanced old age. In April of 1961, the Soviet cosmonaut Yuri Gagarin became the first human being to orbit the earth. The "space race" moved into

My Hills of Home. 1941. Oil on pressed wood. 17¾" x 36". Kallir 99. Memorial Art Gallery of the University of Rochester, New York. Marion Stratton Gould Fund.

high gear with the inauguration of John F. Kennedy. Grandma Moses thought it was a lot of nonsense: "The Lord put us on earth and we should stay here until He comes after us. They're spending money for those space things while lots of people are freezing and starving for want of that money. It's a foolish piece of business." And she wasn't much more enthusiastic about her younger competitors, the current crop of abstractionists: "I don't like them," she said with a laugh. "They do wallpaper and carpet designs. They always paint snakes that get bigger and uglier. What do I think of Picasso? Who's he?"[6]

Because she had been enlivening the American breakfast table for what seemed to be forever with her quips and down-to-earth advice, the death of Grandma Moses was headline news in papers large and

small. A New York shoe store observed her passing with a window display of three of her paintings (and no shoes); giant-sized crowds stood outside on Fifth Avenue in respectful silence. "You'd think everybody was a relative," wrote a Chicago columnist.[7] She was the Nation's Grandma. An American Tradition. Ageless, in her little pink gloves. Seemingly indestructible. The chipper old lady who sold 100,000,000 Christmas cards.[8] People swapped Grandma stories—how she watched Westerns on TV, but only because she loved the horses. The *New Yorker* reasoned that when a very old person, a cheerful and productive person dies, there is small cause for mourning: "If we do mourn, it is for ourselves."[9] From the White House came an official statement from President Kennedy: "Her passing takes away a beloved figure from American life. The directness and vividness of her paintings restored a primitive freshness to our perception of the American scene. All Americans mourn her loss. Both her work and her life helped our nation renew its pioneer heritage and recall its roots in the countryside and on the frontier."[10]

John Kennedy's rhetoric tied Grandma Moses to his New Frontier. It also recalled his inauguration ceremony, on January 20, 1961. The youngest President had invited an old Vermont poet to speak suitable lines on this important morning. Robert Frost was 89, as much a vestige of the nation's past as Grandma Moses. In his public appearances, too, he had often played the part of the cranky national grandpa, the old New England farmer who just happened to write the odd verse. For this occasion, he had written a poem called "Dedication." But Washington was blanketed in fresh snow. The glare blinded Frost. The wind whipped his white hair into a froth and ruffled his papers. So in his best folksy manner, Frost recited from memory a verse that he had written in 1942: "The land was ours before we were the land's . . ."[11]

"Crop artist" Lillian Colton won a ribbon at the Minnesota State Fair for her tribute-portrait of Grandma Moses rendered entirely in seeds. 1975.

Frost. Kennedy. Grandma Moses. Within two years, they would all be gone. On the day of her passing, however, the formal Presidential statement had managed to go straight to the heart of the matter. Grandma Moses *had* been the land's own daughter, child and mother and grandmother of the beautiful Cambridge Valley. And she was, for his generation, the poet-painter of Kennedy's mystical American frontier.

The art press had not been kind to Grandma in life. In death, she was largely ignored. *Art News* gave her obituary two lines of type. Other journals followed suit. James Thrall Soby, with his distaste for her art and his conviction that publicity and nostalgia accounted for her popularity, was silent. But what was wrong with looking backward, sometimes, asked her fans? "Nostalgia is beneficial to everyone," declared a eulogist in the *Manchester Union Leader*. "It pulls us up sharp, bringing us back to when we were less worldly, less jaded, and when we possessed Grandma's own steadfastness of purpose."[12] At a time when it was anathema *not* to paint abstract canvases, she proved that in America "an artist does not have to conform to win an audience and a devoted following."[13] As for all that publicity and hoopla, it simply meant that "her paintings have brightened literally thousands of homes" in the form of cards, dishes, Early American curtains, or dresses for pretty little girls.[14]

In the face of almost universal affection for Grandma and her art, Lloyd Goodrich, director of the Whitney Museum of American Art, spoke in careful, measured phrases on behalf of his constituency. "She represented the folk tradition that has been such an important part of American art in the past, but that seemed to be in danger of dying out," Goodrich said. "Hers was a very fresh and personal art."[15] The only closely reasoned appraisal of the art of Grandma Moses came from John Canaday, critic for the *New York Times,* writing on the morning after her death. Mrs. Moses' reputation "was all out of proportion to her achievement esthetically," he argued, but she wouldn't have used any of those words nor cared much about them. "Her magic was that she knew how magical it was to be alive, and in her painted records of her life she managed to relay some of this magic to the rest of us."[16]

Was she a Sunday painter? A primitive? A folk artist? A force of

Grandma Moses' *The Quilting Bee* (1950)
replicated in three-dimensional form for a
Dayton's holiday display, Minneapolis, 1974.
Photograph, Target Corporation.

nature? An American phenomenon? Was she cherished for her great age, her wit, her beautiful old face? Did it matter? "I look back on my life like a good day's work," she wrote toward the end of that life and those long years of painting the pages of her story.[17] "It was done and I feel satisfied with it. I was happy and contented. I knew nothing better and made the best out of what life offered. And life is what we make it, always has been, always will be."

Prologue

1. Dorothy Canfield Fisher, *The Bedquilt and Other Stories,* ed. Mark Madigan (Columbia: University of Missouri Press, 1996), p. 42.
2. The story of Rauschenberg and the quilt is told in Calvin Tomkins, *Off the Wall: Robert Rauschenberg and the Art World of Our Time* (New York: Doubleday, 1980), pp. 136–137. Tomkins says the quilt came from a fellow student at Black Mountain—Dorothea Rockburne, also a New York painter.
3. Quoted in G. R. Swenson, "Robert Rauschenberg Paints a Picture," in *The Art World: A Seventy-Five-Year Treasury of "Artnews"* (New York: Rizzoli, 1977), p. 327.
4. Quoted in Jane Kallir, *Grandma Moses: 25 Masterworks* (New York: Harry N. Abrams, 1997), p. 38.
5. See *The Grandma Moses Songbook* (New York: Harry N. Abrams, 1985), pp. 24–25; "And 'twas from Aunt Dinah's quilting party / I was seeing Nellie home."
6. *Pro Hart's "Waltzing Matilda"* (Willoughby, Australia: Rigby, 1979), p. 24.
7. Kenneth L. Ames, *Beyond Necessity: Art in the Folk Tradition* (Winterthur, Del.: Winterthur Museum, 1977), p. 18. For a recent reappraisal of the field, see Gary Alan Fine, *Everyday Genius: Self-Taught Art and the Culture of Authenticity* (Chicago: University of Chicago Press, 2004), pp. 8–10.
8. Tom Patterson, *Contemporary Folk Art* (New York: Watson-Guptill, 2001), pp. 96–99.
9. Bob Dylan, *Chronicles,* vol. 1 (New York: Simon & Schuster, 2004), pp. 18, 39, 236.
10. Karal Ann Marling et al., *Dateline Kenya: The Media Paintings of Joseph Bertiers* (Los Angeles: Smart Art Press, 1998).

1. The Air Castle Years

1. Otto Kallir, ed., *Art and Life of Grandma Moses* (New York: Gallery of Modern Art, 1969), p. 104. The phrase comes from a handwritten commentary on a 1950 painting of the building.

2. Facsimile pages in Otto Kallir, *Grandma Moses* (New York: Harry N. Abrams, 1973), pp. 19–20. This volume contains the definitive catalog of Grandma Moses' work and a listing of her exhibitions.

3. Grandma Moses, *My Life's History* (New York: Harper, 1952), pp. 11–12. Otto Kallir both instigated and edited her memoirs.

4. Ibid., pp. 4–10, 26–27.

5. Ibid., p. 18.

6. Ibid., p. 27.

7. Ibid., p. 134.

8. Quoted in Nancy Davids, "'To Grandmother's House We Go,'" *Collier's,* January 6, 1945, p. 48.

9. Otto Kallir, ed., *Grandma Moses: American Primitive* (Garden City, N.Y.: Doubleday, 1947), plate 14 and commentary.

10. O. Kallir, *Art and Life of Grandma Moses,* p. 104.

11. O. Kallir, ed., *Grandma Moses: American Primitive,* plate 13 and commentary. See also Roger Cardinal, "The Sense of Time and Place," in Jane Kallir, *Grandma Moses in the 21st Century* (New Haven: Yale University Press, 2001), p. 102.

12. Otto Kallir in *Grandma Moses, American Primitive,* p. 29.

13. Moses, *My Life's History,* p. 41.

14. On readers and the Moses readers, see Elliott J. Gorn, ed., *The McGuffey Readers* (Boston: St. Martin's, 1998), and Edith Dickson, ed., *Meddlesome Mattie and Other Selections from McGuffey's Readers* (New York: Harper & Bros., n.d.), pp. 32–33, which includes volumes from 1842, 1844, and 1853–1857.

15. S. Knox, "Grandma Moses Presents Canvas," *New York Times,* October 22, 1953, p. 31.

16. Moses, *My Life's History,* pp. 18–19.

17. William H. Armstrong, *Barefoot in the Grass: The Story of Grandma Moses* (Garden City, N.Y.: Doubleday, 1970), p. 19. Ostensibly a novel for children, Armstrong's book is based on a long list of interviews with friends and intimates of Mrs. Moses and their descendants.

18. Moses, *My Life's History,* p. 35.

19. Reproduced in O. Kallir, *Grandma Moses* (1973), p. 123.

20. Louisa May Alcott, *Work* (New York: Penguin, 1994), p. 18.

21. Harriet Beecher Stowe, *Poganuc People* (Hartford, Conn.: Stowe-Day Foundation, 1977), p. 121.

22. Mrs. Child, *The American Frugal Housewife* (Boston: Carter, Hendee, 1833), p. 13.

23. Moses, *My Life's History,* p. 37.
24. Ibid., p. 106.
25. Catherine Beecher, *A Treatise on Domestic Economy* (New York: Schocken, 1977), p. 149.
26. Sarah Orne Jewett, *The Country of the Pointed Firs* (New York: Signet, 2000), p. 34.
27. See Karal Ann Marling, *Merry Christmas! Celebrating America's Greatest Holiday* (Cambridge, Mass.: Harvard University Press, 2000), pp. 329–331.

2. The Old Oaken Bucket

1. Handwritten commentary in Otto Kallir, ed., *Grandma Moses: American Primitive* (Garden City, N.Y.: Doubleday, 1947), p. 52.
2. For a slightly more complicated version of the poem, see Hazel Felleman, ed., *The Best Loved Poems of the American People* (Garden City, N.Y.: Doubleday, 1936), p. 455.
3. Felleman, ed., *Best Loved Poems,* p. 385. The Edison Disk of 1915 is #50265-L.
4. As early as the 1840s, the poem was appearing in McGuffey's Readers; see Edith Dickson, ed., *Meddlesome Mattie and Other Selections from McGuffey's Readers* (New York: Harper, n.d.), p. 37.
5. "Poet's Tomb to be Moved from S. F.," *San Francisco Chronicle,* July 11, 1937.
6. Otto Kallir, *Grandma Moses* (New York: Harry N. Abrams, 1973), p. 49.
7. "First New York State Show Scores Success," *Art Digest,* May 15, 1941, p. 15.
8. "From Every Tier of the Empire State," *Art News,* May 15, 1941, p. 14.
9. "Mother Moses, Primitive," *Art Digest,* December 15, 1942, p. 15.
10. "Young Artists Often Lack Warmth of 'Grandma Moses,' Expert Finds," *Syracuse Post-Standard,* October 5, 1944; Nancy Davids, "'To Grandmother's House We Go,'" *Collier's,* January 6, 1945, p. 48; "She Found Her Metier at the Age of 79," *Syracuse Post-Standard,* September 17, 1944. See also cover illustration, *Town and Country* (April 1945).
11. For the letter, dated September 3, 1943, see Jane Kallir, *Grandma Moses: The Artist Behind the Myth* (New York: Clarkson N. Potter, 1982), p. 63.
12. S. J. Wolf, "Grandma Moses, Who Began to Paint at 78," *New York Times Magazine,* December 2, 1945, p. 16.

13. Frederic A. Conningham, *Currier & Ives Prints: An Illustrated Checklist* (New York: Crown, 1983), p. 199.
14. Jane Kallir, *Grandma Moses* (1982), pp. 36–39.
15. Cited in ibid., p. 63.
16. William H. Armstrong, *Barefoot in the Grass: The Story of Grandma Moses* (Garden City, N.Y.: Doubleday, 1970), pp. 56–57.
17. Bryan F. LeBeau, *Currier & Ives: America Imagined* (Washington, D.C.: Smithsonian Press, 2001), pp. 5, 187, 338.
18. Reproduced in J. Kallir, *Grandma Moses* (1982), p. 64. There is also another possible source: a Currier & Ives print of a grist mill, after a painting by George Durrie (1864).
19. "Local Matters: Mother-Goose Party," *Richmond State,* April 16, 1884.
20. Sylvia Yount, *Maxfield Parrish* (New York: Harry N. Abrams, 1999), p. 75.
21. *Juvenile Lyre, or Hymns and Songs, Religious, Moral, and Cheerful, Set to Appropriate Music. For the Use of Primary and Common Schools* (Boston: Richardson, Lord and Holbrook, 1981), p. 72.
22. See Dickson, ed., *Meddlesome Mattie,* pp. 33–34.
23. Douglas Brinkley, *Wheels for the World* (New York: Penguin, 2003), p. 219.
24. Karal Ann Marling, *George Washington Slept Here: Colonial Revivals and American Culture* (Cambridge, Mass.: Harvard University Press, 1988), pp. 269–270.
25. See *roadsideamerica.com,* the website companion to Mike Wilkins, Ken Smith, and Doug Kirby, *The New Roadside America* (New York: Simon and Schuster, 1992).
26. Grandma Moses, *My Life's History* (New York: Harper, 1952), p. 89.

3. Making Soap, Washing Sheep

1. Otto Kallir, *Grandma Moses* (New York: Harry N. Abrams, 1973), pp. 25–26.
2. These pages would be the basis of Grandma Moses, *My Life's History* (New York: Harper, 1952).
3. "'Turkey and Trimans' with Grandma Moses," *New York Times Magazine,* November 21, 1948, pp. 19, 60, 62.
4. Grandma Moses, "How I Paint and Why—By Grandma Moses," *New York Times Magazine,* May 11, 1947, pp. 12–13.
5. "'Turkey and Trimans' with Grandma Moses," p. 19.
6. Beth Moses Hickok, *Remembering Grandma Moses* (Bennington, Vt.: Im-

ages from the Past, 1994), p. 42. Mrs. Hickok says that Frank and Anna Mary moved back north because of a fire on their farm; Grandma Moses says nothing about such an event.

7. Grandma Moses, *My Life's History*, p. 69.

8. Ibid., pp. 73–74.

9. Quoted in Jane Kallir, *The Essential Grandma Moses* (New York: Wonderland Press, 2001), p. 15.

10. Mrs. Child, *The American Frugal Housewife* (Boston: Carter, Hendee & Co., 1833), pp. 92, 99.

11. Otto Kallir, ed., *Grandma Moses: American Primitive* (Garden City, N.Y.: Doubleday, 1947), Plate 12.

12. Norma R. Fryatt, *Sarah Josepha Hale: The Life and Times of a Nineteenth-Century Career Woman* (New York: Hawthorne Books, 1975), p. 91.

13. See Michael C. Batinski, *Pastkeepers in a Small Place* (Amherst, Mass.: University of Massachusetts Press, 2004), p. 8.

14. From George Sheldon's monumental *History of Deerfield* (1895–96), quoted in Batinski, *Pastkeepers,* p. 147.

15. Grandma Moses, *My Life's History*, pp. 32–33.

16. Mrs. Child, *The American Frugal Housewife,* p. 23.

17. Grandma Moses, *My Life's History,* p. 33.

18. See "Report of the Board of Women Managers," in *Report of the Board of General Managers of the Exhibit of the State of New York at the World's Columbian Exposition* (Albany, N.Y.: James B. Lyon, 1894), pp. 195–196.

19. Quoted in W. Elliot Brownlee and Mary M. Brownlee, *Women in the American Economy* (New Haven: Yale University Press, 1976), p. 113.

20. Grandma Moses, *My Life's History,* pp. 31–32.

21. Similar candle-dipping racks are prized antiques today, not for their functional properties but for display as abstract works of art.

22. Cited in Dona Brown, *Inventing New England: Regional Tourism in the Nineteenth Century* (Washington, D.C.: Smithsonian Press, 1995), p. 161. See also Patricia West, *Domesticating History: The Political Origins of America's House Museums* (Washington, D.C.: Smithsonian Press, 1999), p. 136.

4. Sugaring Off

1. See Roger Cardinal, "The Sense of Time and Place," in Jane Kallir, ed., *Grandma Moses in the 21st Century* (New Haven: Yale University Press, 2001), pp. 99–100.

2. Jane Kallir, *Grandma Moses, The Artist Behind the Myth* (New York: C. N. Potter, 1982), pp. 132–147, studies the clippings that stand behind these works in detail.

3. Quoted in Albert K. Baragwanath, *Currier & Ives* (New York: Abbeville, 1980), p. 16.

4. Many of these same motifs occurred in the newspaper and magazine clippings she saved; see Jane Kallir, "Catalog," in *Grandma Moses in the 21st Century,* pp. 132–136.

5. [Carlyle Burrows], "A Woman Primitive," *New York Herald Tribune,* October 13, 1940.

6. "Grandma Moses," *Time,* October 21, 1940, p. 56.

7. Louis Caldor, quoted in "A Painter at 80, Farm Woman Will Exhibit Art," *New York Herald Tribune,* October 8, 1940.

8. Grandma Moses, *My Life's History* (New York: Harper, 1952), p. 29.

9. Ibid., pp. 28–29.

10. Roger Cardinal offers this definition in Gerard C. Wertkin, ed., *Encyclopedia of American Folk Art* (New York: Routledge, 2004), p. 362.

11. Dorothy Canfield Fisher, *Vermont Tradition: The Biography of an Outlook on Life* (Boston: Little, Brown, 1953), pp. 248, 186.

12. Dorothy Canfield Fisher, *Memories of Arlington, Vermont* (New York: Duell, Sloan and Pearce, 1957), p. 3. The book was part of a series of "hometown books" appended to the American Folkways series, introduced by the same publisher in 1941. The goal was to encourage the production of regional literature.

13. Dona Brown, *Inventing New England: Regional Tourism in the Nineteenth Century* (Washington, D.C.: Smithsonian Press, 1995), pp. 148–149.

14. Harriet Beecher Stowe, *Poganuc People* (Hartford, Conn.: Stowe-Day Foundation, 1977), pp. 239–245. The novel begins c. 1818. Grandma Moses includes a cast-iron coring machine in several of her apple butter scenes.

15. Roger B. Stein, "After the War: Constructing a Rural Past," in William H. Truettner and Roger B. Stein, eds., *Picturing Old New England: Image and Memory* (Washington, D.C.: National Museum of American Art, Smithsonian Institution, 1999), pp. 16–17.

16. In *American Poetry: The Nineteenth Century,* vol. I (New York: The Library of America, 1993), p. 485.

17. Calvin Coolidge, *The Autobiography of Calvin Coolidge* (Rutland, Vt.: Academy Books, 1972), pp. 26–27. This is a facsimile of the 1929 edition.

18. Quoted in Karal Ann Marling, *George Washington Slept Here* (Cambridge, Mass.: Harvard University Press, 1988), pp. 265–267.

19. See Henry Ford, "President and Prince Autograph a Bucket," *Good House-keeping,* March 1935, pp. 218–219.
20. See Devin Corbin, "Keeping Time," *American Scholar,* Spring 2004, pp. 49–57.
21. Wallace Nutting, *Vermont Beautiful* (New York: Bonanza Books, 1922), p. 66.
22. Ibid., p. 125.
23. *Images of America: Bennington* (Charleston, S.C.: Arcadia Press, 2002), p. 108.
24. Edward Connery Lathem, *The Poetry of Robert Frost* (New York: Henry Holt, 1975), pp. 275–277.
25. Quoted in Truettner and Stein, eds., *Picturing Old New England,* p. 137.
26. Margaret Breuning, "The Personal World of Grandma Moses," *Art Digest,* February 15, 1944, p. 9.
27. Alice Graeme, "Rural Scenes by Anna Moses Have Flavor of Early U.S. Art," c. 1941, unidentified clipping *(Washington Post?)* in Moses Scrapbooks (Galerie St. Etienne, New York), vol. I, a review of an exhibition at the Whyte Gallery in Washington, D.C., January 1941. Chances are that Grandma Moses had never seen a Bruegel. But in the 1930s and 40s, the so-called "Flemish Primitives" enjoyed a vogue in the United States. Grant Wood used Flemish portraiture that he saw in Germany as the basis for several of his Midwestern portraits and landscapes. U.S. audiences also saw similar works: for example, "Flemish Primitives," an exhibition organized by the Belgian Government through the Belgian Information Center (New York: M. Knoedler Gallery, 1942).
28. See a black-and-white reproduction of *Bringing in the Maple Sugar* (c. 1939) in the *Washington Sunday Star,* January 19, 1941, for example, and a color reproduction of *Sugaring Off* (1943) on the cover of the *Christian Science Monitor* magazine section, January 5, 1946.
29. "Vermont Maid," a syrup brand with a trademark young lady in the Mary Pickford style, plays on the regulations governing such products. Purists charge that "Vermont Maid" contains only 2 percent or less of the real thing!
30. See, for example, Henrietta Murdock, "Hook Rugs the Fast New Way," *Ladies' Home Journal,* November 1949, pp. 180–181; Polly Crane, "A Colonial Home Borrows Modern Ideas," *Better Homes and Gardens,* February 1952, p. 18; and untitled photos in *American Home,* June 1948, pp. 39, 44. Ads for paint and flooring are also filled with decorating "tips."
31. Erwin O. Christensen, *The Index of American Design* (New York: Macmillan, 1950), was the first large-scale color collection of reproduc-

tions drawn from the Index. For the sap bucket, see Clarence P. Hornung, *Treasury of American Design,* vol. II (New York: Harry N. Abrams, 1976), no. 1692.

32. See unpaginated ad in *Modern Stationer,* April 1947, and "Grandma Moses Cards," *Modern Stationer,* October 1947, p. 58.

33. 1947 card, 4 × 5½″, in the collection of the author; copyright Galerie St. Etienne, New York City.

34. Ad, Gimbels department store, *New York Herald Tribune,* November 14, 1940.

5. Mother Moses "Discovered"

1. Nancy Davids, "'To Grandmother's House We Go,'" *Collier's,* January 6, 1945, p. 48.

2. "Grandma Moses," *Time,* October 21, 1940, p. 56.

3. Jane Kallir, *The Essential Grandma Moses* (New York: Wonderland Press, 2001), p. 29.

4. Bruce Bliven, Jr., "Grandma Moses Has a Birthday," *Life,* October 25, 1948, p. 78.

5. "Artist Just By Hobby 'Doesn't Mind Fuss,'" *New York Times,* November 15, 1940.

6. Louis J. Caldor to Otto Kallir, July 3, 1951, quoted in Jane Kallir, *Grandma Moses: The Artist Behind the Myth* (New York: C. N. Potter, 1982), p. 12.

7. Ibid.

8. Grandma Moses, *My Life's History* (New York: Harper, 1952), p. 129.

9. Ibid., p. 130.

10. Ibid., pp. 45–46.

11. Ibid., p. 85.

12. Ibid., p. 106.

13. Ibid., p. 129.

14. Georgiana Brown Harbeson, *American Needlework* (New York: Bonanza Books, 1938), pp. 186, 195–196. Both transfer patterns and stamped linens were sold and given away by manufacturers of sewing supplies, such as Clarke and Butterick, as early as the 1890s. See *www.vintagecat.com/embroidery.htm.*

15. For a guide to common stitches, see Rose Wilder Lane, *Woman's Day Book of American Needlework* (New York: Simon & Schuster, 1963), pp. 24–34. For nineteenth-century needlework, see Susan Burrows Swan,

A Winterthur Guide to American Needlework (New York: Rutledge, 1976), pp. 58–63, and Elsa S. Williams, *Heritage Embroidery* (New York: Van Nostrand Reinhold, 1967), especially the guide to the couched trellis stitch, p. 97.

16. Jean Lipman and Alice Winchester, *The Flowering of American Folk Art, 1776–1876* (New York: Whitney Museum of American Art, 1974), pp. 15ff.

17. Beth Moses Hickok, *Remembering Grandma Moses* (Bennington, Vt.: Images from the Past, 1994), p. 38.

18. Quoted in ibid., p. 14.

19. Grandma Moses, *My Life's History,* p. 138.

20. Caldor to Moses, March 20, 1939, quoted in J. Kallir, *Grandma Moses: The Artist Behind the Myth,* pp. 12–13.

21. Sidney Janis, *They Taught Themselves: American Primitive Painters of the 20th Century* (New York: Sanford L. Smith, 1999), p. 6. The book is a reprint of the 1942 edition.

22. Kenneth L. Ames, in *Beyond Necessity: Art in the Folk Tradition* (New York: W. W. Norton, 1977), p. 82, faults Holger Cahill's 1932 show for constructing a specious parallel between folk art and fine art.

23. Quoted in Beatrix T. Rumford, "Uncommon Art of the Common People: A Review of Trends in the Collecting and Exhibiting of American Folk Art," in Ian M. G. Quimby and Scott T. Swank, eds., *Perspectives on American Folk Art* (New York: W. W. Norton, 1980), p. 36.

24. Henry McBride, quoted in *Art Digest,* December 15, 1932, p. 14.

25. *Contemporary Unknown American Painters* (New York: Museum of Modern Art, 1939), unpaginated introduction.

26. Horace Pippin, the African-American artist "discovered" by Cahill in time for his 1938 show at MoMA, painted at least two works that may have been influenced by Grandma Moses: *The Old Mill* of 1940 and *Maple Sugar Season* of 1941.

27. Elizabeth McCausland, "Exhibitions in New York," *Parnassus,* December 1939, p. 28.

28. Alfred Frankenstein, "An Octogenarian Is Prodigy of the Primitives," unidentified clipping (c. 1945) in Moses Scrapbooks, vol. I.

29. Janis, *They Taught Themselves,* p. 130.

30. Quoted in ibid., p. 131.

31. Otto Kallir, *Grandma Moses* (New York: Harry N. Abrams, 1973), p. 35; cat. 42.

32. Allan M. Jalon, "The Hungarian Jew Who Led Grandma Moses to Art's

Promised Land," *Forward,* July 20, 2001; *www.forward.com/issues/2001/01.07.20/arts2.html.*

33. "Grandma Moses," *Art Digest,* October 15, 1940. This was among the many journals to take up the name immediately; the Galerie St. Etienne assembled a sheet of reviews, including the *Herald-Tribune* notice, while the show was still in progress; see Moses Scrapbook, vol. I.

34. "Widow, 80, Hailed for Art, Eagle Bridge Spurned," *New York Journal American,* October 8, 1940.

6. From Farm Wife to Media Darling

1. Howard Devree, "A Reviewer's Notebook," *New York Times,* October 13, 1940.

2. "Grandma Moses," *Art Digest,* October 15, 1940, p. 7, summarizing reviews by Devree, Carlyle Burrows, and Emily Genauer.

3. Gimbels ad, *New York Daily Mirror,* November 13, 1940.

4. Gimbels ad, *New York Times,* November 14, 1940.

5. Edward Filene quoted in Bill Lancaster, *The Department Store: A Social History* (London: Leicester University Press, 1995), p. 171.

6. William Leach, *Land of Desire: Merchants, Power, and the Rise of a New American Culture* (New York: Pantheon, 1993), pp. 136–138.

7. See the many newspaper ads for November 1940 in Moses Scrapbooks, vol. I.

8. "Grandma Moses," *Time,* October 21, 1940, p. 56.

9. Otto Kallir, ed., *Grandma Moses: American Primitive* (Garden City, N.Y.: Doubleday, 1947), commentary by the artist on Plate 28.

10. "Grandma Moses Just Paints and Makes No Fuss About It," *New York World-Telegram,* November 15, 1940. An ad for Gimbels' Christmas merchandise appears below the story.

11. Grandma Moses, *My Life's History* (New York: Harper, 1952), pp. 130–131.

12. "Grandma Moses Just Paints," *New York World-Telegram,* November 15, 1940.

13. Gimbels ad, *New York Daily Mirror,* November 13, 1940.

14. Peter Schjeldahl, "The Original," *New Yorker,* May 28, 2001, p. 136, commenting on "Grandma Moses in the 21st Century," curated by Jane Kallir.

15. See John Rockwell, "The Foggy, Foggy Dew," in Sean Wilentz and Greil Marcus, eds., *The Rose and the Briar: Death, Love, and Liberty in the American Ballad* (New York: W. W. Norton, 2005), pp. 231–233.

16. O. Kallir, *Grandma Moses: American Primitive,* commentary on Plate 17.
17. *Northwood* quoted in Norman R. Fryatt, *Sarah Josepha Hale* (New York: Hawthorne, 1975), pp. 114–116.
18. Harriet Beecher Stowe, *Poganuc People* (Hartford: Stowe-Day Foundation, 1977), p. 317.
19. Harriet Beecher Stowe, *Oldtown Folks* (New Brunswick, N.J.: Rutgers University Press, 1987), pp. 282–290.
20. Quoted in Karal Ann Marling and Helen A. Harrison, *7 American Women: The Depression Decade* (New York: A.I.R. Gallery, 1976), pp. 31–33. Lee's paintings were often called "Americana," "folk," or "primitive" by reviewers, even though she had been trained in a variety of American art schools and had studied in Paris. In 1947 she and her husband, Arnold Blanch, who worked in a similar style, published *It's Fun to Paint* (New York: Tudor, 1947), recommending their style for Sunday painters. A Grandma Moses landscape was illustrated in the book, on p. 114.
21. Nancy Davids, "'To Grandmother's House We Go,'" *Collier's,* January 6, 1945, p. 48.
22. Grandma Moses, "'Turkey and Trimans' with Grandma Moses," *New York Times Magazine* (November 21, 1948), p. 62. See also "An Old-Fashioned Thanksgiving as Painted by Grandma Moses," *Look,* November 23, 1948, pp. 112–113.
23. Jane Wickerson, "Thanksgiving Dinner," *New York Times Magazine,* November 23, 1947, p. 17.
24. Ad, *New York World-Telegram,* November 19, 1950.
25. "We Break Bread Together," *McCall's,* November 1956, pp. 52–53.

7. A "Primitive" Artist

1. See *Home for Thanksgiving,* 1952, in Margot Cleary, *Grandma Moses* (New York: Crescent, 1991), p. 16.
2. Otto Kallir, *Grandma Moses: American Primitive* (Garden City, N.Y.: Doubleday, 1947), p. 28.
3. "A Great-Grandmother Wins an Art Award," *Binghamton [N.Y.] Press,* May 12, 1941. The competition was juried by a panel of distinguished New Yorkers, including John Marin, a pioneering American Cubist and a follower of Alfred Stieglitz, a leader of the New York avant-garde.
4. See *Contemporary Art of the United States: Collection of the International Business Machines Corporation* (New York: IBM, 1940), unpaginated.

5. Quoted in Karal Ann Marling, *Wall-to-Wall America: Post Office Murals in the Great Depression* (Minneapolis: University of Minnesota Press, 2000), p. 39.

6. O. Kallir, *Grandma Moses: American Primitive,* p. 32.

7. See Grandma Moses, *My Life's History* (New York: Harper, 1952), p. 131, and O. Kallir, *Grandma Moses: American Primitive,* p. 24.

8. Robert M. McCain, "She Took Up Art at 76," *The Woman,* May 1943, pp. 15–16.

9. Otto Kallir includes a definitive list of Moses shows in O. Kallir, *Grandma Moses* (New York: Harry N. Abrams, 1973), pp. 343–352.

10. The question in 2006 is, rather, *did* artists wear aprons? If they were folk artists and the study was written after the advent of the women's movement, of course they did! See C. Kurt Dewhurst, Betty MacDowell, and Marsha MacDowell, *Artists in Aprons: Folk Art by American Women* (New York: Dutton, 1979), a joint publication with the Museum of American Folk Art.

11. "A Book A Day," *Honolulu Star-Bulletin,* February 14, 1947.

12. Untitled notice, *Lewiston [Idaho] Tribune,* June 12, 1947.

13. "*Grandma Moses: American Primitive*" (book review), *Christian Science Monitor,* March 22, 1947.

14. "Bogie and Bacall Got Their Marital Start Down on the Farm," *St. Louis Post-Dispatch,* July 22, 2001.

15. Louis Bromfield, "Introduction," in O. Kallir, ed., *Grandma Moses: American Primitive,* pp. 11–13.

16. This work may have been his payment for the essay.

17. Bob Hope, "It's the Spirit," *Chicago Times,* January 17, 1946.

18. Untitled review, *Saturday Review of Literature,* February 1, 1947; clipping in Moses Scrapbooks, vol. I.

19. See Serge Guilbaut, *How New York Stole the Idea of Modern Art* (Chicago: University of Chicago Press, 1983), p. 33 and passim.

20. "A *Life* Round Table on Modern Art," *Life,* October 11, 1948, p. 62.

21. Untitled review, James Thomas Flexner, *Magazine of Art,* May 1947, in Moses Scrapbooks, vol. I.

22. F. W. Weber, "Today's Book," *New York Post,* May 23, 1947.

23. Henry McBride, "Artists in Books," *New York Sun,* May 29, 1947.

24. Quoted in Jane Kallir, *Grandma Moses: The Artist Behind the Myth* (New York: Clarkson N. Potter, 1982), p. 16.

25. Grandma Moses, *My Life's History,* p. 132.

26. Wambly Bald, "Fame Comes to Grandma at 77," *New York Post,* April 10, 1946.

27. Ben Wolf, "The Dirty Palette," *Art Digest,* April 5, 1946, in Moses Scrapbooks, vol. I.

28. Ad, *Good Housekeeping,* May 1946, in Moses Scrapbooks, vol. I.

29. See Lois W. Banner, *American Beauty* (Chicago: University of Chicago Press, 1983), p. 273. Revlon pioneered the use of striking profiles and unusual costumes in its lipstick ads of the postwar period; see also the ad for fuschia lip color (1945) in Jim Heimann, ed., *40s All-American Ads* (New York: Taschen, 2001), p. 307.

30. Ad, *New York Times,* May 5, 1946. See also *Art, Design, and the Modern Corporation* (Washington, D.C.: Smithsonian Institution Press, 1985).

31. Russell Lynes, *The Tastemakers: The Shaping of American Popular Taste* (New York: Dover, 1980), p. 293, a reprint of the 1949 edition including the *Life* photos. See also Steven Biel, *"American Gothic": A Life of America's Most Famous Painting* (New York: W. W. Norton, 2005), pp. 132–133.

32. "Grandma Moses On 'We, the People,'" *Hoosick Falls Standard,* May 2, 1946.

8. Cakes and Cards

1. Ellen Jones, "Grandma Moses Celebrates 87th Birthday with Party," *Troy [N.Y.] Record,* September 8, 1947.

2. Mary L. Alexander, "Taft Museum Slates Exhibition of Work of Grandma Moses," *Cincinnati Enquirer,* December 12, 1950.

3. Emily Genauer, "'Grandma' Moses' Canvases Among Other Displays," *New York World-Telegram,* March 2, 1946. Wilder's *Our Town* (1938) was made into a movie starring William Holden in 1940, with a score by Copland.

4. Quoted in "Grandma Moses," *Park Avenue Social Revue,* September 1950, p. 13.

5. Ad, *New York Times,* November 24, 1946. For the Vermont phase of Rockwell's life, see Stuart Murray, *Norman Rockwell at Home in Vermont* (Bennington: Images From the Past, 1997).

6. Cover, *House & Garden,* December 1946; *Holiday,* February 1947. The *Holiday* cover won a 1947 award from the Art Directors Club of New York. Other winners for that year included Thomas Hart Benton and Doris Lee, who often worked for advertisers.

7. Helen Markel Herrman, "Don't look now but your Christmas card is showing," *House Beautiful,* November 1947, in Moses Scrapbooks, vol. I.

8. Hallmark brochure, 7 pp., in Moses Scrapbooks, vol. I.

9. See full-page ad in *Modern Stationer,* April 1947, unpaginated, with a photo of Grandma Moses and one of the cards—a white church in the snow surrounded by a drawn-in frame.

10. Joyce C. Hall with Curtiss Anderson, *When You Care Enough* (Kansas City: Hallmark, 1979), p. 165.

11. Unidentified newspaper clipping, "Birthday Cake Almost Too Big," [Albany, N.Y.?], September 9, 1948, in Moses Scrapbooks, vol. I.

12. Quoted in Bruce Bliven, Jr., "Grandma Moses Has a Birthday," *Life,* October 25, 1948, p. 77.

13. Norman Rockwell, as told to Tom Rockwell, *My Adventures as an Illustrator* (New York: Harry N. Abrams, 1994), p. 341.

14. *Saturday Evening Post,* December 25, 1948, front cover. Rockwell's son Jerry is the boy arriving home, with sons Peter and Tommy looking on. Mary Rockwell hugs Jerry. See also Norman Rockwell as told to Nanette Kutner, "Grandma Moses," *McCall's,* October 1949, pp. 26–27.

15. See, for example, *Vogue,* October 15, 1948. The Hallmark ads were created by Foote, Cone & Belding.

16. The Hallmark brochure for November 1953 added Doris Lee to its roster of big stars.

17. Edward J. Mowery, "Masters Mirrored on Greeting Cards," *New York World-Telegram,* August 3, 1948. See also "Miniature Works of Art," *New York Star,* December 6, 1948. Rockwell was a frequent visitor to Hallmark headquarters; see "Christmas Card Design," *Design,* December 1948, pp. 7–8.

18. See, for example, similar articles in the *New York World-Telegram,* the *Rochester Democrat and Chronicle,* the *Danbury News-Times,* and scores of other papers in upstate New York and New England during the first week of September, 1949. Fisher, who was also drawn by Rockwell, was a particular friend of his wife Mary. *Understood Betsy* (New York: Henry Holt, 1946), Fisher's 1917 novel, is about a little girl like Mary Rockwell who has relatives in Vermont.

19. See G. H. Gregory, ed., *Posters of World War II* (New York: Grammercy Books, 1993), pp. 28–35, and William L. Bird, Jr., and Harry R. Rubenstein, *Design for Victory: World War II Posters on the American Home Front* (New York: Princeton Architectural Press, 1998), pp. 82–87.

20. "U.S. Likes Native Artists' Work for Yule Cards," *Boston Traveler,* December 20, 1949.

21. *Look,* April 1949, clipping in Moses Scrapbooks, vol. I.

22. Bill, "The Low Down," [Oakland, Calif.] *Neighborhood Journal,* November 23, 1949.

23. Berton N. Hassing, "Brickbats and Bouquets," *Ocean Beach [Calif.] News,* November 10, 1949.

24. Ad for the Hustler Press, Farmington, N.M.; *Farmington [N.M.] Times,* November 25, 1949.

25. Ad for Diamond's department store, Phoenix; *Arizona Republic,* August 28, 1950. Churchill's contract with Hallmark was announced at the same time. See "Winston Churchill, Xmas Card Artist," *Art Digest,* March 1, 1950; clipping in Moses Scrapbooks, vol. I.

26. Two-page layout in *Good Housekeeping,* June 1950, pp. 64–65.

27. "Grandma Moses' Painting Used in Draperies," *Jamestown [N.Y.] Post-Journal,* May 9, 1950.

28. Whitney's ad, [Albany, N.Y.] *Knickerbocker News,* September 6, 1950; "Grandma Moses' Painting To Be Shown at Institute in Honor of Her 90th Birthday," *Albany Times Union,* September 7, 1950. See also "Hail Granny Moses at 90," *Boston Record,* September 8, 1954.

29. Harriet Morrison, "Grandma Moses Designs for Homes," *New York Herald Tribune,* June 21, 1950.

30. "'Grandma' Moses Plates Show Four Reproductions," *Hoosick Falls Standard Press,* June 28, 1950.

31. See McCreery's ad, *New York Times,* June 25, 1950.

32. "Grandma Moses Listed Among Outstanding U.S. Women," *Christian Science Monitor,* April 16, 1949.

33. "Truman Plays for Mrs. Moses at Tea," *Washington Post,* May 16, 1949.

34. See ads in *Minneapolis Star,* April 13, 1951. See also *Grandma Moses: Sixty of Her Masterpieces,* commemorative brochure for the exhibition held April 9–28, 1951, by the Dayton Company; exhibition files, Galerie St. Etienne.

35. For Fisher and the Moses Red Feather paintings, see, for example, "Grandma Moses' Red Feather Painting Will Be Shown Here," [Jamestown, N.Y.] *Post-Journal,* August 7, 1950.

36. Nan Kutner, "It's Never Too Late To Begin, Grandma Moses Starts a New Business at the Age of 91," *American Weekly,* May 18, 1952, p. 17.

9. G. Moses, Inc.

1. Barbara E. Scott Fisher, "'Go Ahead and Paint': 'Anybody Can Paint If they Go About It,' Says Successful Artist Grandma Moses," *Christian Science Monitor,* January 5, 1946. Howard Finster and other folk artists of the twentieth century have been criticized for producing too much

work, often by those whose profits depend on scarcity (and high prices).

2. Moses to Caldor (in pencil), March 13, 1944, in Galerie St. Etienne files.

3. Emily Genauer, "'Grandma Moses' Canvases Among Other Displays," *New York World-Telegram*, March 2, 1946.

4. See Ernestine Evans, "Untaught, She Painted What She Loved," *New York Herald-Tribune Book Review*, December 22, 1946.

5. Item in *New York Times Magazine*, January 16, 1949.

6. "March of Dimes Show presents Advance Spring Fashions," *Brooklyn Daily Eagle*, February 2, 1949.

7. Cartoon, *New Yorker*, October 15, 1949, p. 24.

8. "'Harry, Play the Piano for Me,' Is Revealed as Classic Quip of Grandma Moses to Truman," [Springfield, Mass.] *Union*, January 5, 1950.

9. June Kimball, "Art Shows Flood Berkshires; Grandma Moses Biggest Name," *Berkshire Eagle*, July 21, 1949.

10. "Grandma Moses Dinnerware," *Crockery & Glass Journal*, December 1953, unpaginated; Amy Rollinson, "Floral Patterns Popular for New China, Pottery," *Houston Chronicle*, January 10, 1954. See also "She'll Be 92 Sunday," *New York Times*, September 6, 1952.

11. See ads, [Colorado Springs] *Gazette Telegraph*, February 7, 1954; *Billings [Mont.] Gazette*, February 4, 1954; *New York Times*, April 18, 1954.

12. Distributor's flier, Berndae, Inc., for New York City Gift Shows, c. April 1953. In Moses Scrapbooks, vol. II.

13. Alma Archer, "Some Gift Suggestions," *New York Mirror*, December 8, 1954.

14. SBF ad, *St. Louis Post-Dispatch*, December 5, 1954.

15. The Post cereals ads blanketed the nation throughout the spring of 1955; see Moses Scrapbooks, vol. III.

16. Untitled article, [Saginaw, Mich.] *News*, January 9, 1955.

17. "Macy's Easter Display Features Famed Artists," [San Francisco] *Bulletin*, March 26, 1956.

18. "Grandma Moses Subject of Clio Club Program," [Warsaw, Ind.] *Times-Union*, March 29, 1956.

19. "Originals by Grandma Moses Sell for Thousands . . .," *House & Garden*, *New York Times Magazine*, etc., November 1956.

20. Untitled article, [Roanoke, Va.] *World-News*, September 7, 1956.

21. "Grandma Moses Prints, Capes," *Women's Wear*, October 31, 1956, and "Children's Wear—Spring," *Women's Wear*, November 7, 1956.

22. "Grandma Moses Turns Hand to Designing Dress Styles," [New Rochelle, N.Y.] *Standard-Star*, January 2, 1957.

23. See Moses Scrapbooks, vol. III, for pages of early 1957 ads and features about the Cinderella dresses.

24. "Presents from Grandma," *Time,* December 28, 1953, cover and pp. 38–42.

25. "People," *Time,* June 14, 1954, p. 43.

26. "Grandma Moses Celebrates 90th Birthday," *New York Times,* September 8, 1950.

27. Cover, *Life* magazine, September 19, 1960.

28. Arnold Newman photographs for "Portrait Backgrounds," *Life* clipping (1952), in Moses Scrapbooks, vol. II.

29. "Eisenhower Gets Painting of Farm," *New York Times,* January 19, 1956.

30. "Grandma Moses Painting of His Gettysburg Farm," *New York Herald-Tribune,* January 10, 1956.

31. "Not Altogether Primitive," *New York Times,* January 20, 1956.

32. Ala Story, "Meetings with Grandma Moses Recalled by Director Ala Story," [Santa Barbara, Calif.] *News-Press,* February 15, 1953. In 1952, Story became Director of the Santa Barbara Museum of Art.

33. Gary O. Larson, *The Reluctant Patron: The United States Government and the Arts, 1943–1965* (Philadelphia: University of Pennsylvania Press, 1983), pp. 24–25. See also Michael L. Krenn, *Fall-Out Shelters for the Human Spirit: American Art and the Cold War* (Chapel Hill: University of North Carolina Press, 2005).

34. Ralph M. Pierson, "Hearst, the A.A.P.L., and Life," *Art Digest,* December 15, 1946, p. 25.

35. Part of the American British show of 1948 (17 pictures) went to Lenox in July. The checklist for that exhibition includes the MacLeish essay.

36. Thomas Carr Howe, Jr., "Grandma Moses," in exhibition brochure for Grandma Moses show at the American British Art Gallery (now on East 55th Street), January 30–February 18, 1950. Galerie St. Etienne exhibition files.

37. See Carlyle Burrows, "Grandma Moses," *New York Herald-Tribune,* March 3, 1946.

38. See Emily Genauer, "'Grandma Moses' Canvases Among Other Displays," *New York World-Telegram,* March 2, 1946. By the time of her 1948 show, Genauer had tempered her scorn somewhat; Grandma, she said, had learned something about technique that saved her from "sugary sweetness." See "Granny Gains Stature As Painting Marvel," *New York World-Telegram,* June 1, 1948, and cover, *Art Digest,* May 15, 1947.

39. See, for example, "Paris va peut-être connaître cet hiver une curieuse ex-

position de peinture . . .," *Paris Hedbo,* August 1947, clipping, Moses Scrapbooks, vol. I.

40. "Grandma Goes to Europe," *Time,* July 3, 1950, p. 48.

41. *Grandma Moses: American Primitive* had already been favorably reviewed in the *Gazette des Beaux-Arts,* 31 (May/June 1947), p. 101.

42. The phrase served as the title for a book by Irving Sandler, *The Triumph of American Painting* (New York: Praeger, 1970). The subtitle, *A History of Abstract Expressionism,* points to the art expected to "triumph" in the artistic vacuum of postwar Europe.

43. Aline B. Louchheim, "Americans in Italy," *New York Times,* September 19, 1950.

44. Unsigned editorial, *Art Digest,* November 15, 1953, p. 5.

45. Otto Kallir, "Letters: Quality," *Art Digest,* November 15, 1953, p. 3.

46. Robert Goldwater, *Primitivism in Modern Painting* (New York: Harper, 1938), 1st edition. The enlarged and revised edition appears under the title *Primitivism in Modern Art* (Cambridge, Mass.: Harvard University Press, 1986).

47. Robert Goldwater, "Letter from Paris," *Magazine of Art,* May 1951, p. 1.

48. Elise Clemes, "French Critics Praise Grandma Moses Show," *European Traveler,* December 21, 1950. See also "Grandma Moses a sacrifié ses confitures à la peinture naïve," *Paris Press,* December 7, 1950.

49. See "Merry Christmas," [Santa Ana, Calif.] *Register,* October 28, 1949.

50. See Emily Genauer, ". . . Grandma Moses at Berne," *New York Herald-Tribune,* August 1, 1950.

51. "Reagans Enjoy Grandma Moses Art," [Glens Falls, N.Y.] *Times,* February 26, 1956.

52. The painting dates to 1954.

53. "A Tribute to Grandma Moses," pp. 6–9, 10, 16–17, 31, in Galerie St. Etienne exhibition files. Otto Kallir chose the paintings for the 1955 show.

54. Alice Hughes, "Grandma Moses Fibs About Her Age," King Features Syndicate tear sheet, December 5, 1955, in Moses Scrapbooks, vol. III.

55. Edith Evans Asbury, "Grandma Moses, 95 Tomorrow, Eager for End of Birthday 'Fuss,'" *New York Times,* September 6, 1955.

56. Joan Hanauer, "Grandma Moses Isn't Painting Much Today—She'll Observe Her 95th Birthday This Week," [Memphis, Tenn.] *Commercial-Appeal,* September 4, 1955.

57. See *TV Guide* for the week of March 28, 1952, p. 13; see also "Films, Music," [Los Angeles, Calif.] *Examiner,* March 20, 1952.

58. "Miss Gish Urges Secy. of Art," [Los Angeles, Calif.] *Examiner,* January 22, 1955.

10. Grandma Is Very Old

1. Untitled paragraph on M-G-M in *News-Week,* May 9, 1949; Louella O. Parsons, "Hollywood," *New York Journal-American,* January 18, 1949.

2. "Grandma Moses, 88, Sees Self at Work on Painting Through Television Set," [Albany, N.Y.] *Times-Union,* December 20, 1948. See also listing for WABC (Channel 5) show at 7:30 P.M., *New York Times,* December 18, 1948, and "Design for Living," *New York World-Telegram,* May 4, 1949.

3. See "Down in the Valley," a 1950 RCA album, and "The Grandma Moses Suite" from Columbia Records, 1952. See also Edwin H. Schloss, "Recorded Music," *Philadelphia Inquirer,* August 2, 1951; "Millionaire Makes Movies," *Cue,* February 18, 1961.

4. Bosley Crowther, "The Screen in Review," *New York Times,* October 24, 1950.

5. Helen M. Franc, "Film Review," *Magazine of Art,* November 1950, in Moses Scrapbooks, vol. I.

6. Quoted in Emily Genauer, "Art and Artists," *New York Herald-Tribune,* August 27, 1950.

7. "Television," *New Yorker,* February 16, 1953, p. 28.

8. James Thrall Soby, "A Bucolic Past and a Giddy Jungle," *Saturday Review of Literature,* November 4, 1950, pp. 40–41.

9. James Thrall Soby, "Grandma Moses," in *Saturday Review Reader* (New York: Bantam, 1951), pp. 173–177.

10. Doron K. Antrim, "Life Begins at 50," *New York Herald-Tribune,* October 17, 1948.

11. Leo Lerman, "Over Seventy," *Harper's Bazaar,* December 1945, p. 104.

12. Ernest LaFrance, "Shall Old Age Be Burden or Blessing?" *Parade,* July 6, 1947, p. 7.

13. Gayelord Hauser, "Release and Develop Your Submerged Side to Achieve Happy State of Balanced Living," *New York Journal American,* July 19, 1950. Hauser's best-selling advice book was entitled *Look Younger, Live Longer.*

14. "Grandma Moses Finds Long-Living 'a Cinch,'" [Binghamton, N.Y.] *Press,* September 8, 1950.

15. Wendy and Everett Martin, "Busy Grandmas," *Philadelphia Inquirer Magazine,* March 4, 1951.

16. Ad for Chicken of the Sea tuna, *Ladies' Home Journal,* April 1947, p. 300, and *Better Homes & Gardens,* April 1947, p. 93. A variation on the type— two old ladies amazed by modern technology—appears in an ad for automatic garage door openers: *Better Homes & Gardens,* April 1947, p. 165.

17. Ad for "Grandma's Molasses," *Better Homes and Gardens,* May 1947, p. 30, and *Ladies' Home Journal,* March 1947, p. 237.

18. Jim Harmon, *The Great Radio Heroes* (New York: Ace Books, 1967), pp. 172–174.

19. See ad, *Ladies' Home Journal,* January 1949, p. 65.

20. "Grandma Moses and 'Spry,'" *Food Field Reporter,* January 19, 1959.

21. "Food, Groceries," [Minneapolis, Minn.] *Tribune,* February 1, 1959.

22. The "New Leisure" was the crusade of *Holiday* magazine, beginning in 1956. See ad, *New York Times,* February 16, 1956. The March issue was devoted to "A Stratagem for Retirement," with case studies involving Grandma Moses, Cervantes, Albin Barkley, Clara Barton, and other active elders. See William Graebner, *A History of Retirement* (New Haven: Yale University Press, 1980), pp. 215ff.

23. "Harriman Opens Parley on Problems of the Aging," *New York Herald-Tribune,* October 19, 1955.

24. See Dr. F. Hunter Wilson, "Can You Stay Young and Live on Forever?" *Chicago Sun,* December 6, 1955.

25. Barbara E. Scott Fisher, "Go Ahead and Paint," *Christian Science Monitor,* January 5, 1946.

26. Jess Stern, "Everybody Is Painting Now, And We Don't Mean Houses," *New York News,* November 27, 1949.

27. See Emily Genauer, "Art and Artists," *New York Herald-Tribune,* January 8, 1950.

28. Quoted in [Tulsa, Okla.] *World,* September 3, 1950.

29. "Winston Churchill, Xmas Card Artist," *Art Digest,* March 1950, in Moses Scrapbooks, vol. I.

30. Untitled notice, *Harper's Magazine,* December 1950, in Moses Scrapbooks, vol. I.

31. Tear sheet for Hallmark corporate ad, November 1953, in Moses Scrapbooks, vol. II.

32. "Herald Tribune Forum to Hear Dulles, Brownell," *New York Herald-Tribune,* October 4, 1953.

33. See William L. Bird, Jr., *Paint By Number* (Washington, D.C.: Smithsonian Institution, 2001), chap. 2, "The New Leisure."

34. "Grandma Moses and Kallir," *New York Herald-Tribune,* October 25, 1953.

35. "'Grandma' Moses a Delight to Tuesday Forum Session," *New York Herald-Tribune,* October 25, 1953.

36. "'Grandma' Moses Art on Textiles," *New York Herald-Tribune,* October 25, 1953.

37. Marie Beynon Pay, "You Can Be an Amateur Painter," *Coronet,* March 1954, pp. 82–83.

38. "Grandma Moses on Eisenhower's Art," *Look,* July 27, 1954, pp. 48–51; "Revival of Amateur Art," *Greenwich [Conn.] Journal,* June 16, 1954.

39. Donna M. Binkiewicz, *Federalizing the Muse: United States Arts Policy and the National Endowment for the Arts* (Chapel Hill: University of North Carolina Press, 2004), p. 27. See also Joan Shelley Rubin, *The Making of Middlebrow Culture* (Chapel Hill: University of North Carolina Press, 1992).

40. Emily Genauer, "Bad Press for U.S. Art Show in Paris Examined," *New York Herald-Tribune,* April 17, 1955.

41. *High Society* was released in 1956.

42. Murrow's poor performance is critiqued in "Straight-Talking Grandma," *San Francisco Chronicle,* December 15, 1955.

43. "Focus," *Newsweek,* May 1956, p. 114.

44. See *The Grandma Moses Night Before Christmas* (New York: Random House, 1991), which contains reproductions of twelve original paintings, several color sketches, and additional snowscapes.

45. Howard Finster, the great Southern folk artist, was also persuaded to undertake the same project shortly before his death; see Howard Finster, *The Night Before Christmas* (Atlanta: Turner Publishing, 1996).

46. On this moving moment, see Jack Gould, "TV: American Originals," *New York Times,* December 14, 1955.

47. Murrow died in 1965, four years after Grandma Moses.

48. Sally MacDougall, "Grandma Moses Finally Views December TV Appearance," *New York World-Telegram and Sun,* May 14, 1956.

Epilogue

1. "Grandma Moses, 101, Dies," [Albany, N.Y.] *Times-Union,* December 14, 1961.

2. "Grandma Moses Dead at 101; Primitive Artist 'Just Wore Out,'" *New York Times,* December 14, 1961; "Grandma Moses Funeral at Her Home Tomorrow," *New York Herald-Tribune,* December 15, 1961.

3. The ceremony in honor of her 100th birthday, the "Grandma Moses Memory Book Musicale," was held in Manchester, Vermont, on August 6, 1960. The title of this chapter alludes to an old song that was performed at the event. The souvenir program contained a tribute by Dean Fausett,

president of the Southern Vermont Art Center, who painted a portrait of Mrs. Moses in honor of the occasion. See Allan Keller, "Grandma Moses Going Strong at 100," *New York World-Telegram,* September 7, 1960; Edith Evans Asbury, "Grandma Moses Turns 100 Gaily," *New York Times,* September 8, 1960; "Grandma Moses Burial Private," [Newburgh, N.Y.] *Evening News,* December 16, 1961.

4. "Grandma Moses, Primitive Artist, Dies," [Newburgh, N.Y.] *Evening News,* December 14, 1961.

5. Peter D. Franklin, "Gay Grandma Moses 100 Tomorrow," *New York Herald-Tribune,* September 3, 1960.

6. "Grandma Moses Lived with Zest," unidentified clipping, c. 1960, Moses Scrapbooks, vol. IV.

7. Herb Lyon, "Tower Ticker," *Chicago Tribune,* December 17, 1961; "All for Art," *Footwear News,* December 28, 1961.

8. "Grandma Moses Services Saturday," *New York Post,* December 14, 1961.

9. "Notes and Comment," *New Yorker,* December 23, 1961, Moses Scrapbooks, vol. VI.

10. "JFK Hails Aid of Grandma Moses to U.S.," *New York Journal-American,* December 14, 1961.

11. Jay Parini, *Robert Frost: A Life* (New York: Henry Holt, 1999), p. 414.

12. "Grandma Moses," *Manchester [N.H.] Union Leader,* December 15, 1961.

13. "Grandma Moses," [Durham, N.C.] *Herald,* December 17, 1961.

14. "On Second-Thought," [San Antonio, Tex.] *Express & News,* December 17, 1961.

15. "Grandma Moses Dies at Age 101," *Los Angeles Mirror,* December 14, 1961.

16. John Canaday, "Art of Grandma Moses," *New York Times,* December 14, 1961.

17. Grandma Moses, *My Life's History* (New York: Harper, 1952), p. 140. This concluding paragraph from her book was quoted and misquoted scores of times in the days after her death.

All Grandma Moses illustrations copyright © 2006, Grandma Moses Properties Co., New York. Kallir numbers in the captions refer to the definitive listing of Moses works appended to Otto Kallir, *Grandma Moses* (New York: Harry N. Abrams, 1973), pp. 280–328. Additional credits are given below.

p. 3
Bed by Robert Rauschenberg. The Museum of Modern Art, gift of Leo Castelli in honor of Alfred H. Barr, Jr. Art © Robert Rauschenberg / Licensed by VAGA, New York, NY. Digital image © The Museum of Modern Art / Licensed by SCALA/Art Resource, NY.

p. 13
Christmas Gator by Mike Hanning. Photograph by Ashley Wilkes.

p. 26
Home of Hezekiah King, 1776 by Grandma Moses. 1943. Collection of Phoenix Art Museum, gift of Mrs. N. A. Bogdan, New York, in memory of Mr. Louis Cates.

pp. 50, 86, 87
Lithographs published by Currier & Ives. From the Collections of The Henry Ford.

p. 108
Hoosick Falls, 1944, by Grandma (Anna Mary Robertson) Moses. Southern Vermont Arts Center, gift of Mrs. Gerard B. Lambert.

p. 118
The Old Covered Bridge by Grandma Moses. The Wadsworth Atheneum Museum of Art, Hartford, Conn. Gift of Mr. and Mrs. Andrew G. Carey.

p. 150
Thanksgiving (c. 1935) by Doris Lee (American, 1905–1983). Oil on canvas, 71.3 x 101.8 cm. The Art Institute of Chicago, Mr. and Mrs. Frank G. Logan Purchase Prize Fund, 1935.313. Photography © The Art Institute of Chicago.

p. 152
Catching the Thanksgiving Turkey by Anna Mary Robertson Moses. San Diego Museum of Art (gift of Pliny F. Munger).

p. 174
"Primitive Red" ad. Photograph by Ashley Wilkes.

p. 186
Photo of Norman Rockwell and Grandma Moses. © 1949, photographer unknown. Courtesy of Norman Rockwell Museum, Stockbridge, Massachusetts.

p. 188
Christmas Homecoming, Saturday Evening Post cover by Norman Rockwell, December 25, 1948. The Norman Rockwell Art Collection Trust, Norman Rockwell Museum, Stockbridge, Massachusetts. Used with the kind permission of the Norman Rockwell Family Agency, Inc. Copyright © 1948, the Norman Rockwell Family Entities.

p. 193
Dividing of the Ways, 1947, by Anna Mary Robertson "Grandma" Moses (1860–1961), Eagle Bridge, Washington County, New York. Oil and tempera on masonite, 16″ x 20″. Collection American Folk Art Museum, New York. Gift of Galerie St. Etienne, New York, in memory of Otto Kallir. 1983.10.1. Photo by John Parnell, New York. Copyright © 1969 (renewed 1997), Grandma Moses Properties Co., New York.

p. 206
Newspaper ad for Dayton's exhibition. Photograph courtesy of Tony Jahn, Target Corporation.

p. 254
My Hills of Home by Grandma Moses. Memorial Art Gallery of the University of Rochester, New York. Marion Stratton Gould Fund.

p. 256
Seed portrait of Grandma Moses. Copyright © 1975 by Lillian Colton. Photograph by Jorge Zegarra.

p. 258
Dayton's holiday display. Photograph courtesy of Tony Jahn, Target Corporation.

INDEX

Page numbers in italics refer to pages where Moses' paintings are reproduced.

285